THE MODE IN
Footwear

THE MODE IN
Footwear

A Historical Survey with 53 Plates

R. TURNER WILCOX

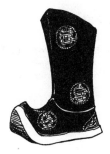

DOVER PUBLICATIONS, INC.
Mineola, New York

Bibliographical Note

This Dover Edition, first published in 2008, is a republication of *The Mode in Footwear*, first published by Charles Scribner's Sons, New York, in 1948.

DOVER *Pictorial Archive* SERIES

Library of Congress Cataloging-in-Publication Data

Wilcox, R. Turner (Ruth Turner), 1888–
 The mode in footwear : a historical survey with 53 plates / R. Turner Wilcox.
 p. cm.
 Originally published: New York : Scribner, 1948.
 ISBN-13: 978-0-486-46761-0
 ISBN-10: 0-486-46761-9 (pbk.)
 1. Shoes—History.

GT2130 .W55 2008
391.4/13—dc22

 2008034269

Manufactured in the United States of America
Dover Publications, Inc., 31 East 2nd Street, Mineola, N.Y. 11501

FOREWORD

IN THESE DAYS the politically minded and the erudite take pleasure in comparing our civilization with that of Rome at its height of opulence. I agree that the comparison is justified and I find that the shoes of the Romans point up the comparison excellently. There we surely have much in common with these Ancients. They surpassed all other and earlier peoples in their extravagant and frivolous styling of shoes, fashions which did not generally reappear until this twentieth century. Again the mode caters to footwear in a wide variety of design, but while one may indulge in extravagance one also buys the practical. And there is this vast difference, that only the wealthy Roman owned a large shoe wardrobe while today most individuals possess particular shoes for certain occasions.

When I undertook to compile a work on footgear, I soon discovered that I had taken on a real task involving much research but it proved a most absorbing subject and a thoroughly enjoyable one. I have endeavored to put down for the designer and posterity all the known shoe designs, keeping in mind that the return of any fashion no matter how fantastic is not impossible in the mode. And of course, very often the most practical idea stems from some absurd-looking creation.

So here is my record of foot-tire of the wide world—the primitive, the pagan, the conservative and the practical, all of which styles are very much in evidence in the time in which we live.

<div align="right">R. T. W.</div>

Tenafly, New Jersey
1947

CONTENTS

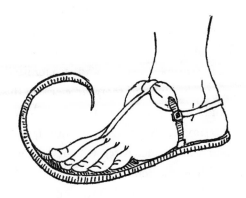

EGYPTIAN FOOTWEAR

CHAPTER ONE

ONE MAY assume that man has always needed some sort of foot protection or cover against intemperate climate or when traversing rough land. He first made use of that which nature placed at hand: bark, leaves and animal skins. Thousands of years have gone into the development of the shoe from the first crude urgently needed covering through all the stages of comfort by means of cutting, fitting and sewing to the final finished product which fulfills not only practical requirements but the demands of vanity as well. The history of the shoe also has to do with religion, rank and social position, but topping all these is that very human characteristic, vanity or fashion.

It was fashion that turned the peaked toe of the Oriental shoe into an exaggerated, long, slim point on the sandal of the Egyptian king. The style reappeared in the Moyen Age during which the turned-up stuffed toes acquired such length that fine chains and ribbons held them secured to knee or girdle to prevent the dandies from tripping over them. The wooden clog was an Oriental invention to prevent fine shoes from coming in contact with muddy streets, but again in Medieval times the fashionable aristocracy wore them higher and higher until the noble ladies fairly hobbled along on stilts. Too, vanity prompted the fashion of the broad, slashed toes which concealed the goutish toes of the Tudor kings, toes so broad that Queen Mary finally forbade fronts of shoes wider than six inches.

Coming down to our times one can recall the sharply pointed, slim, tortuous toes of the early twentieth century when women in particular were vain enough to suffer and disfigure their feet wearing the dainty-looking boots.

The development of a people socially and economically can be readily traced through the ages in the styles of footgear worn in the different periods of history. First, the crude foot protection of the primitive, nomadic types of earliest times. Then the simple, well-made but entirely functional designs of a well-balanced and practical people. After which we find every effort made to denote rank and wealth in the refinement of detail followed by a production of foot dress in which protection is less and less thought of. Finally, the beautifully ornamented, bejeweled shoes of costly leathers and fabrics indicative of an excess of indulgence in living, luxury, costliness and decadence corresponding to the lives of the wearers.

From the earliest Oriental civilizations of Egypt and Mesopotamia come our sandal, shoe and boot. The footgear of the most ancient civilized people, the Egyptians, was a very simple affair, for their warm, dry climate required nothing more than protection from the hot sands and pavements. The sandal of the Old and the Middle Kingdoms of two and three thousand years before Christ does not appear to have been worn indoors. A wall painting of about 3500 B.C. furnishes the information that in early Egypt even individuals of rank wore shoes only when necessary, the picture showing a king being followed by his servant who carries the royal sandals. Most historians seem to be of the opinion that footwear in ancient Egypt was a privilege indulged in only by nobility, priests and warriors. Or if worn by the upper class, sandals were removed in the presence of a superior of rank and never worn in sacred places.

The Egyptian sandal which was shaped to the right and left foot was simply a sole held on by a thong passing between the large and second toe. This single thong attached to an ankle band made it easy to slip in and out of the shoe. One of the most ancient of handicrafts is that of plaiting and the early sandal was of closely interlaced strips of wood, rush, flax, palm bast or papyrus stalk. Though the Egyptians early perfected the tanning and dressing of hides there were sandals of rawhide or untanned cattle and buffalo skins. The priest wore sandals of papyrus only, refusing to defile himself by contact with a dead animal.

The Egyptians reached a high degree of perfection in the dressing of skins

into leather. They tanned hides with the acids of certain plants according to the requirements of the different skins but best known was alum, the vegetable tannage in use today. They produced a leather similar to moroccan leather of Babylonian origin. It was lamb or goatskin dressed and dyed scarlet, green and purple, the colors after four thousand years retaining the brilliancy of the primitive hues.

In the Louvre Museum of Paris is one of the most ancient pairs of sandals taken from the feet of an Egyptian mummy. The workmanship is interesting indeed and reveals a method of manufacture in use in these modern times. The soles are two thicknesses of leather, the under one of ox, cow or buffalo sewn to an upper sole of thin leather. And surprisingly too, they are sewn together with a waxed thread.

It is to Theban frescoes painted on the walls of tombs in the fifteenth and nineteenth centuries before Christ that we go for the oldest pictures of the craft of shoemaking. Egyptian cobblers are shown making shoes, using tools like those of today. One workman is making the leather pliable by staking it over a currier's bench, another is cutting leather on a low sloping bench and using a circular knife. In another view loopholes are being pierced with an awl and in the sewing process the workman is seen tightening the thong with his teeth.

In the period of the New Kingdom from about 1500 to 1150 b.c., though people of rank often went barefoot indoors they paid great attention to the shoes they wore in public. By that time no man or woman of the upper class appeared in the streets barefoot, as it had become improper to do so, though for housewear many of the feminine sex preferred bare feet adorned with jeweled toe rings and tinkling bangles attached to anklets. People of the middle class who by now wore sandals, as often went barefoot. The priests, when about to perform religious duties in the temple, discarded their sandals of white papyrus at the entrance.

Fine leathers were reserved to the rulers and high dignitaries, and heavy leathers were made into footgear for soldiers. Sandals of soft thin leather, dyed vivid colors—scarlet, green and especially purple—were elaborately encrusted with jewels and embossed with gold and secured by beautifully fashioned buckles attached to straps. One pharaoh turned over to his queen for her wardrobe the annual revenue of the fisheries of a large lake which amounted to a surprisingly huge sum. Considering the few scant, sheer gar-

ments such a lady wore, a great part of the money must have gone to defray the cost of her footwear.

Sandals were often lined with linen upon which was painted the figure of a bound captive. The Egyptians hated and despised the enemies of their country and in the hieroglyphics which accompany tributes to kings is the frequently used idiom: "You have trodden the impure Gentiles under your powerful feet." Inside the sole of a sandal in the British Museum is painted a Jewish captive, his race made known by his hair and beard.

Shoes of the wealthy were veritable works of art as the tombs of royal families have evidenced. Several such came to the light of day in 1923 with the discovery of the tomb of the boy pharaoh Tutankhamen whose date is circa 1350 or 1342 B.C. One special sandal about three thousand years old is considered to be without equal in beauty of design and workmanship in the history of archæology. The well-preserved sole is of papyrus but the leather used has deteriorated, bits of which still cling to the shoe. The ankle strap of leather is edged with gold ribbon. The motif on the wide straps represents a water scene on the Nile with small ducks' heads protruding from among the lotus flowers, all beautifully executed in thin rondels of gold in different tones. The thong is composed of gold plaques topped with an exquisite enameled gold lotus blossom.

Another pair which some authorities consider state sandals were of leather painted and embossed with gold. A pair of figures decorated each inner sole done in colored leathers picturing Egypt's traditional enemies, a Syrian and a Lybian upon which the king trod. The feet of the mummy of Tutankhamen were dressed in sandals of embossed sheet gold with pointed toes rounding up over the front of the feet.

The upturned, piked or peaked toe was first worn in the Mesopotamian Valley and from there spread to the surrounding countries. Sometimes in the Egyptian design the toe took the form of an elephant's tusk, as long as eight inches and rising four or five inches above the toe. One archæologist claims that the point of a young prince's sandal lengthened as he acquired age. The peaked toe appears to have been the prerogative of kings, princes and priests. Queens and princesses wore as elegant footwear but seldom the turned-up toe and only in modified form.

There were changes of fashion in Egyptian costume over the centuries and, while most generally worn, not all footgear was confined to the sandal. Of

the late period there are examples extant in museums of socklike boots in fine leather decorated in several colors, ankle-high leather shoes, children's slippers of red and green leather and ladies' slippers lined with rose and ornamented with gold rosettes. Also men's sandals of thick hard leather and wooden ones with a metal strap. These, however, are of the last centuries before Christ and significant of the influence of foreigners such as the Persians, Greeks and the Etruscans. In the second century of our era when the Egyptians were under Roman domination we find them, as well as the Romans, making use of an ankle-high knitted or fabric sock which was fashioned with a stall for the large toe. It was made thus, apparently for wear with the sandal.

Proof of the ancient wearing of heels is given in a tomb painting at Thebes wherein an individual, supposedly a butcher, walks in shoes with heels, no doubt for the very practical purpose of raising the feet off the ground during the slaughtering. In another fresco a man wears wooden sabots. And the chopine, which reached Medieval and Renaissance Europe by way of Turkey, was known to these ancient people. Such shoes have been found in the tombs, stout soles of wood raised nearly a foot high by means of four round wooden sticks.

One must mention an Oriental type of slipper worn by the Egyptian lady of the late period. It is seen in sculptured reliefs and is of plaited straw but looking for all the world like a little flat-bottomed boat. No doubt of Persian origin, it was worn also by the "free and noble Greek women" who called the shoe a "peribaride."

Much attention was given the care of the feet and before each meal it was an Egyptian custom to bathe and perfume the feet.

A story of a shoe related to the Egyptian Pharaoh Psammetichus who reigned from 660 to 610 B.C. resembles the European tale of Cinderella. According to the legend, one day when the beautiful Greek slave Rhopodis was bathing in the Nile an eagle swooped down and carried off one of her dainty sandals which farther on he dropped right into the lap of the king. Psammetichus was so impressed by the happening and the tiny shoe that he ordered the land searched for the owner. Upon finding her, so the story goes, he married the lovely maiden and they lived happily ever after.

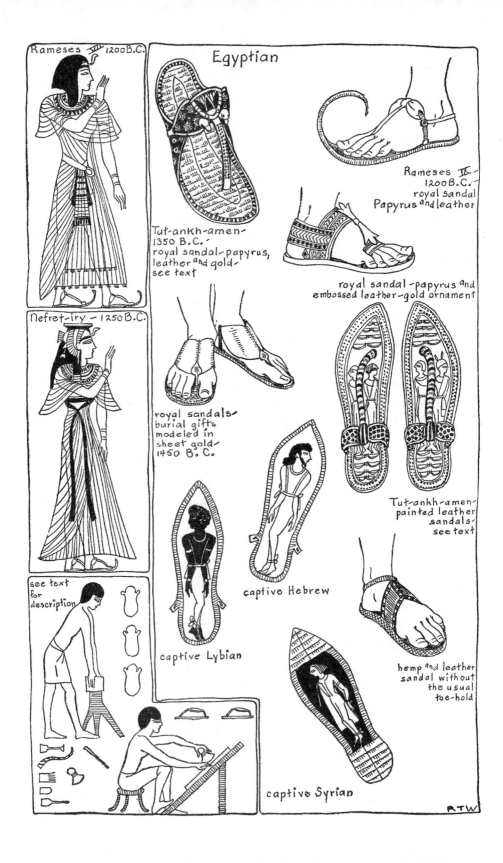

Rameses VI 1200 B.C.

Egyptian

Tut-ankh-amen-
1350 B.C.-
royal sandal-papyrus,
leather and gold-
see text

Rameses VI
1200 B.C.-
royal sandal
Papyrus and leather

royal sandal-papyrus and
embossed leather-gold ornament

Nefret-iry — 1250 B.C.

royal sandals-
burial gifts
modeled in
sheet gold-
1450 B. C.

Tut-ankh-amen-
painted leather
sandals-
see text

see text
for
description

captive Lybian

captive Hebrew

hemp and leather
sandal without
the usual
toe-hold

captive Syrian

RTW

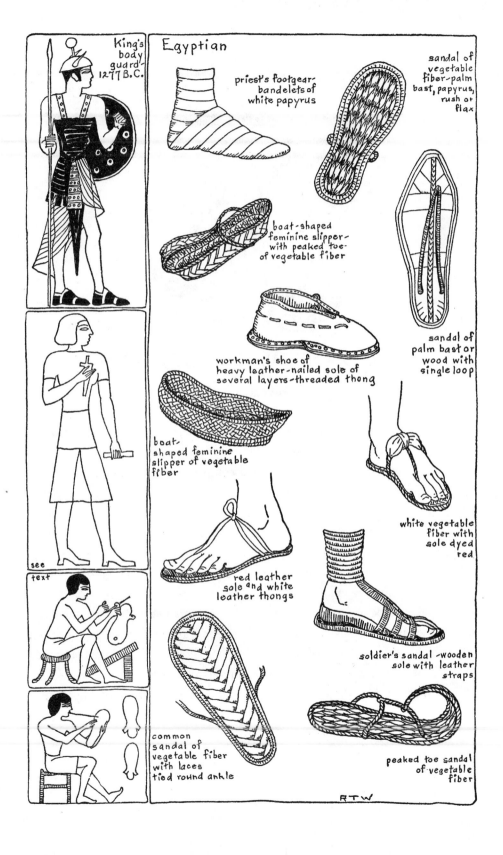

King's body guard 1277 B.C.

Egyptian

priest's footgear - bandelets of white papyrus

sandal of vegetable fiber - palm bast, rush or flax

boat-shaped feminine slipper - with peaked toe - of vegetable fiber

sandal of palm bast or wood with single loop

workman's shoe of heavy leather - nailed sole of several layers - threaded thong

boat-shaped feminine slipper of vegetable fiber

white vegetable fiber with sole dyed red

red leather sole and white leather thongs

soldier's sandal - wooden sole with leather straps

see text

common sandal of vegetable fiber with laces tied round ankle

peaked toe sandal of vegetable fiber

RTW

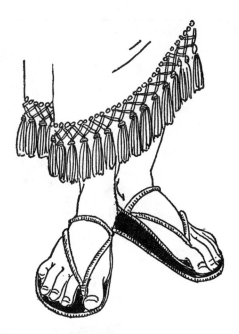

MESOPOTAMIAN FOOTWEAR

CHAPTER TWO

IN CONSTANT intercourse with Egypt were the countries of the Mesopotamian Valley or the Near East. The Babylonian Empire was nearly as old as her great neighbor Egypt. In 1917 B.C. it comprised Elam, Assyria and Syria. Babylonia was conquered in 1250 B.C. by the Assyrians; next the Assyrians fell to the Medes and in 640 B.C. the Persians were the victors over the Medes.

Certain distinctive characteristics of costume were common to all these peoples and the source of information comes from the sculptured reliefs, colored tiles and painted decorations of temples and palaces both in their own countries and Egypt.

The oldest type of footwear in pictorial representation is the Oriental shoe with turned-up toe. A clay model of such a shoe was found in 1938 by British archæologists excavating in Mesopotamia. It has the peaked toe and the shape of the boot is that worn by the Syrian peasants of today.

In a piece of Akkadian sculpture of about 2600 B.C. a shoe with upturned toe and pompon is being presented to the hero-slayer of what was considered the most dangerous of animals, the buffalo. The Akkadians, an ancient Semitic people from the north, founded the oldest civilization in Babylonia and are thought by some authorities to have been Mongolian and the ancestors of

the Chinese. Apropos of this latter supposition it is interesting to note that the boot with peaked toe is quite commonly worn among the Mongols today.

Down through the ages and in modern times we find this shoe the generally worn slipper of Mohammedans of both sexes. In modern Greece not only has the turned-up toe been retained but also its ornamental pompon, a very large one in red or blue. The shoe is worn by the shepherds and the Greek Highland troops, that of the latter of red leather.

The pointed toe was a characteristic feature of Hittite dress as pictured by their enemies the Egyptians and Assyrians. Little is known of the Hittites of Asia Minor, a once mighty people of Semitic race who waged war with Egypt and Assyria for many centuries. Both men and women wore the shoe and the style spread to the surrounding countries, Egypt, Cyprus, Mycenæ and Crete. The Phœnicians also adopted the fashion, as did the Etruscans, who probably hailed from Asia Minor.

The Phœnicians, the greatest seafaring and trading nation of ancient times, carried merchandise all along the Mediterranean coast and in their cargo there were articles of dress and the famous purplish scarlet dye known as Tyrian or Phœnician red. Their name "Phœnicians," meaning "the purple folk," was given them by the Greeks. The lovely brilliant shade was a coveted color for fine footwear.

The people of Asia Minor also wore the sandal. The model with simple toe hold was sufficient to the Egyptians living in a mild, dry climate, but not adequate against the rain and mud of the Fertile Crescent, as that part of the world is called. Their leather sandal with thick or thin leather sole, while equipped with a toe loop, also had a heel protection. The loop for the large toe was sometimes a jeweled ring and straps or thongs laced over the instep.

The preparation of fine leather from tanned kid or goatskin dyed in brilliant color which we called morocco is supposed to have been of Babylonian origin and a craft in which they excelled. This became the cordovan of Medieval times, the secret having been preserved down the centuries and carried to Spain by the invading Arabs or Moors who produced and exported the leather from Cordova. Indeed the shoes of the Moyen Age made of this leather were called "Babylonian shoes." The Babylonians perfumed their leather. They were famed for their embroidery which became known as "Babylonian work." It was applied to some luxurious shoes, the work especially done in gold thread.

9

From Babylonia comes our word "mule" derived from the Sumerian word "mulu." Women wore the mulu at home, a thin soft slipper without back and a flat sole. And today such a slipper or babouche is the favored type of shoe among Easterners.

Assyrian footwear which they called "street leather" was of several styles in sandals, low shoes and boots. They dyed their leathers many colors, principally red, yellow and scarlet and often employed several colors in a shoe, sometimes in variegated strips for the footgear of kings and princes. Persons of rank usually were shod in red or yellow, delicate colors were favored especially by people of wealth, pale blue an outstanding note. These colorful footcoverings of beautiful leather were frequently embroidered with gold thread and the sandals of royalty were still further ornamented with pearls and gems.

Warriors and hunters wore a buskin style of boot laced from top to the instep. Some military boots were entirely covered with ornamentation either painted on or embroidered in brilliant colors. Another form of leg protection for the soldier was the greave of bronze or brass with which he wore the sandal.

The Medes and Persians wore shoes and boots of soft leather of varied height. The enveloping low shoe was fastened in front by means of buttons or buckles. This was probably the simple leather shoe, the "persique," that the Greeks thought too plain to be worn with the accompanying rich costume and said so. From another viewpoint it would seem to have been a perfect foil for the elaborate dress.

Crœsus, last king of Lydia (560–548 B.C.), was named "soft-footed" by the oracle because of his soft leather shoes. Cyrus the Great, the founder of the Medo-Persian Empire in the sixth century before Christ, is recorded as wearing boots the color of fire. A Persian shoe of the third century of that era is described as being of felt in purple and enriched all over with finely embroidered motifs outlined with gold. Pale blue and yellow were particularly favored colors.

Like the Greeks and Romans the Persians made use of layers of cork in the soles of shoes and as heel pads to add to their stature. The Greek historian Xenophon, of 430 to 352 A.D., notes that the small man could add to his height by placing pads in his shoes. To be short was deemed a disfigurement and actors especially made use of false heels. That the Persian was vain about the size of his feet is plain from the tiny feet which the sculptor gave the figures in the ancient bas-reliefs of Persepolis.

The ancient Phrygians of Asia Minor have left us little documentation upon their costume. According to that little they wore the shoe styles of the other peoples of their part of the world, the sandal and the soft shoes of leather both high and low. The high-laced boot, the buskin or cothurnus, is supposed by some archæologists to have been a Phrygian origination. Sometimes they added extra protection to the soft leather sole by tying on a sandal of wood or leather. The Phrygians, a pastoral people, were absorbed by the Persians in the sixth century B.C.

About 1504 B.C. the Pharaoh Tuthmosis III ascended the Egyptian throne and it was during his reign that the Exodus of the Israelites took place. Moses, who led them out of captivity, died in 1461 B.C. While under Egyptian domination the nomadic Hebrews learned shoemaking, compelled as they were by their captors to confine themselves to handicrafts. When freed of bondage they resumed their former professional and mercantile life but retained a love for beautiful footwear.

Documentation upon Hebrew costume is only to be had from pictorial remains produced by their enemies whose fashions they appear to have copied. The Hebrew religion discouraged art but fostered literature and the earliest references to shoes are to be found in that collection of their greatest writings, the books of the Old Testament. The first mention is Genesis 14:23, in which Abram in his oath before the king of Sodom refuses to accept anything "from a thread to a shoe latchet" lest the king boast that he had made Abram rich.

In Exodus 3:5 there is the command from God in the burning bush to Moses to "put off thy shoes from thy feet, for the place whereon thou standest is holy ground." The Mohammedan religion is also founded upon the Hebrew Bible and here we have the origin of the custom among Eastern peoples of removing their shoes before entering a place of worship and when in the presence of Eastern potentates.

In Deuteronomy 25:9 it is told that when a man refuses to take over his brother's widow, she shall in the presence of the elders loosen his shoe and spit in his face. Surely an ignominious but simple way out of a dilemma for the unfortunate man. And he is further punished, "And his name shall be called in Israel, the house of him that hath his shoe loosed."

Claiming land by planting the foot upon it is in the Biblical sentence, "Over Edom I cast my shoe." That the shoe, like the glove, was a symbol of

investiture especially in the transfer of property is evident in Ruth 4:7, where it is written that a man gave testimony to the deal by handing over his shoe. The shoe signifying the transfer of ownership is still heard today in the expression "to stand in another's shoes." Similar is the phrase "in dead men's shoes."

In Chapter 9 of Joshua, the Gibeonites in order to practice deceit upon Joshua pretended that they were ambassadors from a foreign country by wearing worn garments and old shoes. Another Biblical reference to shoes occurs in the story of Judith and Holofernes given in the Apocryphal book of her name in which Holofernes is impressed by the richness of her apparel but particularly by her "sandals which ravished his eyes."

In earliest times the Hebrews like their neighbors wore the simple sandal, changing to the various new fashions over the centuries, eventually wearing the rich footgear of the later periods. There were sandals of leather, felt, cloth or wood, sometimes shod with brass or iron. Shoes denoted the class or rank of the wearer by color and fabric. Purple, that most precious color, was worn by the high priest, but when in the temple priests or Levites wore no foot-covering, believing that shoes would defile the holy ground. In later times men of wealth wore black shoes but the sandal remained the general foot-piece especially for poor people.

With their trousers or tunics of fine linen or silk, embroidered with gold and jewels, Hebrew women delighted in the tinkling sounds of their anklets. Of silver or gold they were and ornamented with many bangles, a costly and pretty adornment worn with bare feet. The prophet Isaiah severely rebuked them for their love of such vanities, but anklets continued as part of their costume to modern times, when the favored slipper became red embroidered with gold. One also reads of their wearing pale-violet shoes with cords of purple which too were decorated with small metal and bronze trinkets making a pleasing sound when they walked.

A sentimental custom among young women consisted in having the name or likeness of their sweethearts engraved upon a metal plate which was placed under the heel so that it left the imprint upon the ground when walking. A young man in those times presented his future wife not only with the engagement ring but a shoe, which implied mutual possession of their worldly goods. Another Hebrew custom of more serious nature was to go barefoot during the funeral period upon the death of a parent.

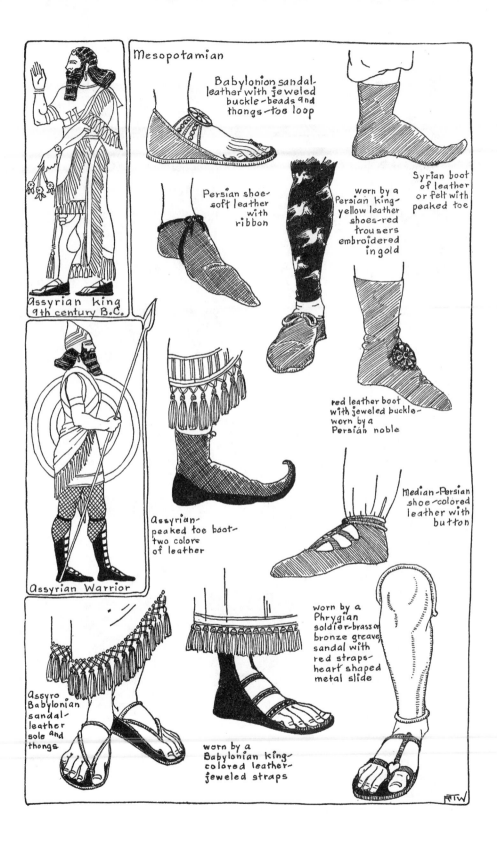

Mesopotamian

Babylonion sandal-
leather with jeweled
buckle-beads and
thongs-toe loop

Persian shoe-
soft leather
with
ribbon

worn by a
Persian king-
yellow leather
shoes-red
trousers
embroidered
in gold

Syrian boot
of leather
or felt with
peaked toe

red leather boot
with jeweled buckle-
worn by a
Persian noble

Assyrian king
9th century B.C.

Assyrian-
peaked toe boot-
two colors
of leather

Median-Persian
shoe-colored
leather with
button

Assyrian Warrior

worn by a
Phrygian
soldier-brass or
bronze greave
sandal with
red straps-
heart shaped
metal slide

Assyro
Babylonian
sandal-
leather
sole and
thongs

worn by a
Babylonian king-
colored leather-
jeweled straps

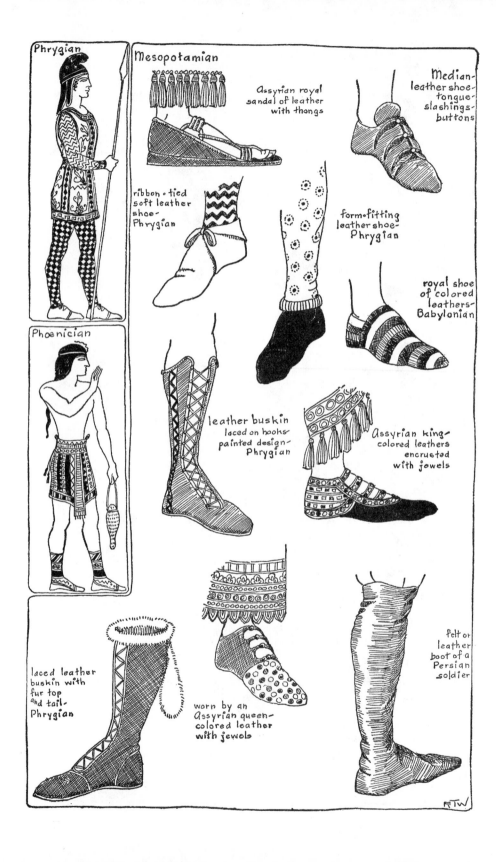

Phrygian

Mesopotamian

Median leather shoe - tongue - slashings - buttons

Assyrian royal sandal of leather with thongs

ribbon-tied soft leather shoe - Phrygian

form-fitting leather shoe - Phrygian

royal shoe of colored leathers - Babylonian

Phoenician

leather buskin laced on hooks - painted design - Phrygian

Assyrian king - colored leathers encrusted with jewels

laced leather buskin with fur top and tail - Phrygian

worn by an Assyrian queen - colored leather with jewels

felt or leather boot of a Persian soldier

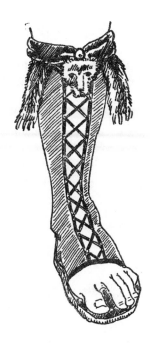

GRECIAN FOOTWEAR

CHAPTER THREE

THE ANCIENT civilizations of Crete and Mycenæ were as old as that of Babylonia and of the period 3000 to 1000 B.C. Sandals, shoes and boots were worn by the people of the Near East and the Mediterranean.

The costume of the Ægeans differed widely from the later classical dress so well known. The fashion of the Cretan lady was indeed most modern and sophisticated in design with corseted figure and tiny waist. She wore a flaring ruffled skirt topped by a little jacket which left the breasts bare, a jacket which is thought to have been of leather. Its trim, tailored shape and the ornamentation of gold disks would seem to verify the supposition. But despite her refined and artificial air the lady's feet were bare while the men of her period wore high boots of light-colored leather.

As in Egypt the wearing of footwear or going barefoot had no social or monetary significance among the earliest Greeks. According to their idea of body culture it was considered more dignified that a man's feet be bare than tightly laced in boots, that he was thus freer to enjoy the rhythmic movement of his body when walking. As late as the Classical Period (450–323 B.C.) the custom of going barefoot indoors was indulged in. Children went barefoot always, wearing sandals only in inclement weather.

In the sixth century before Christ, Pythagorus, the Greek mathematician and philosopher, led his disciples in a moral and austere life. He wore sandals of plaited papyrus like those of the Egyptians because like the priests of Egypt he would not contaminate himself by wearing the skin of a despoiled animal.

By the fifth century we find footgear quite generally worn because Plato the famous Greek philosopher endeavored to persuade his countrymen to discard foot dress, a suggestion which met with very little acceptance. And again in the fourth century before Christ it was the Attic orator Lycurgus who attempted to curb the extravagant taste for expensive footwear by ordering people to forego shoes.

Finally, in the Hellenistic Period of 323 to 31 B.C., bare feet when out-of-doors became the insignia of slavery. In this later sophisticated period the wearing of shoes signified the free man, and a man of position would not think of appearing without foot-covering in public for fear of being mistaken for a slave. We have the words of Plutarch, the historian and moralist, who lived in the first century of our era: "Bare feet, a sign of a slave's degradation."

Slaves were barred from ever wearing shoes except in the country, where they wore the "sculponæ," a kind of sandal with thick wooden sole. Slaves were known by the Greek name of "cretati," meaning "chalked people," because when put up for sale their feet were marked with chalk or plaster.

The code of rules governing the wearing of shoes in Greece was not as involved as that of later Rome, but it was etiquette for dinner guests to remove their footgear in the dwelling of their host. This custom was the outcome of a desire to make the visitor feel at home.

Millenniums old is the system of measuring the foot with a size stick. A picture of a shoe merchant in ancient Greece portrays him with measuring stick in hand in horizontal position and waiting upon customers.

As time passed Greek footwear lost its simplicity and took on an air of costly elegance, becoming a very conspicuous costume accessory. The Greek shoe attained a degree of perfection in craftsmanship, artistry of design and luxury unsurpassed by any other nation. The beautiful Greek creations were especially desirable to the wealthy Romans.

As ever with modish costume, fashions in footwear varied with the changing periods and there were finally so many styles with so many different names that, even among the Greeks themselves, confusion existed as to a

given shoe. A Greek writer of the day made the comment that for women alone there were twenty-two different designs, one for each specific occasion, which prompts the thought that the life of an elegant person in antiquity was not less complicated than today. Such being the case we shall try to enumerate only the most generally worn styles.

The commonest and most primitive shoe of the ancients was the karbatine or carbatine. It was made of rawhide in one piece and drawn up over the foot by a threaded thong which was tied round the ankle, the very same idea as that of the early deerskin moccasin of the North American Indian. To the Greeks it was the monodermon because fashioned of one piece. The shoe was worn by the Asiatic, Greek and Roman peasants and mountaineers. The carbatine eventually acquired a sole which was sometimes hobnailed and in a later, dressier version the skin was often cut out in reticulated design. Today in France the name carbatine is still applied to undressed hides.

Based upon the practice of physical culture was the simple, unconfining pedila or sandal, the commonly worn shoe of the Greeks during the Homeric or Epic Age of about 1000 to 700 B.C. Of Oriental origin is the word "sandalon," in Greek sandalion and in Persian sandal, with the root *sanis* meaning board. But the Greek word sandalion signified not our idea of a sandal but a soft slipper with an upper of Oriental type. Pedila was the Greek name for the sole tied with thongs or ribbon laces. Nevertheless, the shoe consisting of sole with laces, no matter how simple or elaborate, has come down the ages as the sandal.

Essentially Greek were the use and arrangement of straps as differing from the toe hold of the Egyptian sandal and that of the Near East. The common sandal of little cost worn by the poorer class was of wood and fitted either foot while that of the more fortunate people had a sole of felt or leather and was cut to the right or left foot. Leather soles were in two layers but as time passed the aristocrat's shoe was distinguished by its height which was sometimes of the thickness of "two fingers." Later, soles frequently rose to five layers with two of cork, or even all cork, as in the case of the tragic kothornos which we shall describe in another paragraph. It was important that ties be neatly adjusted, loosely tied laces indicating careless grooming, a very serious fault indeed in good dressing.

A development of the pedila was the krepis of the fourth century B.C. The sole was of a finger's thickness with leather at the sides and back of the foot

leaving the toes uncovered. Often the upper leather was cut out in a reticulated design resembling crossed strips. The feature of the krepis was the lingula or ligula, a tongue over the instep with slits through which the straps passed. On richly made shoes of the Hellenistic Period the leather tongue became a plate of silver, gold or ivory. The lingula was indicative of the free man or citizen, the ornament being forbidden on the sandal of the slave.

The krepis was worn by both sexes either with the himation or the chlamys. It was really a part of the national costume, and gods and heroes were usually portrayed wearing the shoe. In Rome, where the krepis was known by the Latinized name crepida, they called the Greeks "Crepidati," or the wearers of the crepida.

The style of krepis for civilian and military use differed and sometimes the Greek warrior wore but one sandal and that usually on the right foot, although on the sculptured figure of Pallas Athene the artist put the sandal on the left foot. The soldier's leg and foot were also afforded protection by the cnemis, an ensemble of leather legging and sandal. Cnemis was also the name of the molded brass or bronze greave which was lined with leather.

The Hittite shoe with turned-up toe was known to the early Greeks and occasionally worn by them, but it was considered typically Oriental and used in pictorial art to characterize the Semitics. Of wood or leather with heavy sole, the shoe was adaptable to rough, mountainous country such as that of Greece. And no doubt for that very reason it has survived through the centuries and it is today worn by Greek shepherds and the highland troops. In these times, the Ionian shoemaker can be seen in his little shop, building the picturesque shoe of colored leathers, a large red or blue pompon perched on the toe when completed.

Boots of rawhide, that is, of dressed but untanned leather, were known to the Greeks of the Ægean region before 1000 B.C. The "endromis," a boot of untanned skin with the fur on the inside, was finished with a dashing ornamental flap in front and sometimes one in back too. This boot, seen in the vase paintings of the seventh century before Christ, opened in front and was secured by a long strap bound round the leg above the ankle. The endromis was worn by athletes, hunters and travelers and the Greek gods were pictured wearing it in mythological scenes.

Buskins or laced boots became commonly worn in the fifth century B.C. Opening down the front from top to instep they were laced the whole length

by means of small hooks at the sides. It was believed that the Athenian warriors adopted the buskin after their battle with the Amazons. The actual existence of the Amazons is a much-disputed fact, but the heroic feminine warriors exist in Greek tales and were pictured in sculpture and on pottery, either barefoot, booted or wearing metal greaves. And sometimes they appeared in the peaked-toe boot.

The boots of the Amazons had a decorative touch in the form of lappets of leather or fur hanging from the tops. The fur-trimmed boot, supposedly from Thrace, ornamented with a small animal's muzzle and a pair of paws was a favored military fashion which the luxury-loving Romans eagerly adopted.

The Athenian general Alcibiades (450–404 B.C.), observing that the ordinary sandal gave very little protection to the soldier's foot, invented a low military boot covering the foot. It was laced and looked very much like our late tennis shoe. It was known as the alcibiade and was just one of many styles bearing generals' names.

The Spartans when going into battle wore red shoes and tunics to conceal blood flowing from wounds. These red boots were the envy of all Spartan youth, who were prohibited from wearing them until they shouldered arms.

Of the kothornos, a word of Cretan dialect, there were several variations and one model from Lydia in Asia Minor had the peaked toe. This latter, also called the Scythian boot because worn by the barbarians north of the Black Sea, was a short boot of soft leather and cut single to be worn on either foot. It resembled the riding boot still worn by the Mongolians of Thibet and the Tartars of the Russian steppes.

The distinct feature of the kothornos was the thick sole which added to the wearer's height, a shoe first worn on the stage in the Greek drama, whence its name, the "tragic kothornos." A type of sandal with a sole about three inches high was also called a tragic kothornos. The story of its origination concerns the Greek poet Æschylus (525–456 B.C.), father of Greek tragedy, who created the high wedge sole to give added majesty to the gods and heroes of his plays. As one would expect, Greek women took advantage of this method to increase their height and carried the style to such an extreme that they aroused the criticism of the opposite sex.

Also of the theater but worn by actors of comedy was the sykhos, a soft, low leather boot of Oriental origin. This was the same as the Roman soccus. Here is the source of our old English expression "gentlemen of the sock and

buskin." When of white wool, felt or linen, it was a kind of sock which the ancient Greeks wore inside their shoes as a protection against the cold and damp weather of the winter season.

The phæcasium appears to have been worn first by countrymen and philosophers. Made of wool, felt or linen it cost a very modest sum and seems to have been as popular as the sandal. When worn by the priests of Athens and Alexandria performing sacrificial ceremonies, it was a beautifully fitted, knee-high boot of white leather, sometimes embroidered and laced part way down the front. Such boots were worn in the temples to preserve silence and, too, to protect the handsome marble and mosaic floors.

The phæcasium was considered the shoe of the gods, although in later centuries it became quite commonly worn by mortals. And speaking of gods recalls the talaria or winged shoes of the Greek god Hermes whom the Romans knew as Mercury.

From the Orient came the soft slipper which Greek women wore at home. This was the sandalion mentioned earlier in the chapter. It had a thin leather sole, but the upper was in mule fashion, covering only the front of the foot or a complete upper cut décolleté. Both styles were luxurious shoes fashioned of silk or other costly fabric embroidered with gold and pearls.

Another slipper worn by Greek women of the upper class was the peribaride of Persian origin mentioned in the Egyptian chapter, the basketlike slipper of plaited straw. This basket idea but round in shape was also used for animals, the hoofs of horses and mules being protected by removable shoes of straw, small hoof-shaped baskets tied to the legs by thongs.

White was the prevailing classic color but leathers were also dyed vermilion, scarlet, saffron, green and black, and feminine shoes were further adorned with embroidery, gilt and pearls. In the seventh century B.C. the Greek philosopher Zaleucus in his rules on dress decreed that only the courtesan be permitted to wear sandals decorated with gilt and jeweled buckles.

It is said that the courtesan delighted in wearing red shoes, but one also reads that the gallant lady of Athens was recognized by her white "persaiki" or Persian shoes. The Persian footgear of delicate colors, which Greek women appear to have adopted in the sixth century B.C., had form-fitting uppers of soft leather which completely enveloped the foot with strap fastenings at the ankles. Sometimes additional sandals protected the fragile shoes when out-of-doors.

A bit of information from the verses of the poet Sappho, writing in the sixth century B.C., tells us that the soles of sandals were often dyed red and the purple straps made by the Syrians were coveted luxurious accessories. Purple hues were as a rule reserved for the attire of gods, kings and magistrates among the ancient Greeks and Romans. In the earliest times women of noble birth were not permitted to wear the tiniest bit of the precious color. There were two shades, a purple produced from the purpura shellfish and the purplish scarlet known as Tyrian Phœnician red, the product of the dye of the insect kermes.

A Greek historian of the fifth century B.C. mentions shoes of white, green, red and lemon color for women and notes red and some black in masculine footwear. He especially speaks of the purple shoes that vain ladies wore in small sizes and comments upon the white shoes that graced the feet of the young engaged woman. The feminine shoe wardrobe of ancient Greece was comparable to ours in variety but of course that was the privilege only of the lady of station. There were many styles and the fashionable woman changed her footwear to suit each occasion. If going out for the day and her visits necessitated such, her maids followed her, carrying all the desired shoes in a rich carpet made just for the purpose and called a sandalthique.

Dicæarchus, a Greek historian and philosopher in the fourth century B.C., wrote that the women of Thebes wore simple low shoes of such fine leather and so tightly laced that the feet appeared almost bare. These were the Persian shoes. Such are the shoes worn by the little ladies of the Tanagran statuettes, usually in yellow, no doubt of aluta or chamois skin, with red soles.

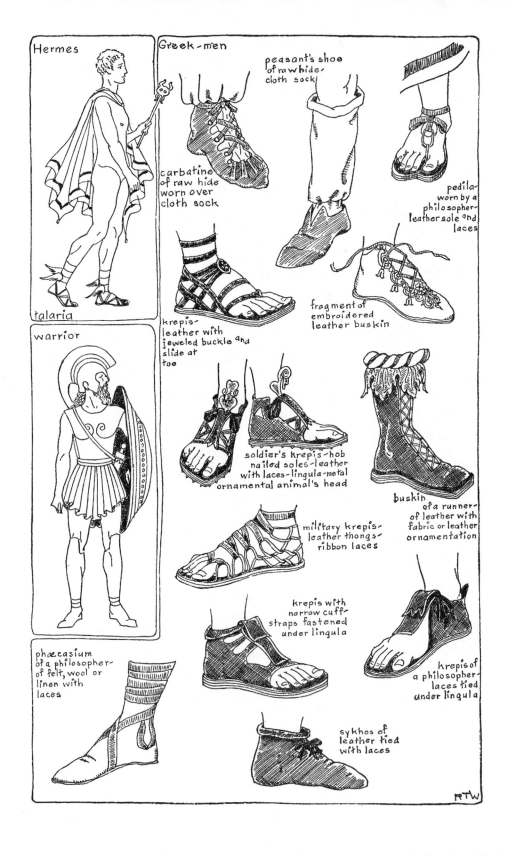

Hermes

talaria

warrior

phæcasium
of a philosopher-
of felt, wool or
linen with
laces

Greek-men

carbatine
of raw hide
worn over
cloth sock

peasant's shoe
of rawhide-
cloth sock

pedila-
worn by a
philosopher-
leather sole and
laces

krepis-
leather with
jeweled buckle and
slide at
toe

fragment of
embroidered
leather buskin

soldier's krepis-hob
nailed soles-leather
with laces-lingula-metal
ornamental animal's head

buskin
of a runner-
of leather with
fabric or leather
ornamentation

military krepis-
leather thongs-
ribbon laces

krepis with
narrow cuff-
straps fastened
under lingula

krepis of
a philosopher-
laces tied
under lingula

sykhos of
leather tied
with laces

RTW

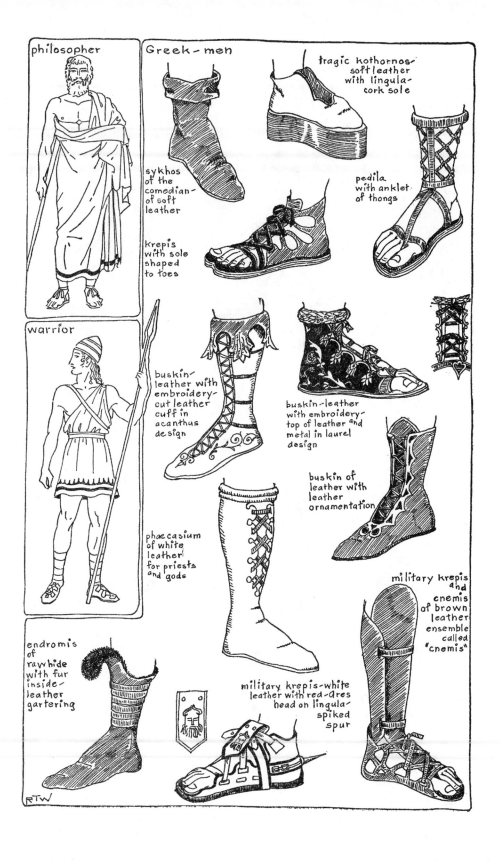

philosopher

Greek – men

tragic kothornos-
soft leather
with lingula-
cork sole

sykhos
of the
comedian-
of soft
leather

pedila
with anklet
of thongs

krepis
with sole
shaped
to toes

warrior

buskin-
leather with
embroidery-
cut leather
cuff in
acanthus
design

buskin-leather
with embroidery-
top of leather and
metal in laurel
design

buskin of
leather with
leather
ornamentation

phaecasium
of white
leather
for priests
and gods

military krepis
and
cnemis
of brown
leather
ensemble
called
"cnemis"

endromis
of
rawhide
with fur
inside-
leather
gartering

military krepis-white
leather with red-ares
head on lingula-
spiked
spur

RTW

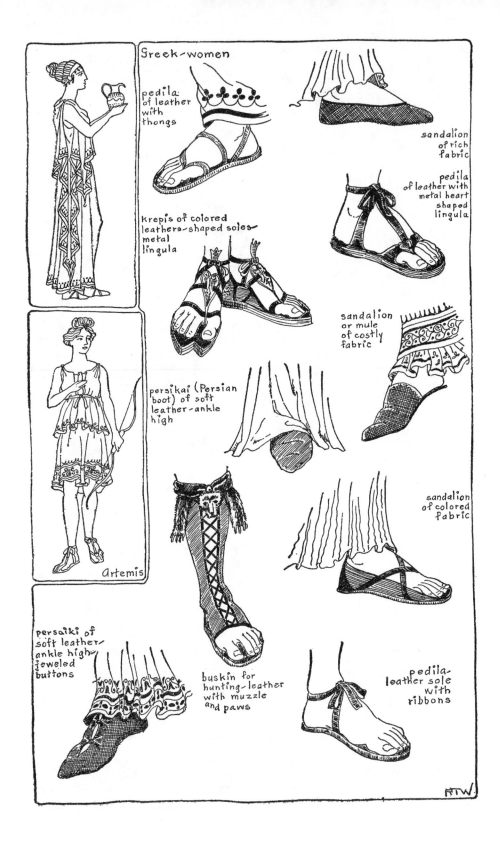

Greek-women

pedila
of leather
with
thongs

sandalion
of rich
fabric

pedila
of leather with
metal heart
shaped
lingula

krepis of colored
leathers-shaped soles-
metal
lingula

sandalion
or mule
of costly
fabric

persikai (Persian
boot) of soft
leather-ankle
high

sandalion
of colored
fabric

Artemis

persaiki of
soft leather-
ankle high-
jeweled
buttons

buskin for
hunting-leather
with muzzle
and paws

pedila-
leather sole
with
ribbons

RTW

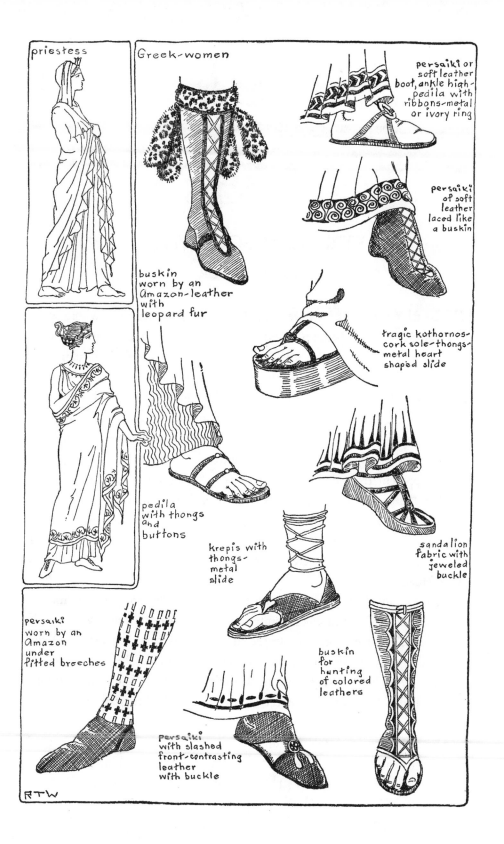

priestess

Greek-women

persaiki or soft leather boot, ankle high-pedila with ribbons-metal or ivory ring

persaiki of soft leather laced like a buskin

buskin worn by an Amazon-leather with leopard fur

tragic kothornos-cork sole-thongs-metal heart shaped slide

pedila with thongs and buttons

krepis with thongs-metal slide

sandalion fabric with jeweled buckle

persaiki worn by an Amazon under fitted breeches

buskin for hunting of colored leathers

persaiki with slashed front-contrasting leather with buckle

RTW

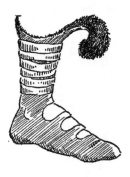

ETRUSCAN FOOTWEAR

CHAPTER FOUR

THE EARLY people of Italy were the Tyrrhenians or Etruscans, whom some think came from the northern islands of the Ægean Sea and the neighboring coast of Asia Minor about 800 B.C. They were a superior people in intelligence, skill and wealth and taught the Italians many things. Because of their contact with the Greeks their costume reflected the Grecian mode but with a decided Oriental feeling. Theirs was a luxurious and sumptuous civilization founded upon a love of beauty and ease, an influence which contributed toward the gorgeous extravagance of the Roman Empire.

It is apparent from their pictorial records of sculpture, painting and vases found in the underground tombs that they excelled in the craft of shoemaking. Both the Greeks and the Romans prized shoes of Etruscan manufacture and especially popular were the sandals with hinged wooden soles reinforced with bronze. Such shoes were fastened with gilded straps and known as "Tyrrhenian sandals."

Their elegant footwear, made with leather or wooden soles, was fashioned of fine leathers of varied colors, embroidered, painted and sewn with jewels and fastened with gilt or gold straps. Since scholars have not yet found the clue to deciphering their many records we do not know the names for the different styles. There were the sandal, mule, slipper, half-boot and buskin; in fact, all the shoes worn in Greece are to be found in Etruscan pictorial art. One notes especially their use of the Oriental peaked toe.

Also as in Greece, people of importance, especially the gods, are portrayed wearing the early endromis, the fur-lined boot of untanned skin. The warrior went barefoot but protected his legs with metal or leather greaves.

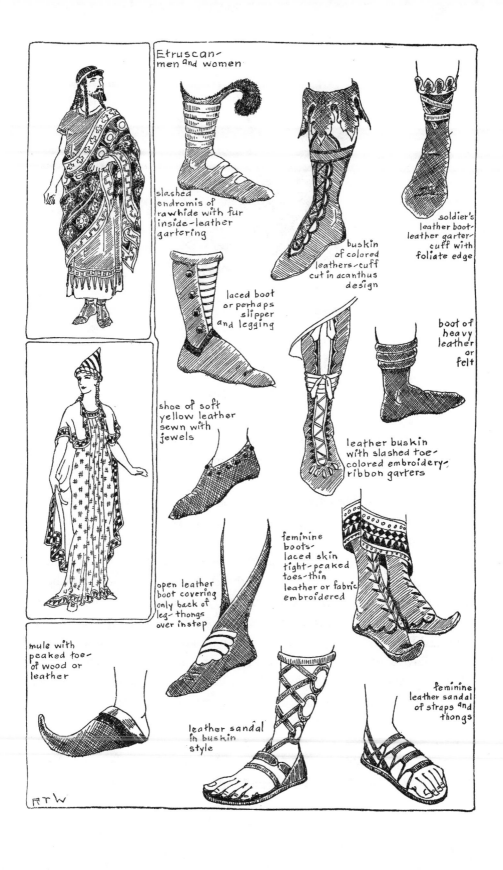

Etruscan—
men and women

slashed
endromis of
rawhide with fur
inside-leather
gartering

buskin
of colored
leathers-cuff
cut in acanthus
design

soldier's
leather boot-
leather garter-
cuff with
foliate edge

laced boot
or perhaps
slipper
and legging

boot of
heavy
leather
or
felt

shoe of soft
yellow leather
sewn with
jewels

leather buskin
with slashed toe-
colored embroidery-
ribbon garters

feminine
boots-
laced skin
tight-peaked
toes-thin
leather or fabric
embroidered

open leather
boot covering
only back of
leg- thongs
over instep

mule with
peaked toe-
of wood or
leather

leather sandal
in buskin
style

feminine
leather sandal
of straps and
thongs

RTW

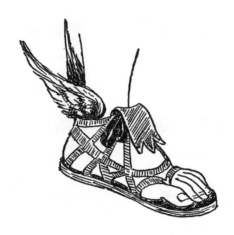

ROMAN FOOTWEAR

CHAPTER FIVE

THE BASIC design of Roman footwear was Greek. Though conquered in 146 B.C. by Rome, Greece remained the fountain head of civilization to the end of antiquity.

The story of the shoe over the centuries in ancient Rome bears the imprint of her history. The early, simple and practical footwear of the republic was indicative of a strong, severely schooled people. During the empire, with the growth of affluence, foot dress acquired a refinement eventually amounting to luxury. And with the decadence of the empire appeared an overelaboration in shoes which bordered on effeminacy, particularly in masculine usage.

In the Greco-Roman Period fashionable footgear was so extravagant that it formed the most costly part of the costume. Indeed, the designing of shoes was deemed worthy the creative talents of some of the most famous artists of the day. Many shoes were veritable works of art and the custom arose of burying them with the wearer. Shoes were such precious pieces of apparel that a lover would treasure the sandal of his mistress as a lock of her hair is treasured in modern times. On the other side of the story, the sandals of gay Roman ladies often served as hiding places secure from husbands' eyes for love letters, which were placed under the foot in the shoe.

The Roman cobbler's craft was an honorable calling, the guild of tanners and shoemaking becoming part of the college of Rome. Because shoemaking was considered an art more than a craft the cordwainers were permitted to put themselves under the patronage of divinity in the person of Apollo. A statue of the god wearing sandals graced the entrance of the street reserved for their shops.

One reads further that under Domitian (81–96 A.D.) the streets became so crowded with cobblers' shops that he ordered their removal. It was in Imperial Rome that shoes were furnished to the army and a large wholesale trade was developed. Shoemaking reached the proportions of manufacture on a large scale, thus replacing the small craftsmen by factories. And besides all this there was a heavy importation of shoes from Greece.

Roman shoe-wearing was bound by a vast code of rules. The Romans, unlike the Greeks, did not indulge in going barefoot, not even in the house. Foot-covering was a featured part of costume design and sumptuary edicts of the empire governed the use of certain shoes for special occasions according to rank, profession and sometimes even the age of the person. It was said that a foreigner versed in Roman usage could tell by the shoes worn not only the social and professional status but also the wealth of the wearer.

Romans banqueted while reclining upon couches and before the feast got under way the sandals of the guests were removed by slaves. Some Roman hosts provided a pretty courtesy in having their servants bathe the feet of the members of the party. And occasionally a host would further display his opulence by providing wine for the foot ceremony.

The well-dressed man had his laces carefully adjusted and tied, and a very important requirement this was. If the shoe covered the toes, the beautiful soft leather was so perfectly fitted that the form of each toe was discernible. The feminine shoe differed little from the man's, only in the material which was softer and more fragile, and women appear to have had less variety of styles than men. The masculine sex took care not to wear an effeminate design and older men did not adopt styles worn by young fellows. A recorded example is that in which Cæsar (101–44 B.C.) was criticized for his lack of taste for wearing in public the high red boots usually worn by younger men. It is noted too that his boots were embroidered and trimmed with gold.

Under Roman rule slaves went barefoot, the soles of their feet usually covered with a coating of chalk or plaster when up for sale. Criminals

wore heavy wooden sabots, heavy enough in fact to make escape difficult.

So many were the styles that it is a perplexing matter to state definitely which shoes the countless Roman names designated. One can only generalize, because certain designs varied with fashion and the period. However, it is possible to place Roman shoes in three classes: the sandal, the slipper and the boot; but again there were many versions of each type.

In wooden shoes there were several kinds for the poor and the rustics, a special one with thick sole of wood called the "sculptone." From the second century B.C. there was a wooden sabot named the "gallica" worn only in the country and in rainy weather. This Latin name meant a Gaulish shoe and was a copy of a Gaulish shoe. Of great interest to us is that some two thousand years later the peasants of Europe are still wearing the sabot and we call our rain overshoes, galoshes or Gaulish shoes. In later centuries, that is, about the fourth and fifth, the galosh was fashioned of cowhide with a heavy sole, a shoe also worn by women.

The primitive carbatine mentioned in the Greek chapter, made of one piece of rawhide and drawn up round the ankle by thongs, was a popular peasant shoe. It continues to be worn in modern times by many Italian peasants.

Another shoe for rustics and the lower class was the "pero," really a better fitted version of the carbatine but also a very ancient shoe and, too, made originally of untanned leather. It was strong, durable and fitted, rising above the ankle and laced in front. During the Republic the pero of dressed leather was reinforced with a sole and worn by all Romans, after which it reverted to the peasants.

Priests, philosophers, men, children and the lower class, all wore the baxea, a woven straw sandal resembling that of the Egyptian, made of palm tree or vegetable fiber or sometimes even of cord. It frequently had a toe covering and often a heel protection. This shoe when worn by the intellectual classes was indicative of their humility but it was also seen on the stage in comedy. The baxea was the shoe preferred by the Macedonian Alexander the Great (356–323 B.C.).

The sandalla or solea, whence our word sole, was founded upon the Greek sandal, a sole usually cut to the right or left foot. It was generally of cowhide or boxwood lined with white flannel or white leather and tied to the foot by thongs. The solea was a negligee piece of footwear to be worn in the house.

A woman might occasionally wear such sandals in public but not so a man, since his appearance in the street in soleæ would have aroused unfavorable comment.

The crepida corresponded to the Greek krepis, the sandal one will recall with the tongue over the instep serving as a stop or buckle for the straps. Lunula was the Roman name for the tongue. In some later examples one finds the tongue folded over the top quite like the shawl tongue on modern brogues. This ornament which distinguished the citizen or free man from the slave was often a piece of gold, silver or ivory. The sole of the crepida was usually thick and leather covered the sides and heel of the foot. The crepida, considered the shoe for traveler, young man and warrior, varied in style for civilian and soldier.

Like the Greek soldier the Roman military man also wore the cnemis, the combination sandal and legging, and he too made use of brass or bronze greaves lined with leather.

The Tyrrhenian sandal noted in the Etruscan chapter was too a Roman favorite.

The Roman cothurnus, like the Greek kothornos, had a thick sole of leather and cork to increase the wearer's height and was a shoe of the stage. And too, as in Greece, there were several versions, a laced buskin reaching to the calf or knee, and another, a loose style fitting either foot. From the latter comes the Roman expression, "more changeable than a cothurnus," said of a person who flitted from one opinion to another according to circumstance. Men of position wore the cothurnus and Roman ladies also availed themselves of the high-soled shoe. The feminine shoe sometimes had a cork sole covered with leather "four fingers high," so they say, and this prompted the remark that "the shoe appeared to be half the person."

Opposing the elegant tragic cothurnus of the stage was the soccus worn by the comedian. It was a low roomy boot like that of the Greeks, and could be slipped on or off with ease. In these two shoes originated the expression for theatrical folk, "brethren of the sock and buskin."

The name soccus or udone was applied to various styles of the low sock-like shoes made of leather or felt, a particular feature being the absence of straps. It accompanied an extra shoe of wood or leather in wet weather, a custom learned in the north and adopted by the soldiers after the Gallic campaigns.

The comfort afforded by protective leg-covering such as socks and short breeches worn by the northerners was forbidden by law to Roman citizens. But the soldiers took to wearing these garments when in the colder climate and, upon returning to Rome, would remove the forbidden accessories before entering the city. Eventually the comfortable piece of underwear or braccæ became part of the military uniform.

Women wore the soccus or udone with sandals and soft slippers, a fashion copied by effeminate young men in civilian life. In the late period it was woven with a separate stall for the large toe similar to the Japanese "tabi." The soccus, usually yellow in color, and of soft leather, goat's hair, wool or linen was finally worn only by women. That of the courtesan was embellished with embroidery and colored stones.

A soft slipper called the "sandalium" worn by Roman ladies at home was borrowed from the fair creatures of the Hellenes. Such a slipper, which was of Persian origin, was made of fine leather and worked in an Oriental design of metal and leather. When developed in precious fabric, fancy ran riot in gold and pearl embroidery. The sandalium of the Medieval popes, the liturgique red slipper, derives from this shoe.

We find the peribaride also part of the patrician Roman woman's wardrobe. This was the Persian, plaited straw, boat-shaped slipper which both the Egyptian and Greek ladies wore.

The calceus considered a boot of Etruscan origin was the principal shoe in Roman civilian life for wear in town with the toga or full dress. In its earliest form the calceus was a low-cut model of the Greek endromis, a snug-fitting ankle-high boot, the front finished in a tongue to facilitate drawing on the shoe. Its next style was cut with the opening on the inner side, and the top of the boot was bound by gartering three or four rows high or to the calf of the leg. What was at first a simple boot of heavy leather became eventually an elegant shoe of supple black or white aluta and sometimes had an added sole.

In the late republican and early imperial periods there were two styles of the calceus, the "calceus senatorius" and the "calceus patricius." The first was black and, as its name implies, was worn by senators and other high-ranking officials and patricians. The calceus patricius because of being dyed red, purple or violet was known as the "mulleus," which in Latin meant "red shoe." This latter was worn by patricians and nobility for ceremonial occasions.

The children of senators could wear the mulleus, a privilege frequently extended to their favorites by the emperors. The shoe was also part of the triumphal costume of victorious generals. Eventually the mulleus lost its stamp of exclusiveness because worn by plebeian persons or commoners who held official position. The wearing of the mulleus coined the expression, "His nobility is in his heels," said in ridicule when a Roman owed the respect given him solely to his birth or wealth. In its final stage the shoe in all colors became a feminine fashion, an event which marked the disappearance of the mulleus or calceus patricius.

The most fashionable color for feminine footwear was white, followed in popularity by yellow and green. The Roman bride wore saffron-colored shoes, with her white tunica and her flame-colored veil topped by a wreath of flowers which she picked herself. To the days of the monarchy, red as a shoe color was carefully avoided by women of quality till some ladies of irreproachable reputation dared to appear in red footgear. Whereupon the Emperor Aurelian, who reigned from 270 to 275 A.D., took a hand in the matter, publicly approving the hue in the feminine mode but at the same time forbidding its use by men. However, he reserved the right to sport red shoes to himself and his successors.

Roman emperors and their wives wore shoes ornamented with pearls and diamonds and exquisitely cut cameos. Virgil, the most celebrated Latin poet, who lived from 70 to 19 B.C., mentions shoes embellished with gold, silver and engraved with black. Not only was gold employed on the uppers in embroidery but some shoes were fashioned with pieces of the metal. Nero (54–68 A.D.) had shoes shod with silver while his wife Poppæa had hers shod with gold. Nero's silver-shod shoes proved fatal to Poppæa, history recording that he killed his former mistress by kicking her.

The jewel-bedecked shoe was a thing of Oriental origin, the fashion reaching such proportions in contemporary Egypt and Persia that it was customary for a king to allot his queen the revenue of a city for the purchase of her attire, of which shoe-money was a very important item. Fine leathers were dyed rare colors, especially purple, and intricately embroidered, all of which cost fabulous sums.

The shoes of Hadrian, emperor from 117 to 138, are noted as being fashioned with gold, silver and gems. Of Heliogabalis, who ruled from 205 to 222 of our era and indulged in the most infamous debauchery, it is said

that he wore shoes glittering with valuable jewels but forbade like adornment on women's shoes. Another bit of information about the man tells us that he never wore the same sandals twice and never twice bestowed the honor of his couch upon the same woman.

In an edict of the Emperor Diocletian (284–305) regulating prices and taxes on food and clothing, he mentions Babylonian shoes. These appear to have been embroidered and jewel-sewn shoes of fine dyed leathers ornamented with gilt in solea and soccus form.

An emperor's shoe in vogue near the end of the empire was the Parthian zancæ, a boot of red leather reaching to the knee. Another, a crepida of purple leather, was the "tzanga," embroidered in gold and finished with a gold eagle on the lunula over the instep. A law prevented any one inferior to the emperor from wearing the tzanga; in fact, the crime was punishable with exile and confiscation of the wrongdoer's possessions.

The "phæcasium," the boot of white leather mentioned in the Greek chapter as worn by their priests, was also the foot dress of the Roman pagan priests. It did not remain priestly attire, however, as we read of its adoption by young Roman coxcombs and gay ladies or courtesans. The boot finally became so commonly worn that the Roman Stoic philosopher Seneca, writing in the first century, notes the change of the term "Crepidatus," designating a Greek as wearer of the crepida, to that of "Phæcasia," the wearer of the phæcasium.

A feminine shoe called the "sicyonia" is spoken of by Cicero (106–43 B.C.), one of the most eloquent of Roman orators. A shoe imported from Sicyon in Greece, it was of light-colored leather worked in a reticulated design which exposed the foot. The sicyonia became the sign of young Roman dandies who were known for their lazy and licentious way of living and the shoe was actually looked upon as an indecent piece of masculine apparel.

The curule chair was a chair of state, originally a folding stool upon which high magistrates of the Roman Republic sat. And when they sat they wore the curule shoe, a peculiar Oriental affair with a turned-up toe. Of black or white leather, it was apparently a badge of office while in session. It fastened at the side and was decorated with a small crescent, which some historians claim signified "centum" for the one hundred magistrates of the early years of the republic.

The "caliga" was the shoe of the soldier up to and including the centurion, varying in design according to rank. It was definitely a heavy-soled sandal,

often hobnailed with iron or bronze nails, and another characteristic was the gartering or ligulæ, which involved an elaborate manner of tying above the ankle. The nails were at the expense of the soldier although some generous emperors were known to distribute them gratis. The caliga was sometimes shod with silver or gold nails when the soldier had been fortunate in acquiring plunder in the wars. The caliga of the superior officer was not hobnailed and was reinforced by an additional strap which passed between the large and next toe.

The Emperor Caligula (37–41) was nicknamed Caliga because as a small boy in his father's camp he always wore the shoes.

Campagus was the name given the caliga worn by the emperor and the highest officers and some senators. It was an elegant boot, the toes usually uncovered and the wide front opening filled by laces. The top was frequently finished with a small animal's skin including the muzzle and the paws. Sometimes a head of ivory or gold replaced the one of fur. The emperor's shoe was dyed purple and it was not unusual that his campagus was embroidered with gold and further elaborated with pearls and gems. The height of the boot denoted the grade of the officer, the highest that of the emperor. The campagus used for hunting was of black leather.

The Romans, like the Greeks, protected the hoofs of their horses and mules with removable shoes which resembled little baskets and were tied to the legs by thongs. As the Romans reached their period of great opulence, wealthy individuals no longer employed straw or iron for the animals' hoofs but silver and gold. The author Pliny, of the first century, records that the aforementioned Poppæa had her handsomest racing horses shod with gold, no less.

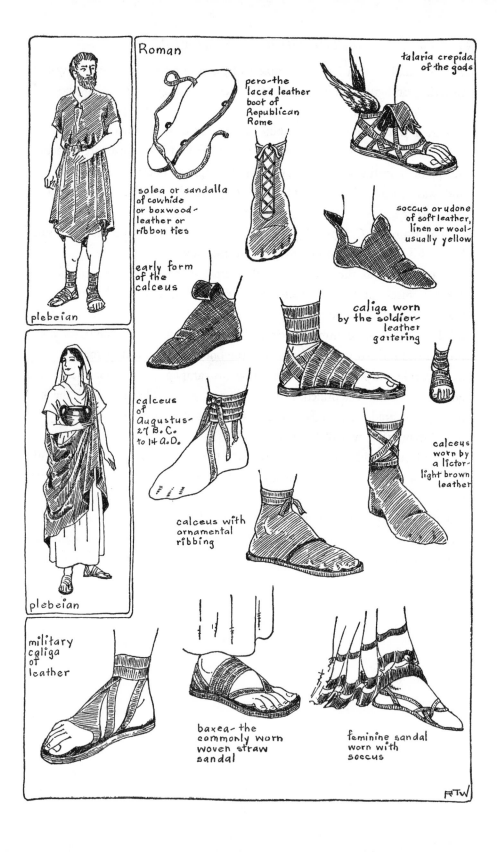

Roman

talaria crepida of the gods

pero-the laced leather boot of Republican Rome

solea or sandalla of cowhide or boxwood-leather or ribbon ties

soccus or udone of soft leather, linen or wool-usually yellow

early form of the calceus

caliga worn by the soldier-leather gartering

calceus of Augustus-27 B.C. to 14 A.D.

calceus worn by a lictor-light brown leather

calceus with ornamental ribbing

plebeian

plebeian

military caliga of leather

baxea-the commonly worn woven straw sandal

feminine sandal worn with soccus

RTW

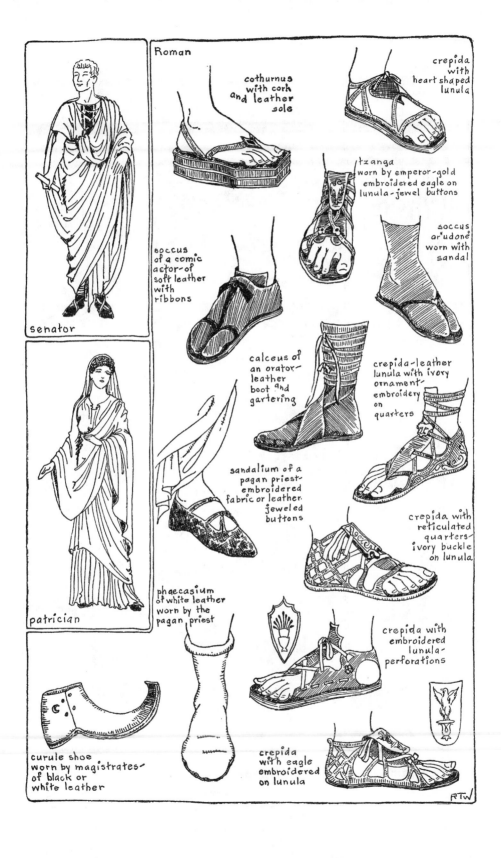

Roman

senator

patrician

cothurnus with cork and leather sole

crepida with heart shaped lunula

tzanga worn by emperor-gold embroidered eagle on lunula-jewel buttons

soccus ar'udoné worn with sandal

soccus of a comic actor-of soft leather with ribbons

calceus of an orator-leather boot and gartering

crepida-leather lunula with ivory ornament-embroidery on quarters

sandalium of a pagan priest-embroidered fabric or leather-jeweled buttons

crepida with reticulated quarters-ivory buckle on lunula

phaecasium of white leather worn by the pagan priest

crepida with embroidered lunula-perforations

curule shoe worn by magistrates-of black or white leather

crepida with eagle embroidered on lunula

RTW

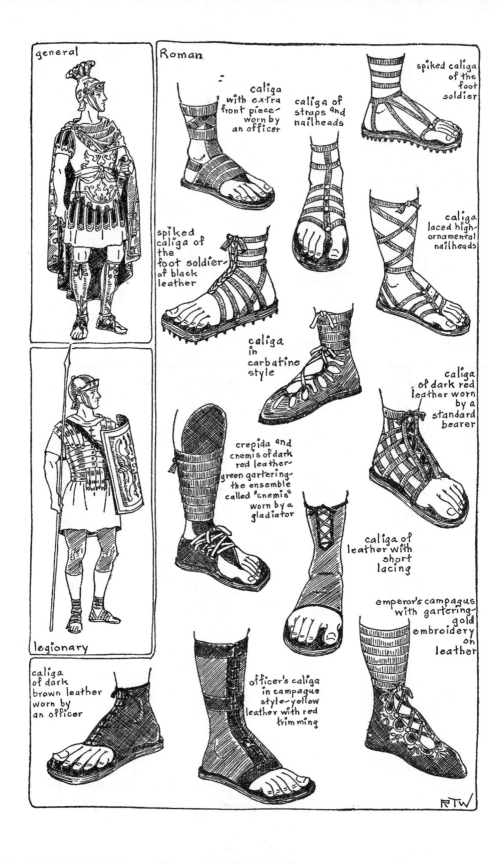

general

Roman

caliga with extra front piece worn by an officer

caliga of straps and nailheads

spiked caliga of the foot soldier

caliga laced high ornamental nailheads

spiked caliga of the foot soldier of black leather

caliga in carbatine style

caliga of dark red leather worn by a standard bearer

crepida and cnemis of dark red leather green gartering the ensemble called "cnemis" worn by a gladiator

caliga of leather with short lacing

legionary

emperor's campagus with gartering gold embroidery on leather

caliga of dark brown leather worn by an officer

officer's caliga in campagus style yellow leather with red trimming

RTW

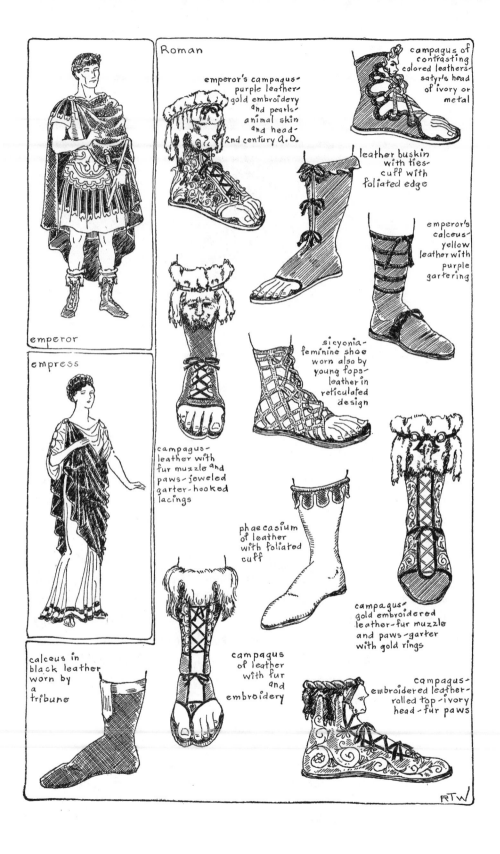

Roman

emperor's campagus-
purple leather-
gold embroidery
and pearls-
animal skin
and head-
2nd century a.d.

campagus of
contrasting
colored leathers-
satyr's head
of ivory or
metal

leather buskin
with ties-
cuff with
foliated edge

emperor's
calceus-
yellow
leather with
purple
gartering

sicyonia-
feminine shoe
worn also by
young fops-
leather in
reticulated
design

emperor

empress

campagus-
leather with
fur muzzle and
paws-jeweled
garter-hooked
lacings

phaecasium
of leather
with foliated
cuff

campagus-
gold embroidered
leather-fur muzzle
and paws-garter
with gold rings

calceus in
black leather
worn by
a
tribune

campagus
of leather
with fur
and
embroidery

campagus-
embroidered leather-
rolled top-ivory
head-fur paws

RTW

EAST INDIAN FOOTWEAR

CHAPTER SIX

THERE ARE roughly three periods in Indian history: the Hindu period of about 2000 B.C. to 1001 A.D., followed by the Mohammedan period to 1757, and from then to date the period of European influence. The Hindus who settled India were the most easterly of the Aryan or Indo-European people, and though contemporary with ancient Egypt these eastern Aryans had no known contact with their western kin.

Their earliest historic date is 557 B.C., the birth of Buddha. Another date is that of 327 B.C., when the Greek Alexander the Great invaded India, setting up kingdoms at important places along the way. It was by way of these centers that Greek art entered India, thereby having a definite influence not only upon her art but upon that of the Chinese and later the Japanese.

This contact was brief and the curtain again shut off India until the sixteenth century. Then explorers, spurred on by the unbelievable tales of India's wealth and gorgeousness, went on a hunt for a short cut to the fabulous land. So until this time we have little documentary evidence of their costume, but one assumes that the attire of the day had been worn for many centuries, the Oriental not being given to change in the fashion of his dress.

In the second century of our era Arrian, the noted Greek philosopher

and historian, wrote a history of the Asiatic expedition of Alexander. And pertaining to our subject he wrote that while the majority of people in India went barefoot others wore luxurious and modern shoes. He described sandals of gold enriched with jewels and boots of white leather with high heels worn by the wealthy.

Indian stuffs, wooden carvings and cut precious stones have been found in Egyptian tombs, bringing to light an intercourse between the two countries. Thus it followed that Indian footwear displayed evidence of contact with the countries of the Near East. There were sandals, mules, slippers, boots and the generally worn shoe of the later Mohammedan world, that with peaked toe.

The wearing of shoes appears to have been the privilege of princes and the rich only and even they discarded their footgear when indoors. Though costume in India has always been regulated by religion and social standing, the Hindus, Moslems, Sikhs and Parsis all wear the same styles of shoes. Those who follow the teachings of Brahma should not wear shoes, a custom, no doubt, formerly more generally observed. Shoes made of cow's leather are taboo to the Hindu, to whom the cow is sacred.

The sandal of antiquity is the foot dress today of the natives living in the hills. It is of straw, grass, rope or wood having a thick sole with a loop for the large toe.

Shoes are designated by the name of the fabric of which they are made, as felt shoes, leather shoes, and so on. Felt, especially for boots, has always been a popular material, a favorite fabric also with their neighbors the Chinese. Styles in shoes until very recent times were the same for men and women, the only difference being that the feminine piece was embroidered and of finer material.

The secluded life of Oriental women and of course the rich carpets upon the floor are reasons for the age-old custom of going barefoot, especially indoors. Like most Oriental women they delighted in circling their ankles with fine gold chains hung with bangles and adorning both fingers and toes with valuable rings. Today the fashionable Occidental shoe is worn by many of the upper class, the feminine sari in company with the French heeled slipper.

The real Moslem slipper is of thin red leather with the turned-up toe, a long wisp of a toe that is sometimes turned back and fastened at the instep. Such a slipper when worn by people of means is handsomely embroidered but mostly plain when clothing the feet of the poor. In this category there is

a mule with a small iron heel while another peaked-toe slipper has the counter folded flat under the heel of the foot.

Both Indian and Persian and very ancient is the knob sandal. Of all the means by which the sandal is held to the foot, the large knob held between the first and second toes appears to have been the simplest and most ingenious idea. But certainly not the most comfortable. The knob sandal, most often cut from solid wood, is worn by both sexes and all classes. At one time in recent centuries there was a feminine version of the sandal in which the clogs were joined by a fine chain, forcing the wearer to walk in mincing steps. One wonders if perhaps fashion and the male had not thus connived to keep the pretty creatures prisoners.

In the Indian collection we show a bridal sandal of hammered silver, silver believed to have many good-luck properties. Many a young Indian lady's dowry consists of silver and many a peasant father will put himself heavily in debt to weigh his daughter down with tinkling pieces of the metal. Indian traders, carrying their wares to Africa, introduced the knob sandal to the dusky feminine natives who delighted in wearing the heavy silver clog as a wedding shoe.

English-made shoes are largely worn by the Indian men of today. For dress with their gorgeous colorful costumes Indian princes wear black patent-leather pumps with white or orange socks or stockings. Those natives who have adopted European shoes are permitted to wear them in the house, though etiquette decrees that footwear be discarded indoors. This is done to keep the carpet clean since the Oriental preferably sits upon the floor. However, when entering a mosque or any other holy place shoes are invariably removed.

In modern centuries the Rajput soldier, an excellent warrior, wore a fabric legging over his breeches, the legging held by leather gartering. This gartering was called patti, the Hindu word for bandage. The Anglo-Indian Army of the nineteenth century wore the patti, which was Englished to puttee and the name eventually applied to all styles of leggings reaching from ankle to knee, whether of one piece or in bandage form. And with the puttee the soldier wore a sturdy peaked-toe shoe of heavy leather with hobnailed sole.

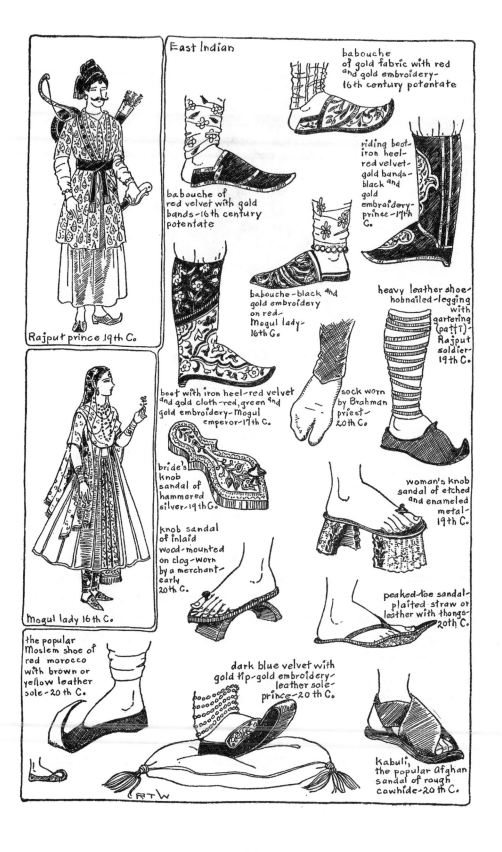

East Indian

babouche of gold fabric with red and gold embroidery—16th century potentate

babouche of red velvet with gold bands—16th century potentate

riding boot—iron heel—red velvet—gold bands—black and gold embroidery—prince—17th C.

babouche—black and gold embroidery on red—Mogul lady—16th C.

heavy leather shoe—hobnailed—legging with gartering (patti)—Rajput soldier—19th C.

boot with iron heel—red velvet and gold cloth—red, green and gold embroidery—Mogul emperor—17th C.

sock worn by Brahman priest—20th C.

bride's knob sandal of hammered silver—19th C.

woman's knob sandal of etched and enameled metal—19th C.

knob sandal of inlaid wood—mounted on clog—worn by a merchant—early 20th C.

peaked-toe sandal—plaited straw or leather with thongs—20th C.

Rajput prince 19th C.

Mogul lady 16th C.

the popular Moslem shoe of red morocco with brown or yellow leather sole—20th C.

dark blue velvet with gold tip—gold embroidery—leather sole—prince—20th C.

Kabuli, the popular Afghan sandal of rough cowhide—20th C.

RTW

CHINESE FOOTWEAR

CHAPTER SEVEN

OF THE Far Eastern peoples of antiquity there is little or no documentation, but it is a natural assumption that the evolution of footgear resembled that of other lands, ranging from the primitive foot protection of leaves, bark, raw skins and wood to the final finished shoe.

China, whose ancient name was "Under the Sky," lays claim to fabulous age, tracing her unbroken history back beyond the Hebrew Scriptures. Since the days of Confucius, who lived from 551 to 479 B.C., the inhabitants of the Celestial Empire have faithfully observed to the twentieth century the ordinances of their great lawgiver in regard to dress, disregarding Occidental change of fashion and retaining an unchanging costume through the ages.

Ancient indeed is the "grass shoe" of twisted rice stalks which the mountaineer people still use for climbing the rocks and on ice and snow. The rope sandal with wooden sole worn by the coolie today is of the millenniums. The thick wooden sole and the high wooden clog were necessitated by a harsh climate and deep mud. To combat cold, a moccasinlike upper of skin was fastened to the sole of wood, the upper usually knee high.

Chinese footwear has retained the peaked toe of antiquity. As noted in an earlier chapter, the pointed turned-up toe was first worn by the founders of

Babylon, the Akkadians, and to repeat further, some historians advance the theory that the Akkadians were northern Mongolians and possibly the ancestors of the Chinese. The ancient pompon ornamented the curling toe of the Mongolian boot as late as the nineteenth century.

Both Mongolian men and women, who practically live their lives on horseback, wear the same cumbersome boot, large enough to allow the wearing of several layers of thick cotton stockings in the winter. The women are probably the most colorful of the Orient in their costumes of many brilliant hues and their multicolored boots of felt or leather adorned with embroidery and appliqué. The masculine boot is frequently decorated but in more reserved color and design. These boots are made by the Chinese from whom the Mongolians buy them.

The art of felting in middle and northern Asia is of time immemorial, as is its use for clothing, tents and armor. From ancient to modern times felt has been an important material for boots and shoes and the thick sole, usually white, of the Chinese shoe is of felt. Like the Greeks and Romans, the actors of the Chinese stage wore the elevated sole when performing, a custom observed today in their dramas of myths and history. A black satin boot is shod with the white felt sole, about three inches high and higher for feminine characters.

When in 1912 China became a republic the event spelled the doom of the colorful, richly embroidered silk robes of the mandarins and their wives. These government officials adopted the somber European costume in place of the picturesque and meaningful dress worn for so many, many centuries. Despite the fact that the costume of Western civilization is gradually taking hold, the traditional footgear of cotton, silk, felt, satin and leather predominates. Fabric, color, rank and occasion guide the Chinese in their choice of shoe.

The upper class always wore boots in public in winter. Of velvet, quilted satin, silk or cotton with thick felt sole, they are beautifully made and often embroidered. Formerly the mandarins carried their papers, fan and pipe in the roomy uppers of their black satin boots finished with white felt soles. The feminine slipper of embroidered cotton or satin is entirely handmade and worn with short white stockings having a center front seam. "Rain shoes" have thick leather soles and a shoe for walking in the mud has a high wooden pedestal which tapers towards the ground.

A strange custom unique to the Chinese and practiced for hundreds of

years to as late as the twentieth century was the stopping of the growth of women's feet. This was accomplished by bending the toes under the foot with tight bindings which were worn day and night till the member ceased to grow.

The story of its origin is that the Empress Taki in the year 1200 was born with very small club feet. To save her from later embarrassment a decree went forth that no lady of the court was truly noble unless her feet were as small as Her Majesty's. There is another version of the story in which the princess, when old enough to realize her deformity, prevailed upon her ministers to issue the order. So began the cruel fashion of deliberately crippling a baby girl's feet.

Usually only one girl in a family was chosen to have "lily feet," perhaps because the crippled beauty needed waiting upon by her sisters or a servant. The pain and discomforture were evidently worth the honor as "lily feet" signified that the young lady was reared not to work but to be a flower. In fact, it is said that quite often a girl with natural-formed feet berated her parents for having been so inconsiderate and neglectful in permitting her to grow up with well-formed feet.

Poets were wont to hold forth on the beauty of the crippled feet, which they affectionately termed "little golden lilies." The tiny deformed stumps and the resulting tottering walk were the admiration of the lady's husband and friends and one reads that the mandarin who chose a wife with lily feet usually took a second wife to act as slave to the first.

In the second half of the nineteenth century great social changes in China made for the education of women and hence the prevention of foot binding. It was the old Empress Dowager who published the first edict forbidding the practice because, of course, she was a Manchu and the Manchus did not bind feet, especially the members of the imperial family. But it was in the early years of the republic after 1912 when Yuan Shih-Kai became president that it was made a penal offense to bind a girl's feet.

This ban led to three types of feminine shoes. First, a shoe for the natural foot, a second style for the deformed foot and a third also for the deformed foot but of a design to conceal the deformity.

This latter was called the "deer foot" or "theater boot," a fashionable shoe worn not only by the deformed-footed ladies but by other well-dressed Chinese women who wished to appear to have "lily feet." It was a boot built on a sole, exactly like our present wedge models, with the heel section very high indeed.

For the deformed feet, walking in the theater boot was no easier than stumping along on crippled toes but the wearer, like modish ladies the world over, was happier in the thought that she was in the latest fashion.

In these 1940's a California designer presents practically the same shoe with the wedge sole very high in back, no counter and with open toe. And he explains that this very modern shoe is "tailored on architectural principles."

Red, the Chinese color for festivities, was formerly the color worn by the bride, and a red shoe tossed upon the roof of the house told would-be visitors that a couple of newly weds were enjoying their honeymoon.

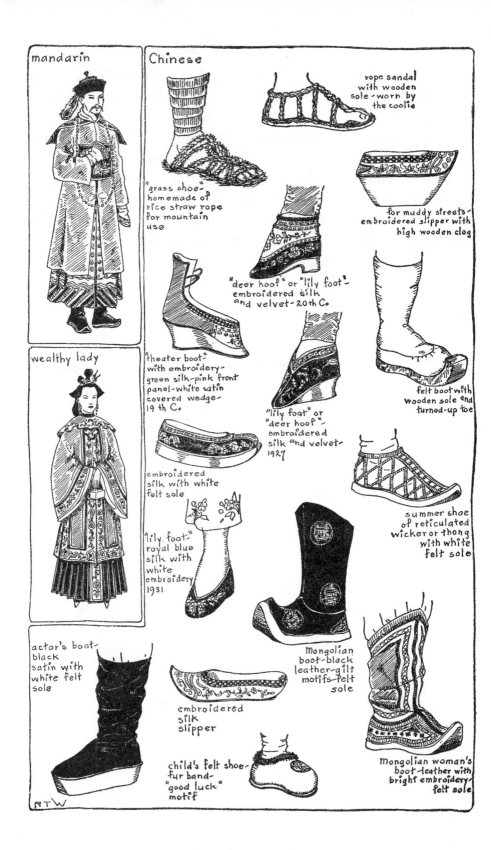

mandarin

Chinese

wealthy lady

rope sandal with wooden sole - worn by the coolie

"grass shoe"-homemade of rice straw rope for mountain use

for muddy streets-embroidered slipper with high wooden clog

"deer hoof" or "lily foot"-embroidered silk and velvet-20th C.

"theater boot" with embroidery-green silk-pink front panel-white satin covered wedge-19th C.

"lily foot" or "deer hoof"-embroidered silk and velvet-1927

felt boot with wooden sole and turned-up toe

embroidered silk with white felt sole

"lily foot"-royal blue silk with white embroidery 1931

summer shoe of reticulated wicker or thong with white felt sole

actor's boot-black satin with white felt sole

embroidered silk slipper

Mongolian boot-black leather-gilt motifs-felt sole

child's felt shoe-fur band-"good luck" motif

Mongolian woman's boot-leather with bright embroidery-felt sole

RTW

KOREAN FOOTWEAR

CHAPTER EIGHT

KOREA'S northern neighbor is Manchuria while to the south the point of her peninsula faces Japan. Korean history runs far back, is contemporary with China and her records antecede those of Japan by about twenty-five hundred years. It is not known whether the Koreans were originally Mongolian or came from Manchuria.

About 1100 B.C. a Chinese sage gave the land the poetic name of "Chosen," or "Land of Morning Calm." The name lasted to 913 A.D., when it was changed to Korai. In the twelfth century when ravaged by the Mongols the Koreans sought the protection of China and thus they absorbed Chinese culture, which in turn was adopted by the Japanese. Japan annexed Korea in 1910 after her two successful wars over the country, with China in 1894 and with Russia in 1904. Korea was renamed Chosen. Today, freed from her conquerors, Korea is occupied by American and Russian troops, with the promise of freedom and independence on the horizon.

Customs and costume have since the fourteenth century remained unchanged. Korean costume differs from Chinese and Japanese dress, but as in China the footgear with the ancient peaked toe is the prevailing style of shoe. The slipper of colored cotton, silk or leather is the same for men, women

and children. It is worn over a bootlike sock of thick white cotton fabric, usually padded percale, which becomes the footwear for indoors as the slipper is discarded before entering a building. Children are dressed in colors but the national adult dress is the all-white cotton costume for all-year-round. A most colorful attire in silks is worn for celebrations and festivities and for New Year's it must be a whole new outfit for both grownups and children.

The generally worn shoe in good weather is the slipper of cotton, silk or leather with leather soles and sometimes a broad but very low heel. The uppers are stitched with a heavy silk cord. Rural Koreans wear wooden shoes in the rain, of pine, willow or date wood. This peaked-toe wooden slipper mounted on stilts costs about forty cents in American money.

Peasants and workmen wear various styles of grass slippers including the straw sandal with thong for the large toe as worn by the Japanese. Both sandal and the modern slipper are of Japanese manufacture, the slipper often made of rubber.

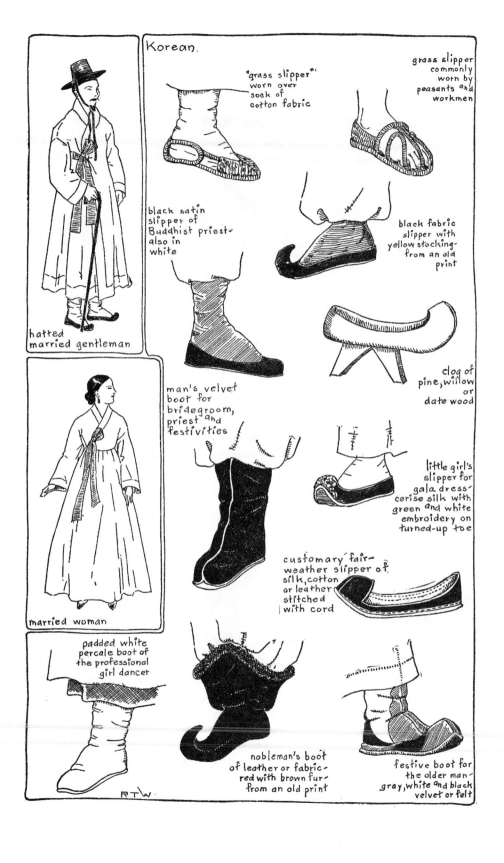

Korean.

"grass slipper" worn over sock of cotton fabric

grass slipper commonly worn by peasants and workmen

black satin slipper of Buddhist priest- also in white

black fabric slipper with yellow stocking- from an old print

clog of pine, willow or date wood

man's velvet boot for bridegroom, priest and festivities

little girl's slipper for gala dress- cerise silk with green and white embroidery on turned-up toe

customary fair- weather slipper of silk, cotton or leather stitched with cord

hatted married gentleman

married woman

padded white percale boot of the professional girl dancer

nobleman's boot of leather or fabric- red with brown fur- from an old print

festive boot for the older man- gray, white and black velvet or felt

RTW

JAPANESE FOOTWEAR
CHAPTER NINE

BOTH SCANT and unreliable is the information to be had of ancient Japanese history, of which the earliest recorded date is about the eighth century. The civilization of the Empire of the Rising Sun is basically Chinese, having been passed on to them by their neighbors the Koreans, to which much of the Koreans' wide knowledge was added. From antiquity to the middle of the nineteenth century, when Japan opened her doors to the Westerners, Japanese costume remained unchanged.

The early people went barefoot, eventually adopting the sandal, which consisted of a sole of plaited bark, straw, hemp or rawhide held to the foot by two straps which passed between the two first toes.

Despite the fact that western footwear has been adopted to quite an extent the age-old sandal or zô-ri remains the national shoe. In a country where it it customary to go shoeless indoors, the floor being the place to sit, the easy-to-slip-on-or-off zô-ri is the practical shoe. The zô-ri is fashioned in many styles and of straw, felt and wood. Sometimes the man's sandal is slightly elevated by a low broad heel, but the feminine variety is always flat.

The zô-ri is occasionally worn in the house over bare feet, but most general for indoor use is the tabi, a padded white cotton sock or footglove with thick sole and a separate stall for the large toe. It is usually of white percale and

fastened up the back by hooks or snaps. The geisha's tabi, which must be scrupulously clean, is fastened along the heel by four snaps instead of the conventional three. The sock is also made of linen or felt.

The separate toe stall and the manner of the thongs passing between the toes brings to mind the remark of an American soldier stationed in the Pacific that a barefoot Jap could not conceal his nationality because of the telltale separation between the first two toes caused by his national footwear.

Peasants and workmen wear long, colored fabric stockings or tabi for weather protection.

The tabi is used outdoors with the gēta, a clog for all kinds of weather and worn for untold centuries. The wooden gēta varies in height from two to six inches and varies widely in design. It is made with no regard to right and left or front and back. As soon as youngsters are able to toddle about they wear the same footgear as their elders. This casual piece of foottire is on sale everywhere in modern Japan either in open-air shops or displayed behind plate-glass windows.

A further protection against rain is afforded by the modern toe-covering of rubber worn over the front of the clog.

Strange indeed are the huge pedestal-like clogs worn with the ancient ceremonial dress by the nobles at court. These gēta appear to be as high as ten or twelve inches, thereby raising the personage above the common herd. Such clogs are to be noted especially in pictures of the emperors and were of carved and lacquered wood. A pair worn by the Emperor Meiji at his coronation in 1837 seem to be wood covered with velvet, while those of the Emperor Hirohito at the solemn rites of his enthronement in 1926 might be carved wood or wood covered with silk.

This pedestal shoe is also worn in the Japanese theater when actors perform traditional plays.

Chinese influence is revealed in the peaked-toe shoe worn by nobility and priests in the early centuries of our era. In the Japanese age of feudalism, which lasted to the middle of the nineteenth century, the newly arrived Westerners found the warrior still clad in chain mail armor. Too, he wore toed socks and sandals, and in cold weather high fur boots with the fur on the outside. Over the shoes went leggings of silk, leather and iron which were lacquered.

The practice of the ancients of protecting the horses' hoofs with straw was in use to recent times by the Japanese, rice straw serving for the purpose.

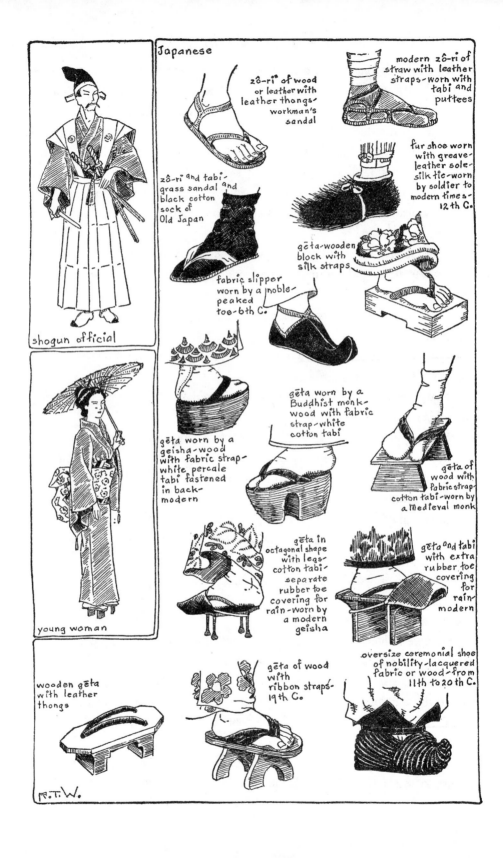

Japanese

zô-ri* of wood or leather with leather thongs- workman's sandal

modern zô-ri of straw with leather straps- worn with tabi and puttees

zô-ri and tabi- grass sandal and black cotton sock of Old Japan

fur shoe worn with greave- leather sole- silk tie- worn by soldier to modern times- 12th C.

gēta- wooden block with silk straps

fabric slipper worn by a noble- peaked toe- 6th C.

shogun official

gēta worn by a Buddhist monk- wood with fabric strap- white cotton tabi

gēta worn by a geisha- wood with fabric strap- white percale tabi fastened in back- modern

gēta of wood with fabric strap- cotton tabi- worn by a Medieval monk

young woman

gēta in octagonal shape with legs- cotton tabi- separate rubber toe covering for rain- worn by a modern geisha

gēta and tabi with extra rubber toe covering for rain- modern

wooden gēta with leather thongs

gēta of wood with ribbon straps- 19th C.

oversize ceremonial shoe of nobility- lacquered fabric or wood- from 11th to 20th C.

R.T.W.

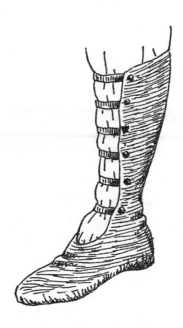

NORTHERN EUROPEAN FOOTWEAR
CHAPTER TEN

THE NORTHERN Europeans of antiquity like other primitive peoples made their foot-coverings of leaves, bark and undressed skins. The northern barbarians or Scythians, as they were known to the Greeks, were nomadic tribes and great hunters, and their vast forests of wild animals supplied them with food, body covering, tools and tents. The shoes of these half-civilized tribes were of a closed kind for severe weather, bare feet being generally preferred during the mild season.

For data on these people we go to the writings of ancient learned authors, vases and the bas-reliefs upon the columns erected in honor of great Roman generals. From the Greeks we know that the Scythians of about 1000 to 500 B.C. wore boots of soft untanned leather with the fur turned inside. A thong tied round the ankle held the baglike boot to the leg. The Vikings of some fifteen hundred years later wore the same boots and so do the Asiatic and Arctic peoples of today. In a small ivory carving of the fourth or fifth century found in a cathedral in north Germany we note one masculine figure wearing breeches and boots made in one. They are of hide and decorated the front length of both legs with small gold buttonlike plaques which the Scyths were fond of using for ornamentation.

The Goths and Celts wore the same primitive shoe as the karbatine or carbatine of the earliest Greeks and Romans. The design is akin to that of the early American Indians. The British name "es-cid" meant "protection from hurt." "Brog" was the Scotch name for this one-piece shoe of untanned hide, a shoe worn by them to recent times and as late as the nineteenth century by the Irish. The Anglo-Saxon model was laced through loops formed of the shoe in the manner of the more modern gillie.

From some bas-reliefs, coins, and figurines one learns that the Gauls wore a sandal of rawhide with straps and in southern Gaul or France there were also sandals and slippers of straw. Noteworthy indeed was the bad-weather shoe of heavy skin with a thick wooden sole. This wooden-soled shoe, worn as early as 200 B.C., was the gallica or Gaulish shoe described in the Roman chapter, the origin of our galosh. The Romans were surprised to find the barbarians wearing such a practical boot and copied it for their own use, especially for country wear. Another style of the same period had a heavy leather sole studded with silver nails.

Roman civilization, reaching northward beyond its borders, changed the way of life of the northerners. To the Romans the Gauls, Franks, and British Celts were the "panted people" because of their custom of clothing their legs in long or short breeches known as "braccæ." The breeches were of wool or coarse linen or hide for hard wear.

Gaul was conquered by Cæsar in 58 B.C. and lived under the rule of the Roman Empire for over four hundred years. It took less than a century for the Gallo-Romans to absorb the culture and costume of their conquerors and, as one writer said, "also Roman corruption."

During this period they wore the solea, the sandal, the caliga and several different styles of the gallica. And after their subjugation and incorporation into the Roman Army the Gaulish soldiers followed the Roman style in military dress. The elegant Gallo-Roman ladies who displayed a flair for the mode acquired vast wardrobes. They wore Oriental slippers at home and outdoors and the solea, sandal or cothurnus when walking abroad. They were fond of gold and silver bracelets, which adorned not only their arms but their bare legs.

When Cæsar in 55 B.C. undertook the conquest of the islands now known as Great Britain they were inhabited by several Celtic peoples. The Romans succeeded in taking and Romanizing only a part, which they held for five centuries. Wales, Scotland and Ireland remained Celtic long after Britain had

become a Roman province. In the fifth century when the Romans were forced to withdraw their legions to protect their own home frontiers, the Saxons and Angles came across the North Sea and took over. All record for the next two centuries is shrouded in darkness and the fate of the Britons is unknown.

The costume of Romanized Britain changed to that of the invading Angles and Saxons wearing the long breeches, knee-high stockings and low shoes of rawhide. The breeches were held close to the lower leg by the long cross-gartered thongs attached to the shoes. Short breeches and cross-gartered knee-high hose revealing bare knees was a remaining note of Roman influence in the silhouette. There was a combination of breech and hose but footless, a garment which reached to the thigh, fashioned of rawhide and for winter wear.

Of documentary data on Anglo-Saxon costume there exists little earlier than the tenth century. Contemporary writers mention "brech and hose" cross-gartered in cloth, woolen and leather bands. Linen bands distinguished the monks from the laity who wore woolen gartering. Men of means often sported gilded straps. The Anglo-Saxon priest was forbidden to celebrate mass in bare legs.

These later Anglo-Saxons were versed in the art of tanning, and leather found a wide use in their costume especially in shoes, belts and garters. The low shoe was usually black and the sole very often of wood. Workmen as a rule went barefooted. Priests wore the humble sandal, which was made with additional straps for the bishop. Noblemen were attired in stockings finished with ornamented tops, the hose cross-gartered by gilded ribbons attached to shoes embroidered with colored silk and yarn.

When the Anglo-Saxon father gave his daughter to the bridegroom he also presented the young man with one of her shoes. By this gesture he implied the transfer of parental authority to her husband. And after the ceremony in York or Kent it was the custom for the groomsman at the church door to throw a shoe to the bridesmaids who stood in line. As we believe today when a bridesmaid catches the bridal bouquet, the lucky maid catching the shoe would be the first to marry. In another Anglo-Saxon rite observed by sailors and smugglers, the shoe tossed after the departing ship was thought to carry luck with it. And thus the shoe for good luck is tossed today after the newly-wed couple departing on their ship of matrimony.

As the Roman Empire declined, the emperors permitted the less civilized German tribes to establish themselves in Gaul. It was in the fifth century of

our era that the Gauls, the Teutonic and Slavic races and the Anglo-Saxons overran all Europe. There was a general resemblance in costume, their legs often entirely bare, though braccæ were used in inclement weather, accompanied by low shoes of rawhide with long garters girding the breeches to the legs.

Their shoes of horsehide or other skins were simple, practical and durable. The low boot with heavy sole was often made retaining the fur. Over the centuries Roman influence is noted in a simple sandal and a laced buskin. Like the Gauls the Teutonic people, too, developed a fondness for modish dress, but they do not seem to have possessed the innate sense of color and design which their kinsmen displayed.

Frankish and new was the manner of winding the long garter round the leg in puttee fashion, leaving the toes bare. Such bandelettes were also dressed over the footless hose or chaussé. When the hose were made with feet and a felt sole they were called soled chausses. Low leather slippers or escarpins were frequently gilded and had long ribbons cross-gartered up the leg over hose of vermilion linen. To the same ribboned slipper the Frankish warrior attached his spurs, but spurs were also attached to wooden soles.

Beginning with the Christian era we find all luxury and art banned by the preachers of the new religion. Shoes according to Christian concepts were to be simple, durable and cover the feet. The male of the species must have ignored these teachings, because the father of the Latin church, Saint Jerome (331–420), preached humility to women and insisted that it was necessary only to have clean and well-fitting shoes. Saint Clement of Alexandria, in the third century, commanded women not to bare their toes. Further rules were that they might wear white shoes at home, but for travel hobnailed and oiled shoes were required.

In the fourth and fifth centuries Europe was invaded by the savage Mongolian hordes from Central Asia. They were the Huns led by Attila, the terrible enemy of civilization, whom the Roman General Aëtius, with the aid of the West Goths, the Burgundians and the Franks, routed in 451. They lived on horseback, drank the milk of their mares and ate raw meat, which they aged by carrying it under the saddle.

They wore a crudely fashioned boot of undressed hide retaining the fur worn either inside or outside, and a seam passing under the foot and up the back held the one-piece skin together. We have the words of a Roman writer who described the boots as "tubes made of goat's leather."

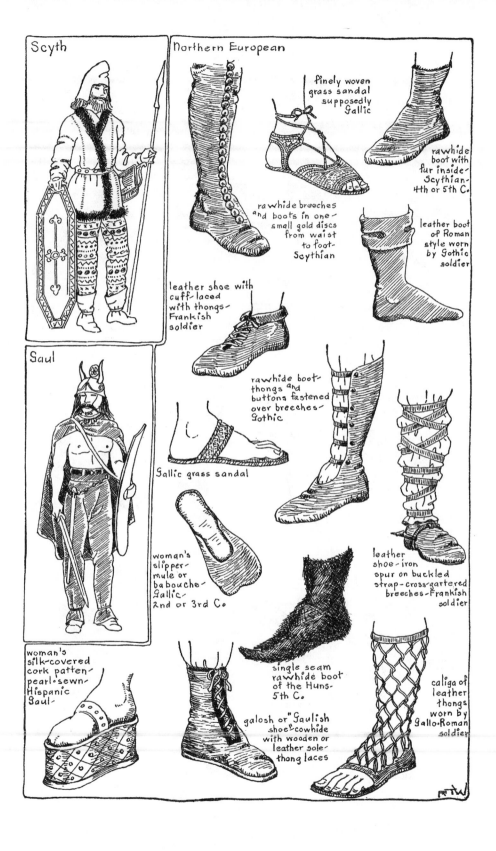

Scyth

Northern European

finely woven grass sandal supposedly Gallic

rawhide boot with fur inside - Scythian - 4th or 5th C.

rawhide breeches and boots in one - small gold discs from waist to foot - Scythian

leather boot of Roman style worn by Gothic soldier

leather shoe with cuff laced with thongs - Frankish soldier

Saul

rawhide boot - thongs and buttons fastened over breeches - Gothic

Gallic grass sandal

leather shoe - iron spur on buckled strap - cross gartered breeches - Frankish soldier

woman's slipper - mule or babouche - Gallic - 2nd or 3rd Co

woman's silk-covered cork patten - pearl-sewn - Hispanic Gaul -

single seam rawhide boot of the Huns - 5th C.

galosh or "Gaulish shoe" cowhide with wooden or leather sole - thong laces

caliga of leather thongs worn by Gallo-Roman soldier

RW

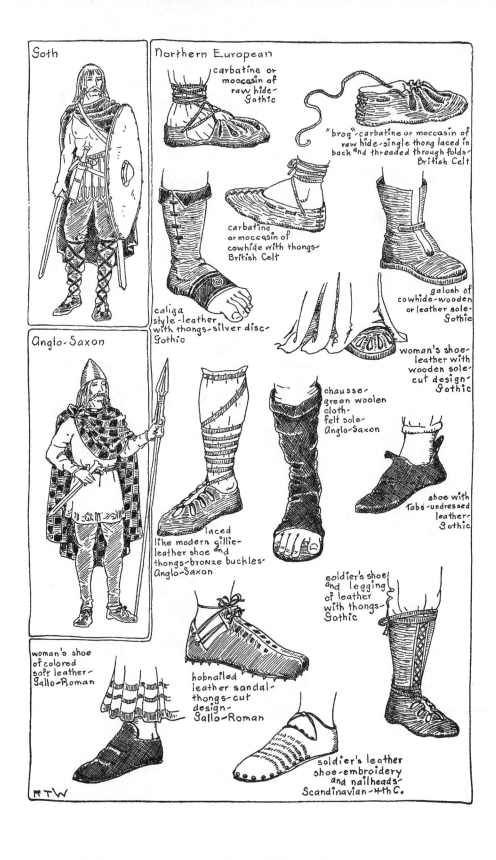

Goth

Northern European

carbatine or moccasin of raw hide - Gothic

"brog" - carbatine or moccasin of raw hide - single thong laced in back and threaded through folds - British Celt

carbatine or moccasin of cowhide with thongs - British Celt

caliga style - leather with thongs - silver disc - Gothic

galosh of cowhide - wooden or leather sole - Gothic

woman's shoe - leather with wooden sole - cut design - Gothic

Anglo-Saxon

chausse - green woolen cloth - felt sole - Anglo-Saxon

shoe with tabs - undressed leather - Gothic

laced like modern gillie - leather shoe and thongs - bronze buckles - Anglo-Saxon

soldier's shoe and legging of leather with thongs - Gothic

woman's shoe of colored soft leather - Gallo-Roman

hobnailed leather sandal - thongs - cut design - Gallo-Roman

soldier's leather shoe - embroidery and nailheads - Scandinavian - 4th C.

RTW

FOOTWEAR OF MEDIEVAL EUROPE
CHAPTER ELEVEN

THE ROMAN EMPIRE was divided into two by the Emperor Diocletian (284–305), thereby creating an empire of the East or the Greek Empire and an empire of the West. In the next change the Emperor Constantine (274–337) moved the capital from Rome to Byzantium, renaming it Constantinople.

The gradual inevitable decay of Rome due to many contributing reasons took place over centuries, carrying the world back to semi-barbarism. Militarism, anarchy, taxation and slavery created great poverty and wretchedness, but beautiful, costly raiment continued to be worn by an ever-diminishing wealthy class. The enfeebled empire was finally conquered by the Teutonic tribes in 476 and it was at Byzantium or Constantinople that Greco-Roman and Oriental culture survived through the so-called Dark Ages. This period covers a time from about the fifth to the eighth centuries.

The Byzantine Period is considered by some to date from 400 to 1100. In a simple over-all statement one might say that the Middle Ages lay between the fall of Rome and the conquest of Constantinople by the Ottoman Turks in 1453. By this time the European Renaissance was well under way, especially in Italy.

European dress by way of Byzantine was decidedly influenced by the teachings of the Christian religion. The long robes of rich, heavy fabrics, straight in line and fold, entirely concealed the body as opposed to the clinging

garments of the ancient Egyptians, Greeks and Romans. The shoe followed the same idea, that it was sinful to reveal the human form.

The Byzantine mosaics in the churches at Ravenna, Italy, furnish us with the earliest historic data of this period. They were executed in the sixth and seventh centuries and picture the Emperor Justinian, the Empress Theodora, the court and the clergy. This valuable source portrays kings and bishops wearing the soccus, the shoe without lacings, the military caliga, the monastic calceum and the sumptuous campagus, and that very practical wooden-soled shoe the gallica. Another piece of footwear was the carpisculas, which we know better by its French name escarpin, a low, soft slipper cut away over the instep with attached ribbons which crossed round the leg and tied below or above the knee.

A few shoes have been preserved to posterity but they are chiefly of noblemen and churchmen. They were beautifully made of very soft leather, colored and gilded and sometimes in black known as Persian leather. They were ornamented with punched designs, colored stones, gilded copper medallions and gold and silver embroidery. The royal ceremonial attire of the court, a white silk dalmatic with purple cloak and heavy precious ornaments, was accompanied by luxurious pearl embroidered shoes of purple silk. Such shoes worn only by the emperor gave rise to the well-known expressions of a prince "being born to the purple," or when he ascended the throne that "he assumed the purple shoes."

Women's shoes resembled the masculine style. In this day and age of the sixth century it was customary for a young lady to present her fiancé with a pair of shoes. Made of soft leather and delicately embroidered, the handsome gift was usually the maiden's own handiwork.

Footgear of the common people was of simple cut and most generally of untanned hide, with the gallica the popular shoe.

In priestly costume shoes conformed to the Roman idea and it was more or less an edict during the eighth and ninth centuries that "priests should celebrate mass wearing sandals of the Roman order." And they were further asked to officiate in shoes especially reserved for the occasion. Pontifical footwear consisted of stockings and the traditional Roman shoes, the sandal and the caliga.

The popes of the Moyen Age wore slippers of soft leather finely embroidered and gilded. Sandalium was the name of the liturgic red papal slipper.

In the twelfth century, slippers were fashioned of cloth or brocaded silk in white, red or purple and eventually of precious velvet. A flat-soled slipper with a bride over the instep was worn by the Episcopal bishop to the fourteenth century, when it was replaced by the velvet mule.

The sandal of the clergy, symbolic of humility, was of leather or wood or often both, also of plaited cord and held to the foot by straps. The low, sturdy buckled shoe of heavy rawhide, which style we today designate as the "monk buckle," is to be noted in England as early as the eleventh century. This simple, durable shoe with broad strap and buckle was made to fit either foot. It originated among the friars of a monastery in the Italian Alps, and an English brother visiting there carried the design back to England, where the shoe was eagerly adopted by both clergy and laity.

Of Asiatic origin was the Medieval custom of kissing the pope's slipper. It was also a Frankish custom when imploring a favor from chief or king, the petitioner kissing the ruler's leg or foot. With the passing of the centuries the performance seemed too servile as people became more enlightened. The pontiff's shoe was then embroidered with a cross, thereby giving the act a religious significance in paying homage to the Lord through his servant.

A kind of stocking, by the Latin name of "tibiala," was worn with the braccæ or drawers under the long tunic. This new costume accessory was chausse to the Normans, heuse to the Germans and hose to the Saxons, and there you have the origin of our word hose. The term stocking does not appear until the sixteenth century, when we shall hold forth upon the subject. Our word shoe is from the Teutonic form "schuh."

The tibiala of leather, cloth or silk was secured by a garter or string drawn through a slot round the top and tied at the knees. Worn by both sexes, that of the noble was carefully sewn and fitted while the commoner's was poorly made of a coarse cloth known as "blanket cloth." Those of leather were "skin hose." Royalty, lords and high churchmen wore costly luxurious ones of brocaded silk or embroidered linen with silk garters variegated in color.

Handsome indeed were the high boots of colored leather, particularly red, which the seigneurs of Cordova wore. The Spanish Moors furnished all Europe with beautiful, soft, brilliantly dyed leather known as cordoban or in old English, cordewan. The shoes made of this leather, snugly enveloping the foot to the ankle, were called "Babylonian shoes."

It was in the **seventh** century that the Arabs built a great Oriental Empire

along the Mediterranean. They established their western Moslem kingdom in Spain, occupying it for eight centuries to 1492. Theirs was considered the highest learning in Europe and to their university at Cordova came Christians from the north looking for knowledge.

The process by which the leather was produced was an ancient Babylonian secret which came down the ages by way of Byzantium and the Moors. When driven from Spain in 1492 by the Christian Spaniards they carried their craft to Morocco, whence the pliable, fine skins then became known as Morocco leather. A peculiarity of the ancient morocco was the dyeing of the skin before tanning, which with the dressing produced a rich red color. Cordovan today is a nonporous leather, dark reddish-brown in color and made principally from fine horsehide split so as to retain the grain, while modern morocco which comes from the country of its name is bright red goatskin.

The French shoemaker of the Middle Ages was a "sueuer" or sweater, from the process of sweating skins in the preparation of leather. When he adopted the Moorish method of making cordovan for his shoes and succeeded in producing leather as beautiful, he became known as a cordonnier and his craft, cordonneria. In English the terms became cordwainer and cordwainery.

By the **ninth** century one notes a variety of shoes of soft or heavy leathers with leather or wooden soles. Nearly all had bandelettes or cross-gartering up the legs. Some ankle-high shoes were tied by a thong run through a slot round the top and there were rights and lefts. The latter fact is proven by the existence of a shoe which belonged to Saint Swithin, a bishop of Winchester, he of the forty-day rain legend.

Soldiers and men of the people are frequently depicted in cross-gartered cloth or leather leggings which left the toes bare.

When the tomb of the grandson of Charlemagne was opened in 1639 this royal boy of the ninth century was found to have worn galoshes of red leather with wooden soles. It must be noted, however, that the wooden soles worn by the European princes of the ninth and tenth centuries were beautifully carved pieces of craftsmanship.

Toes shaped into points in the **tenth** century and appeared spasmodically in and out of fashion for a couple of centuries before they acquired the very long points. The shoes of the wealthy were embroidered, leathers were waxed and polished and lovely soft colors were exceedingly popular. In this period members of the monastic orders also wore the mode of the day and a con-

temporary chronicler writes that the nuns of a French abbey wore with their silken garments "sky blue or green shoes."

In the tenth century the Russians adopted the religion of the Greek Church of Byzantium and with it much of the rich, elaborate costume. But the Mongolian invasion which lasted from the thirteenth to the fifteenth centuries had a real influence, seen especially in the Oriental peaked-toe boot of colored moroccan leather, a style worn to our day.

In the **eleventh** century, due in a large degree to the contact of the Occident with the Orient by way of the Crusades, costume began to change from the simple monumental style to the flowing lines of the Gothic Period. Shoes were high, low, laced or buckled with almost all classes wearing the low wrinkled boots called estivaux. Brodequin or the English variant brodekin was also the name for the half boot. Gamaches or gamashes, which were really chausses or leggings of linen or leather, opened from top to bottom and fastened by means of straps and buckles, lacings or buttons. Escarpins were worn indoors.

The legs of the knight in the reign of the Norman William II of England (1087-1100) were encased in mail as was his body. The long point of his sabbatons or foot-covering turned down, an invention of the king's to prevent the toes from slipping out of the stirrups. Perhaps this suggested the preposterous long points which were to appear later on civilian shoes. Anyway, a few curled-up toes did appear at this time, stiffened and stuffed with moss or wool.

A certain Robert, a hanger-on of William's court, distinguished himself by stuffing his pointed toes and twisting them into the shape of ram's horns. For this clever bit he gained the surname of "Cornardu," an epithet for one with horns. The style was considered much too foolish for the clergy and they were strictly forbidden to indulge in it.

The peaked or piked toe of the **twelfth** century became a little more conspicuous with the shoes reaching two inches beyond the foot. In the feminine mode there were pointed toes too. The footgear of the nobles were well-fitted pieces of apparel partially laced, and, though concealed by the long robes of lord and lady, the wearer missed no opportunity to display them by lifting the gown when walking. Rich fabrics for shoes were in vogue—silks, velvets and metal tissues—and they were further adorned with elaborate embroidery and pearls. The favorite color for gentlefolk was red—somber tones for lesser

folk, while the poor wore shoes of untanned hide or, as in England, went barefoot.

The fashion note of the twelfth century centered around the chausses or long stockings that the gentlemen wore. Chausses, leg-covering from thigh to foot including the foot, were of cloth cut and sewn and secured by laces and points to a belt concealed under the jacket. They were worn over linen "under hose," really a short pair of drawers. Prelates too wore chausses under their long robes, some costing large sums especially when made of brocaded and damassé silks and exquisitely embroidered. It was not unusual for priests, bishops and abbots to wear gold-threaded chausses at a pontifical mass.

"To wear the chausses" in the ménage was like the modern expression "to wear the pants." "He left his chausses on the spot" meant he perished there and "to pull on his chausses" indicated his slipping away.

As to the feminine leg we are told that ladies' colored hose were gartered at the knee.

The tubelike houseaux or leggings were worn over boot and hose. They were often finished at the top with embroidery and it is recorded that the French Philippe-August was crowned at Reims wearing houseaux studded with gold fleur-de-lis.

By the **thirteenth** century the pointed toe had lengthened considerably and the craze for extravagant footwear had created many unusual designs. Some authorities would have us believe that the peaked toe was the result on the part of one Count of Anjou to hide his deformed toes, but certainly he didn't require such an absurd length. The sensible view is that it was probably just one of Dame Fashion's inexplicable whims.

An ordinance passed by the French Cardinal Courson in 1215 forbade shoes with the liripipe being worn by the professors of the University of Paris. Liripipe was the Flemish term from "leer-pyp," meaning a point of leather, and appears to have been eventually applied to any long appendage in costume, really a tippet. The ruling also banned laced shoes, shoes and boots now quite often laced part way on the inner side of the leg. Thus the new has always found objectors; one wonders just what could be wrong in a shapely laced boot.

The use of fine fabrics continued in velvet, cloth of gold, heavy silk and soft leather in varied colors, enhanced with exquisite embroidery and jewels. At the same time many gentlemen wore shoes and slippers in plain black.

For hunting the aristocrat's boot was of the famous Moorish cordovan, while the peasant wore a like style in heavy calf.

The elegant chausse of the masculine beau monde was a very important item in dress. Made of elastic cloth, it was cleverly sewn and fitted with tiny seams, some concealed by embroidery, the origin of today's ornamental clocks. It is very likely that there were chausses of knitted yarn, considering that the ancient Oriental art of knitting had been rediscovered and was being employed in the making of ecclesiastic gloves. The tailored hose were fashioned with feet and some with leather soles. Gay colors and allover geometric designs were in vogue, with slate or grayish blue the general practical color.

Pertaining to women's hose is an order from the household accounts of the English King Henry III (1216–1272) for three pairs for his sister of cloth embroidered with gold.

In the **fourteenth** century between 1300 and 1350 the "snouted" toe reached a fantastic length of about twelve inches beyond the foot, stuffed with moss, hay or wool and shaped with whalebone. This was the height of the eccentric fashion which lasted over a hundred years despite the combined vigorous protests of Pope Urban V (1362–1370) and Charles V of France (1364–1380). The vogue, which might have died of its own volition, only bloomed the more under the attacks. Charles condemned it as "an exaggeration against good manners, a scoffing against God and the Church, a worldly vanity and a mad presumption."

The absurd shoes became known as poulaines in France and crackowes in England, the first name after Poland and the second after Cracow, the then capital of Poland. Though shoes, boots and slippers all grew long toes, it should be kept in mind that many people wore round and pointed toes of normal length. And in spite of the remonstrances of temporal authority the ecclesiastics also adopted the fashion.

The flapping sound of the leer-pyp upon the pavement delighted the wearer as he walked. Frequently dandies had the toes held up by fine chains attached to garters at the knees and during the period when tiny silver bells, folly bells the English called them, decorated the costume, a tinkling bell adorned the upturned toe. Even the articulated sabbaton of the knight's armor was held up by a chain fastened at the knee.

In armor the points very often turned down, and it is told that when the Austrian knights in the Battle of Sempach in 1386 dismounted to continue

the battle on foot they were compelled to break off the long points to facilitate their movements.

Sumptuary laws regulated the length of toes in the following manner: a half foot to the commoner, one foot to a gentleman and two feet or more according to fancy was the privilege of the noble.

In the fourteenth and fifteenth centuries socklike inner shoes, usually of linen, were worn inside the leather or fabric shoes by both sexes. There was a walking boot to protect the delicate shoe in bad weather. Of fabric or leather, it was shod with a cork sole and was roomy enough to pull on easily. The leg section was held up by four whalebones and a ribbon loop at the top hooked over a button at the knee. There were "night boots" of heavy warm fabrics for house wear and fur boots for the clergy when performing nocturnal ceremonies in the cold churches.

We have the accounts of the shoemaker to the French King Charles VI for the year 1387 in which the king ordered twenty-one dozens of soft boots, plain and slashed, colored and black. For his queen we find recorded two pairs of high boots lined with linen from Reims and even more interesting is the note that the queen paid her own bills.

The gentry wore boots and shoes of velvet, cloth, silk, cordovan, boiled leather and kid while the peasants wore cowhide. Some boots were fur-trimmed, leathers were painted and gilded, the fabrics sewn with jeweled ornaments and the principal colors were red, black and white. Red was the predominant Medieval color for shoe and hose. The English poet Chaucer, writing at the end of the fourteenth century, notes that the "hosen" of the "Wife of Bath" were of "fine skarlet redde."

The masculine chausses fitted tightly up to the crotch, with eyelet holes around the edge through which they were laced to the doublet or short jacket. By the end of the century they covered the hips but not until the fifteenth century did they reach to the waist. Of the fourteenth and fifteenth centuries was the craze for parti-colored clothes and the leg partook of fashion in contrasting color and fabric sewn together, often each chausse and each shoe of a different hue. The hose were often gartered below the knee with handsome jeweled ribbons, a favored ornament being the jewel of one's order.

A blue-velvet ribbon, gold-edged and gold-buckled, is the leg adornment of the Order of the Garter, the highest order of knighthood in Great Britain. It was founded somewhere between 1344 and 1350 by Edward III, legend

tells us, when he picked up a lady's garter at a ball. The pretty Countess of Salisbury suffered great embarrassment when her garter dropped to the floor, but the young king retrieved it and returned it to the fair owner with the remark to the whispering guests: "Honi soit qui mal y pense." This tactful observation became the motto of the new order and was embroidered upon the garter which the honored knight members wear upon the left leg.

The sabot or wooden shoe fashioned from a solid block of wood was worn by the peasants of France and the Low Countries as early as the eleventh century. In feudal times when the peasants or vassals were unfairly treated by their overlords they sometimes avenged themselves by trampling their landlords' crops with their sabots, such destruction eventually designated as "sabotage."

A charming old Flemish custom is connected with the sabot, that of bearing Yuletide gifts in wooden shoes akin to ours of placing presents in stockings. The settlers observed the holiday in New Amsterdam, calling it Sankt Klaus, after Saint Nicholas the patron saint of children, a bishop of Myra in Asia Minor, who lived in the fourth century. On the eve of his birthday, December 5th or 6th, the children would place carrots or other dainties in their wooden shoes for his white horse. Next morning in return for the tidbits they would find toys and candy in the sabots. Christmas and the saint's day became a single fête day due to the proximity of the dates.

For comfort the peasants often stuffed their sabots with hay, and from this, when speaking of a man's wealth, came the saying that "his toes are stuffed with hay." There are other sayings founded on the sabot. To be "in sabots" signifies a destitute condition and "I hear you coming in your heavy sabots" means "I know your intentions."

The savate was a coarse common shoe with wooden sole, and in time the word came to mean an old shoe or a clumsy fellow, and finally the name of a French form of boxing in which kicking is permissible.

The modish fragile shoe of delicate color and material called for protection which was afforded by the wooden patten on mounts or the flat clog. When the patten entered the realm of fashion in the last quarter of the fourteenth century, it was very often gracefully carved with pedestals about three inches high. By the middle of the fifteenth century it was sometimes fastened to the sole of the soft leather shoe, foreshadowing the appearance of the true heel. There can be no doubt that the shaped mounts under heel and ball of the

foot led to the creation of the modern heel, which, however, was still a hundred years away.

Our shoe sizes which are measured in thirds of an inch date from the reign of the English King Edward II, specifically in the year 1324. The English inch was one-twelfth of the length of the normal foot, that is, the human foot, all ancient measurements having been derived from the human body. It was then found that three barley corns placed end to end equaled an inch and that thirty-nine barley corns or thirteen inches was the length of the longest foot. So thirteen became the largest shoe size with the smaller sizes graded down from that number. Shoe widths which are a modern deduction are figured one-sixteenth to the inch and other measurements in eighths of an inch.

Of these times is the fairy tale of Cinderella, which was later put into writing by the French author Charles Perrault, who lived from 1628 to 1703. He called his work *Tales of Mother Goose*. Later writers contended that the slipper was made of "vair," the French word for fur, not "verre," which meant glass. However, the theme is very ancient, since the early Egyptians tell a similar story which we have given in the Egyptian chapter.

By the **fifteenth** century, the climax and end of the Middle Ages, the shoes of the nobles had become pieces of rare beauty fashioned of the softest dyed leathers and costliest brocaded and embroidered fabrics. These works of craftsmanship were rated superior to the elaborate footwear of ancient Greece and Rome, and it was in this period that shoemaking was first dubbed "the trade of the gentle craft."

The vogue of the "piked shoon" continued unabated to the last quarter of the century, with some of the elongated turned-up toes squared at the ends. The ridiculous shoe was doomed in 1463, when Edward IV of England enacted a ruling to the effect that any cobbler or cordwainer who made shoes or boots for "unprivileged" persons with toes more than two inches long should "suffer the pain of cursing by the clergy" and forfeit twenty shillings, one part to be paid to the king, another part to the cordwainers of London and the third to the Chamber of London. In France, too, in 1470 the shoemakers were prohibited from making the controversial shoe. About 1480, pikes or beaks went out of fashion, disappearing by the end of the century, and a contemporary writer deplored that "the good times were during the poulaine mode."

As so often happens, fashion then ran to the other extreme, and toes became so broad that by the middle of the following century those in power were again passing sumptuary bills to limit the breadth of the toe.

In 1479 one notes the mention of "a peyr of slyppers." The word is a derivation of the old Anglo-Saxon slyke-sceo or slipper and was applied to "slip-shoes," which were easily slipped on or off. The French called leather slippers cordovans and when made of fabric soliers (souliers). The city of Lyons was famous for her embroidered slippers.

Round-toed slippers and mules were the go in velvet or satin, in vermilion, scarlet and violet, even cloth of gold covered with exquisite embroidery and sewn with pearls. Black slippers lined with red were very smart and when worn by the well-dressed man were accompanied by chausses of fine black cloth and "garters of sky blue ribbon embroidered with gold."

The handsome well-fitted hose came in for as much criticism as ever had the long, pointed toe. Of not so long ago was this Medieval fashion, when one recalls that at the end of the fifteenth century Christopher Columbus and Amerigo Vespucci landed on the shores of our continent wearing cloth chausses, ribbon garters and low-cut slippers. The long, tight stockings joined and became tights and this newer, more comfortable, form was generally adopted—in fact, the older fashion of separate legs was now considered indecent.

The parti-colored costume ended up as the livery of pages, servants and the court jester. For instance, the pages of the court of Louis XII (1498-1515) wore one yellow and one red hose, the upper section red on the yellow leg and yellow on the red leg. The pages of Anne of Britanny wore scarlet tops with one yellow and one black hose. And of Michelangelo, painter, sculptor, architect and poet (1475-1564), 'tis said that when old he wore his chausses of dog leather so long that patches of his skin came off when he finally took them off.

Nobles, soldiers and peasants all wore the long boots of brown cowhide reaching to the thighs. One of the many criminal charges against Jeanne d'Arc in 1431 was that she wore these boots, which evidently were for men only. They were made right and left, and a new feature was the cutting of the vamp separate from the leg. The welt, a rim sewn to the upper for attaching the sole, was known as far back as this period, but it remained for the eighteenth century with its sewing machine to bring the method into general usage.

The European peasant continued to wear houseaux or leggings of yellow felt or leather or of white linen for the lowest class. The English called them "sturtops" or "startups," hence a person risen from humble station was a startup. From this we have our word "upstart" for a parvenu. Too, the peasant still wore the primitive carbatine, the straps cross-gartered over his leggings or breeches.

The galosh with wooden or cork sole in low boot style continued to serve as a bad-weather shoe and the fifteenth-century pattens were shaped "à la poulaine" and very often made in one with the shoe. The gentry wore pattens made of aspen, and an English law passed in 1416 permitted the use of only such aspen "as was unfit for arrows." This act was repealed in 1603.

Unique to the brogue of the Scottish and Irish Highlanders and the origin of the decoration which typifies the modern brogue were the perforations and the pinked edges. Also unique was the manner of lacing the shoe with the thongs passing through slots formed by the turned-under edges in the very same fashion as today's gillie shoe. Of Scotch origin is the modern shoe, the name taken from "gillie," the boy attendant of gentry when hunting, who wore the very crude shoe.

The perforations were for a very practical reason—that of permitting the water to pass through the shoe when wading in the marshes or rivers. According to an earlier description brogues in the thirteenth century were still made of untanned skin with fur. Rawhide sandals or brogans were worn as late as the eighteenth century by seamen.

Sir Walter Scott included in his *Minstrelsy of the Scottish Border* a ballad to the souters or shoemakers of Selkirk. It was a tribute to the heroism of the Selkirk souters who in 1513 fought for their King James IV on the fatal field of battle. They were famous for a kind of brogue—"a single-soled shoon" —made with a thin sole, which the purchaser carried home and himself sewed on an additional heavy sole. The brogue was entirely put together with a thong of horsehide especially prepared for the purpose; neither wax, hemp nor bristles were used and for that reason it was considered much more durable.

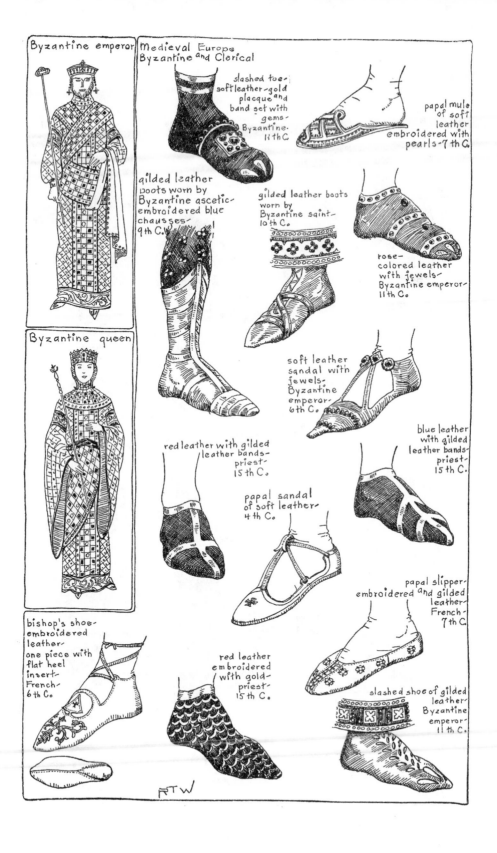

Byzantine emperor

Medieval Europe
Byzantine and Clerical

slashed toe-
soft leather-gold
placque and
band set with
gems-
Byzantine-
11th C.

papal mule
of soft
leather
embroidered with
pearls-7th C.

gilded leather
boots worn by
Byzantine ascetic-
embroidered blue
chausses-
9th C.

gilded leather boots
worn by
Byzantine saint-
10th C.

rose-
colored leather
with jewels-
Byzantine emperor-
11th C.

soft leather
sandal with
jewels-
Byzantine
emperor-
6th C.

Byzantine queen

blue leather
with gilded
leather bands-
priest-
15th C.

red leather with gilded
leather bands-
priest-
15th C.

papal sandal
of soft leather-
4th C.

papal slipper-
embroidered and gilded
leather-
French-
7th C.

bishop's shoe-
embroidered
leather-
one piece with
flat heel
insert-
French-
6th C.

red leather
embroidered
with gold-
priest-
15th C.

slashed shoe of gilded
leather-
Byzantine
emperor-
11th C.

RTW

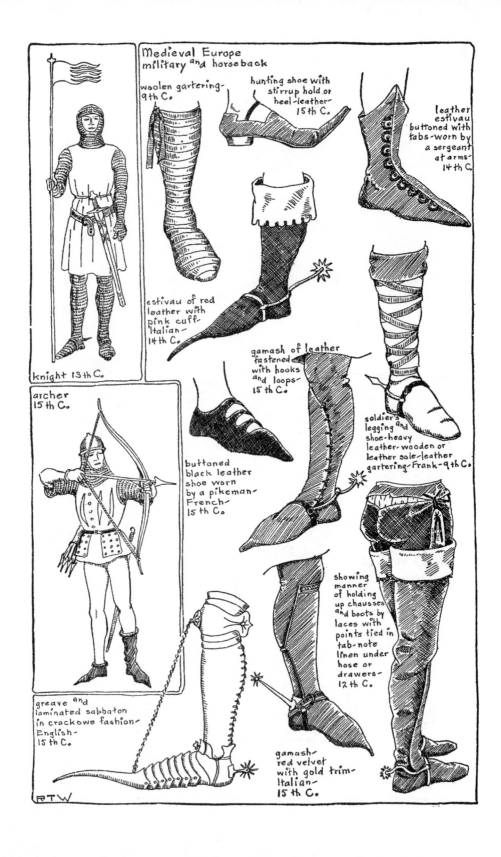

Medieval Europe
military and horseback

woolen gartering-
9th C.

hunting shoe with
stirrup hold or
heel-leather-
15th C.

leather
estivau
buttoned with
tabs-worn by
a sergeant
at arms-
14th C.

estivau of red
leather with
pink cuff-
Italian-
14th C.

gamash of leather
fastened
with hooks
and loops-
15th C.

soldier's
legging and
shoe-heavy
leather-wooden or
leather sole-leather
gartering-Frank-9th C.

buttoned
black leather
shoe worn
by a pikeman-
French-
15th C.

showing
manner
of holding
up chausses
and boots by
laces with
points tied in
tab-note
linen under
hose or
drawers-
12th C.

knight 13th C.

archer
15th C.

greave and
laminated sabbaton
in crackowe fashion-
English-
15th C.

gamash-
red velvet
with gold trim-
Italian-
15th C.

RTW

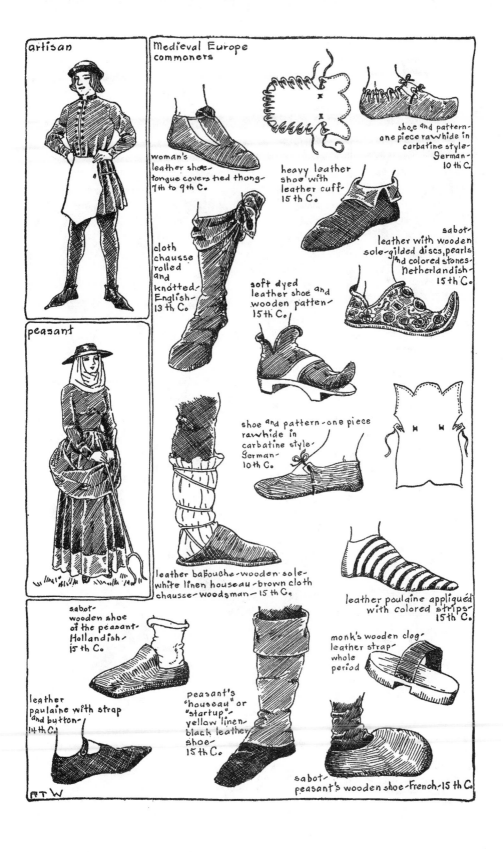

artisan

peasant

Medieval Europe commoners

woman's leather shoe- tongue covers tied thong- 7th to 9th C.

cloth chausse rolled and knotted- English- 13th C.

heavy leather shoe with leather cuff- 15th C.

shoe and pattern- one piece rawhide in carbatine style- German- 10th C.

sabot- leather with wooden sole-gilded discs, pearls and colored stones- Netherlandish- 15th C.

soft dyed leather shoe and wooden patten- 15th C.

shoe and pattern-one piece rawhide in carbatine style- German- 10th C.

leather babouche-wooden sole- white linen houseau-brown cloth chausse-woodsman- 15th C.

leather poulaine appliquéd with colored strips- 15th C.

sabot- wooden shoe of the peasant- Hollandish- 15th C.

monk's wooden clog- leather strap- whole period

leather poulaine with strap and button- 14th C.

peasant's "houseau" or "startup"- yellow linen- black leather shoe- 15th C.

sabot- peasant's wooden shoe-French-15th C.

RTW

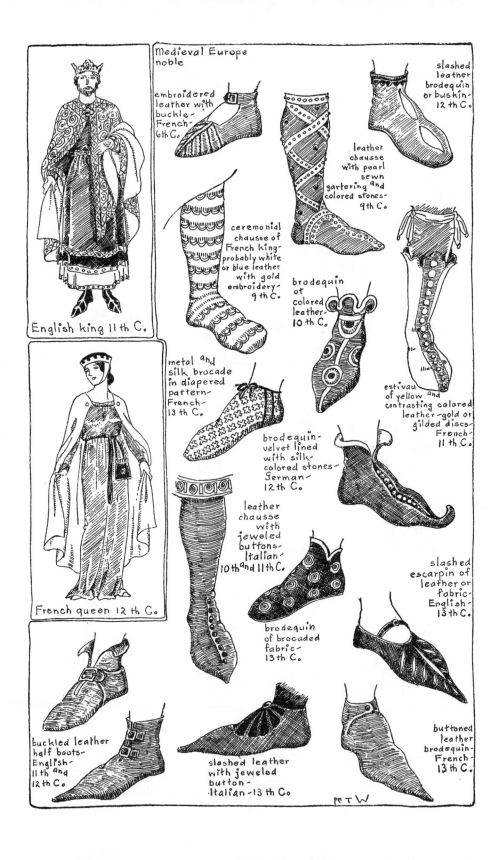

English king 11th C.

French queen 12th C.

Medieval Europe noble

embroidered leather with buckle- French- 6th C.

slashed leather brodequin or buskin- 12th C.

leather chausse with pearl sewn gartering and colored stones- 9th C.

ceremonial chausse of French king- probably white or blue leather with gold embroidery- 9th C.

brodequin of colored leather- 10th C.

estivau of yellow and contrasting colored leather- gold or gilded discs- French- 11th C.

metal and silk brocade in diapered pattern- French- 13th C.

brodequin- velvet lined with silk- colored stones- German- 12th C.

leather chausse with jeweled buttons- Italian- 10th and 11th C.

slashed escarpin of leather or fabric- English- 13th C.

brodequin of brocaded fabric- 13th C.

buckled leather half boots- English- 11th and 12th C.

slashed leather with jeweled button- Italian- 13th C.

buttoned leather brodequin- French- 13th C.

FTW

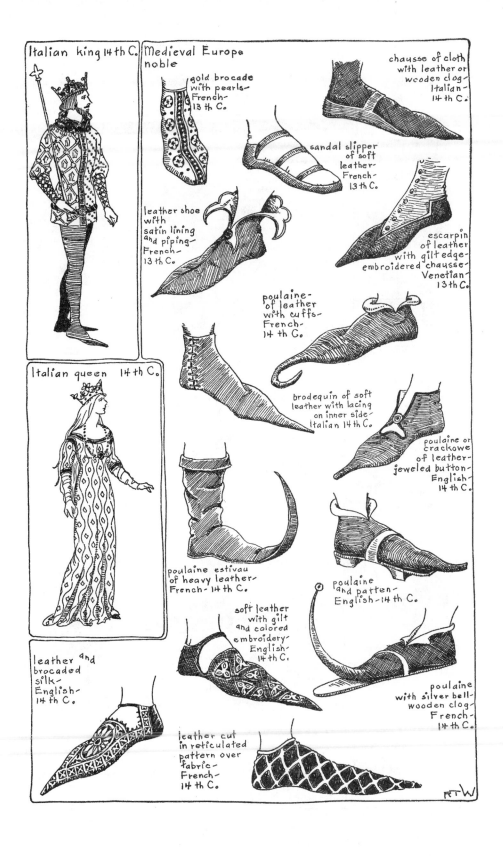

Italian king 14th C.

Medieval Europe noble

gold brocade with pearls- French- 13th C.

chausse of cloth with leather or wooden clog- Italian- 14th C.

sandal slipper of soft leather- French- 13th C.

leather shoe with satin lining and piping- French- 13th C.

escarpin of leather with gilt edge embroidered chausse- Venetian- 13th C.

poulaine of leather with cuffs- French- 14th C.

brodequin of soft leather with lacing on inner side- Italian 14th C.

poulaine or crackowe of leather- jeweled button- English- 14th C.

Italian queen 14th C.

poulaine estivau of heavy leather- French- 14th C.

poulaine and patten- English- 14th C.

soft leather with gilt and colored embroidery- English- 14th C.

leather and brocaded silk- English- 14th C.

poulaine with silver bell- wooden clog- French- 14th C.

leather cut in reticulated pattern over fabric- French- 14th C.

RTW

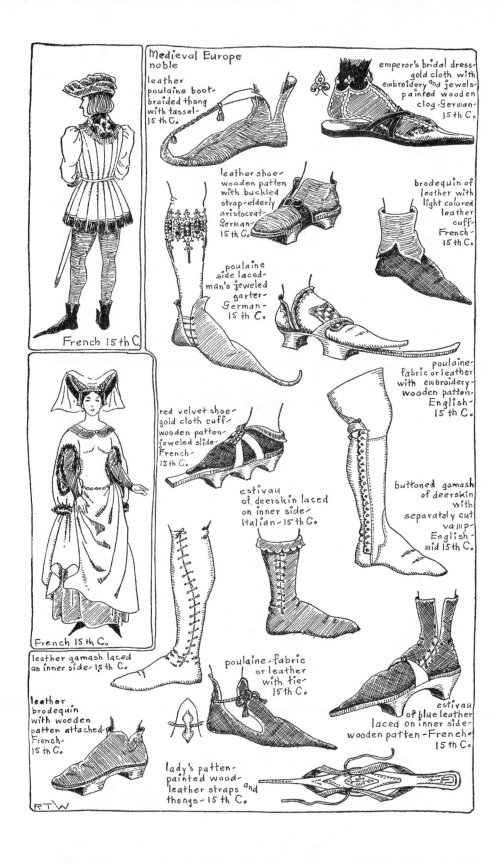

Medieval Europe
noble

leather
poulaine boot-
braided thong
with tassel-
15th C.

emperor's bridal dress-
gold cloth with
embroidery and jewels-
painted wooden
clog-German-
15th C.

leather shoe-
wooden patten
with buckled
strap-elderly
aristocrat-
German-
15th C.

brodequin of
leather with
light colored
leather
cuff-
French-
15th C.

poulaine
side laced-
man's jeweled
garter-
German-
15th C.

poulaine-
fabric or leather
with embroidery-
wooden patten-
English-
15th C.

French 15th C.

red velvet shoe-
gold cloth cuff-
wooden patten-
jeweled slide-
French-
15th C.

estivau
of deerskin laced
on inner side-
Italian-15th C.

buttoned gamash
of deerskin
with
separately cut
vamp-
English-
mid 15th C.

French 15th C.

leather gamash laced
on inner side-15th C.

poulaine-fabric
or leather
with tie-
15th C.

leather
brodequin
with wooden
patten attached-
French-
15th C.

estivau
of blue leather
laced on inner side-
wooden patten-French-
15th C.

lady's patten-
painted wood-
leather straps and
thongs-15th C.

RTW

MEDIEVAL GUILDS AND PATRON SAINTS
CHAPTER TWELVE

THE BANDING together of workers in groups such as the Medieval societies, colleges, guilds, corporations and brotherhoods was not new. Like organizations probably existed in biblical times, but we know definitely that they were part of Greek and Roman artisan life. The legendary king of Rome, Numa, whom historians place at 714 to 671 before Christ, arranged the arts and crafts into groups of shoemakers, tanners, ironworkers, dyers, carpenters, goldworkers, musicians, and so on. And in Italy and the provinces in the third century A.D. the Roman Emperor Alexander Severus organized the shoemakers as well as all the trades.

The reason for the formation of groups of workers has always been more or less one of mutual interest and perfection of the craft, solidarity and charity. But of not less importance were the periodic assemblies, pageants and banquets which the members held. An old English proverb says, "Cobblers and tinkers are the best of ale drinkers."

In the heyday of guilds and corporations the fête day of the patron saint was celebrated with great pomp. Pageants and theatrical performances given in the chapels and the meetings of the societies were dramatic representations of events in the lives of the saints.

79

As the new religion of Christianity took hold over the centuries many of its followers died in martyrdom for their belief and some outstanding victims were enshrined as saints. Like the ancients with their pagan gods and idols, the Christian artisans formed themselves into groups, a separate society for each craft and each body placing itself under the protection of a chosen saint.

Of the shoemakers' patron saints, Saint Crispin and Saint Crispianus are best known, but in some countries the Saints Anien and Damien are the ones revered. Some writers cite Saint Anien as the first protector of shoemakers and say he lived a full two hundred years earlier than the Saints Crispin and Crispianus.

Saint Anien became a convert to Christianity while a shoemaker after a visit from the disciple Mark. He was baptized and Mark made him a bishop in Alexandria because he was unusually eloquent in preaching his faith. When Mark died Anien remained head of the bishopric in Alexandria until his death November 26 in the year 86 of our era. Later a magnificent church was built in his memory with a special chapel for shoemakers. His birthday was celebrated for a long time by some German corporations.

In the third century of the Christian era two brothers, Crispin and Crispianus, the sons of a prominent and wealthy Roman family, traveled to Gaul to preach the gospel to the worshipers of the Roman pagan gods.

They settled in France at Soissons, where they met with cruel persecution but succeeded in making many converts. In need of funds for their living they learned the cobbler's trade and made sandals for the poor. Finally the Roman governor of Belgic Gaul, enraged at their religion and their preaching, condemned them to death by torture. They were beheaded November 8 in 287 or 288 on a plain near Soissons since called Saint-Crépin-en-Chaye.

According to legend the bodies were buried by an aged peasant and his wife under his own house, which became a place of devotion for pilgrims. Then about 649 the relics of the two brothers were placed in a crypt by the bishop of Soissons, this crypt becoming later the foundation of the Benedictine Abbey.

During the ravages of the Normans in the ninth century the Benedictines sent the relics to Mons for safekeeping and several centuries later, in the twelfth, so the tale goes, the relics were returned to the original resting place. The church erected there in 1142 and known as Saint Crispin the Great con-

tained a magnificent chapel for shoemakers. The edifice was demolished by German shells in World War I.

Saint Crispin became enshrined as the patron saint of shoemakers, tanners and saddlers, his fête day being observed by the shoemakers' corporations in many countries on the 25th of October. As to the remains of the two saintly brothers there is a divergence of belief in their resting place; the relics are claimed by some to be in the Church of Saint Laurent at Rome, by others in the Monastery at Leat near Toulouse or in the Abbey of Notre Dame at Soissons.

An English legend tells how Crispin and Crispianus, sons of an ancient British king and his queen, were sheltered at Kent in England where they made shoes for the poor. There Crispin fell in love with a princess whom he married and the birth of their son gave rise to the saying, "A Shoemaker's son a Prince is born." In every case the patron saints are of gentle birth and thus it was that the trade became known as "The Gentle Craft."

Another tale concerns "Saint Hugh's bones" and bears resemblance to the Crispin tale in some particulars. The son of one of the early Briton kings, he preached the gospel and converted men to Christianity by day and made shoes for the poor by night. In this story it is told that when his leather gave out more was miraculously furnished him by an angel. His martyrdom occurs in 287 A.D.

He lost his wealth in a shipwreck during his travels, and after taking up shoemaking he became so fond of his fellow workmen that he bequeathed his bones to them. He died a martyr, and after his bones had been "well picked by the birds" his friends removed them from the gallows and made tools of them. And that is why the appellation "Saint Hugh's bones" was given the bag of cobbler's tools, all of which are specified in the following old English rhyme:

> "My friends, I pray, you listen to me,
> And mark what Saint Hugh's Bones shall be:
> First a Drawer and a Dresser,
> Two wedges, a more and a lesser.
> A pretty Block, Three Inches high,
> In fashion squared like a die;
> Which shall be called by proper name
> A Heelblock, ah! the very same;

A Handleather a Thumbleather likewise,
To put on Shooe-thread we must devise;
The Needle and the Thimble shall not be left alone,
The Pinchers, the Pricking Awl, and Rubber Stone;
The Awl, Steel and Jacks, the Sowing Hairs beside,
The Stirrop holding fast, while we sow the Cow hide;
The Whetstone, the Stopping Stick, and the Paring Knife,
All this does belong to a Journeyman's Life;
Our Apron is the shrine to wrap these Bones in,
Thus shroud we S. Hugh's Bones in a gentle lamb's skin.

The cobbler's bag of implements that a traveling shoemaker carries is in this day called in France a "saint-crépin," the French spelling for Crispin. A poor fellow with very few worldly possessions is said to carry his saint-crépin on his back, and a very tight shoe is a "saint-crépin prison."

In the Middle Ages the formation of guilds took place among the commercial and industrial classes in France, England, Belgium, Germany and the Low Countries. A high standard of artistic craftsmanship was established and membership carried with it the privilege of citizenship. The members of guilds were divided into master, journeyman and apprentice.

In England as early as the reign of William the Conqueror (1066–1087) a tanners' craft guild was organized and chartered by royal decree. The existence of the Shoemakers of Rouen is confirmed by a charter issued by the English King Henry (1100–1135), who governed Normandy, and another was issued to the cobblers. Charters were granted by Henry II, also English (1154–1189), to tanners and furriers. In Göttingen a shoemakers' guild was formed in 1251, and in 1272 the Cordwainers' Company of London is recorded. 1304 is the date of the foundation of the Shoemakers' Guild in Ghent, while that of the Brotherhood of Paris Shoemakers is 1370.

RENAISSANCE FOOTWEAR
CHAPTER THIRTEEN

"Now for good lucke, cast an old shoe after me."—John Heywood, 1565

THE EUROPEAN RENAISSANCE sprang to life in Italy a good one hundred years before it reached north of the Alps. Its height is generally placed in the middle of the fifteenth century and the climax, a period of undreamed of prosperity and refinement, about 1500. When the French Kings Charles VIII (1483–1498) and Louis XII (1498–1515) invaded Italy they were astounded at the elegance and luxury they found there.

Yet, at the same time, one reads that Charles and his retinue were gorgeously attired on this trip, that even the hose of his halberdiers were of cloth of gold. While the French admired the rich simplicity of Italian dress the Italians were charmed by French courtliness; and thus it was that the Italian Renaissance had its effect upon western Europe.

The sixteenth century is also important in our own history. The French and Spanish, accompanied by Jesuit priests, came to the New World to establish colonies. The earliest date of an actual settlement is 1565, the founding of the Spanish post Saint Augustine in Florida. The colonizing attempts of the English Sir Walter Raleigh (1552–1618) took place in the latter part of the century. All these adventurers and explorers came to our

country wearing rich bombasted costumes with wasp waists, padded breeches, chausses or long, fitted hose with ribbon garters and low leather shoes with slashed toes.

From the letters of the explorers of the New Continent and some few drawings of the time, one gathers that the Indians along the Pacific coast from Alaska to Mexico and from Virginia south commonly went barefoot. Grass or fiber sandals were worn by the natives of Mexico, the southwest desert country and South America, while the northerners of upper Mississippi and New England locales wore moccasins and leggings.

The newcomers found the northern natives making use of a softly tanned deerskin in white, yellow, red and black for their moccasins and leggings, these worn by both sexes. De Soto, the Spanish explorer (1499-1542), described the beautifully dyed vermilion skins as resembling fine broadcloth, and the black, which was used principally for shoes, as brilliant.

The masculine legging reached to the thigh, where it was secured by being tied to the belt of the breech-clout. The feminine legging reached only to the knee, held by a string garter. In general, the moccasin resembled the primitive European shoe, the carbatine, in being fashioned of a single piece for the foot but differing in an additional flap or collar, which was worn up or down. The Indian of the forest wore a soft-soled shoe, while his plainsman brother fortified the sole with heavier leather.

The seams and flaps were adorned with embroidery of tiny beads of wampum and porcupine quills, but later the Indian, who was always eager for new ideas in dress, made use of the European beads.

And now back to the Europeans. The Italian scarpine (escarpine in French), the broad-toed, soft décolleté slipper, proved the death knell of the long-toed poulaine. Soleret it was called, because it resembled the armor foot-covering of thin articulated plates. Other names for the shoe were duck's bill, bear's paw and the German, cow mouth. The broad toe acquired astonishing width in the same manner that its predecessor had taken on such unbelievable length. Stuffing was again resorted to, the toes shaped into rolls by being stuffed with moss. Up north in France, Germany, the Low Countries and England the toe actually became square. By the middle of the century the English Queen Mary (1553-1558) must needs limit the width of toes to six inches.

The shoe is generally associated with Henry VIII (1509-1547) of Eng-

land and François I (1515-1547) of France, both reigning in the first half of the century. These two rulers inaugurated an era of extravagance and gorgeousness in costume. François loved fine clothes not only for himself but for his courtiers' ladies. It was he who changed the old court etiquette in which the ladies spent their time with the queen and the courtiers with the king. He liked being associated with gay, fashionable people and included the women in all festivities and sports, considering them an asset to the gatherings.

Of fine workmanship and varied style was the low-cut slipper, usually made with a bride across the instep. Delicate colors and violet were smart in leather, velvet, silk and other fabrics, some with "edges snipped like crab claws." One does, however, notice a greater use of leather.

Trunk hose, which were very short, puffed breeches, appeared in the early sixteenth century, causing a revolution in masculine leg-covering. They were the beginning of modern breeches and, at first, were made in one with stockings and separate for each leg. About the middle of the century some styles of trunk hose reached only to the knee, thereby creating two pieces of apparel for the man's leg, upperstocks or breeches and netherstocks or stockings. After that, hose were made long or short according to the upper stocks, and tied by points or garters at the knee.

There were many versions of trunk hose: Venetians, Spanish slops, full slops or galligaskins and short tubelike ones. The padded ones were stuffed with bran, horsehair, flocks and whatnot! And apropos the stuffing, there is the story of the young courtier whose trunk hose were rent by a nail and the bran poured from his finery to the great mirth of the ladies present. Such breeches were done in luxurious silks and velvets, slashed, paned and embroidered.

During this vogue for puffs, panes and slashes the broad slipper came in for its share of like decoration, the slashes over the toes filled in with taffeta puffings. The Swiss soldiers gave birth to the fashion when, to mend their ragged garments, they made use of the banners, tents and furnishings left on the field by the Burgundians routed in 1477. The style was indulged in to the greatest extreme by the lansquenets or German foot soldiers.

Hose were still tailored, cut and sewn of cloth and of such new fabrics as serge and etamine in vermilion, scarlet, white or black. The color most favored by the ladies appears to have been deep or pale scarlet, their stockings reach-

ing three inches above the knee and finished with a border of cut-out embroidery. Both sexes wore garters tied above or below the knee, but we are more familiar with the masculine leg encircled by ribbon garters with fringed ends, and set off with a costly jeweled ornament.

A perfect fit was the very first requirement in gentlemen's long hose; and one wonders why knitted hose were not thought of before this, but they did not appear much before the mid-century. The popes are known to have had precious knitted gloves, and an English act of 1553 enumerates "knitte hose, knitte peticotes, knitte gloves and knitte sleeves."

Knit hose of wool or silk had been made in Spain and Italy since the previous century but they were uncommon, as it is said that Henry VIII, who lived to 1547, wore silk stockings but rarely. A couple of items from his house books of 1517 reveal the purchase of "a yarde and a quarter grene velvete for stocks for a payr of hose for the kyng's grace" and "a purpul saten to cover the stocks of a payr of hose of purpul cloth of gold tissewe for the kynge."

The first knit silk stockings came from Spain, a country of great wealth and commanding position at this period. Her way of living, her dress and etiquette signified "the grand manner" to the other European courts. Very elegant indeed was her penchant for rich black fabrics, and black was the hue of the beautiful, fine and costly Spanish silk stockings. They were expensive enough to serve as a gift to a monarch, Sir Thomas Gresham, the English financier, presenting a pair to the young King Edward VI (1547–1553). In France the story is that Henri II wore them in 1559 for the first time at the wedding of his daughter.

Knit woolen hose made a debut in Elizabeth's reign (1558–1603) and a contemporary narrator tells the story: That an apprentice in London in 1564 seeing such a pair, which an Italian merchant brought from Mantua, borrowed them, copied them and presented the pair to the Earl of Pembroke.

Queen Elizabeth was presented with a black silk pair by her "silk woman," Mistress Montagne, who knitted them, and the queen was so delighted with the stockings that she said she would never wear cloth hose again. But silk stockings were not manufactured in England till the following century, though one of her subjects invented the first knitting and stocking frame.

He was the Vicar William Lee of Calverton in Nottinghamshire. Lee's stocking frame was the first machine to manufacture a knitted fabric; and thus was the origin of all later hosiery and lace mechanical-producing devices.

Certain features of his stockinger have never been improved upon. Lee's knitting frame produced a flat, straight-edged piece, but he soon found a way to shape the piece by manipulating the needles along the edges.

When, in 1589, he exhibited his invention to the queen she gave no encouragement because she feared the loss of work to her many subject hand knitters. Elizabeth really need not have been uneasy over the possibility of depriving the knitters of work because only the very wealthy could afford a pair of silk knit hose.

Lee carried his machine to France where Henri IV eagerly extended his patronage. At Rouen, in Normandy, Lee built up a prosperous industry, but the assassination of the French king brought on evil days. The Protestant Lee suffered persecution under the Catholic Marie de' Medici (1573-1642), and he died in prison in 1610. His group of workmen returned to England, leaving two men and one machine to carry on in France.

A well-known and amusing story concerns another queen. In this tale, a pair of the machine-knitted stockings was presented to the queen of Spain through the person of her ambassador. His haughty refusal of the gift was couched in the following words: "Take back thy stockings and name the thing not again, for know, O foolish sir, that the Queen of Spain hath no legs."

Silk, of course, was the thing but there were also knit hose of worsted, crewel, linen, jersey open-work and sewn cloth. And we read of bed stockings for winter wear. The Spanish hand knitters excelled in their product, a position they retained a long time. Marie de' Medici wore Spanish silk stockings in red, orange or purple, embroidered with the French crest or the French lilies. In the last quarter of the century ornamental motifs or clocks were embroidered over the seams in gold, silver and colored thread.

The word stocking, which appears first in the sixteenth century, derives from the Anglo-Saxon word "prican," to stick. And because the hose were "stock" or "stuck" with sticking pins, which we term knitting needles, hose eventually became stocken, then "stocken of hose" and, finally, stockings. Knee-length hose were just plain stocks.

Stockings became a general extravagance in the second half of the period, particularly in men's dress, and the following tirade from *Anatomie of Abuses* by the Puritanical writer Philip Stubbes, published in 1583, is thoroughly worth giving:

"Then have they nether stocks or stockings, not of cloth though never so fine, for that is thought too bare, but of Jarnsey, worsted, crewel, silk, thread and such like, or else at least of the finest yarn that can be got, and so curiously knit with open seams down the leg, with quirks and clocks about the ankles, and sometimes haply interlaced with gold or silver threads, as is wonderful to behold; and to such impudent insolency and shameful outrage it is now grown that everyone almost, though otherwise very poor, having scarcely forty shillings of wages by the year, will not stick to have two or three pairs of these silk nether-stocks, or else of the finest yarn that can be got, though the price of them be a royal, of twenty shillings, or more, as commonly it is; for how can they be less, whereas the very knitting of them is worth a noble or a royal, and some much more? The time hath been when one might have clothed all his body well from top to toe for less than a pair of the nether-stocks will cost."

And he rants further for the benefit of the weaker sex, "Their stockings in like manner are either of silk, Jarnsey, worsted, crewel, or at least of fine yarn thread or cloth as is possible to be had; yea, they are not ashamed to wear hose of all kinds of changeable colours as green, red, white, russet, tawney, and else what not. These thin delicate hosen must be cunningly knit and curiously indented in every point with quirks, clocks, open seams, and everything else accordingly."

Gentlemen protected their treasured silk hose with gamashes or gaiters of velvet, which buttoned or buckled at the sides or sometimes tied in back with narrow laces. Some very handsome ones were embellished with gold or silver embroidery. One must remember that travel was entirely by horseback and gaiters were very necessary coverings. The gaiter or gamash, as it is still called in rural England and Scotland, continues to be part of the Anglican bishop's dress, a reminder of the mode of travel of his predecessor. The peasants also covered their hose with leggings, but they were of durable linen or woolen cloth, of imperfect fit and usually tied round knee and ankle.

Parti-colored hose which ended up on the legs of pages, grooms and henchmen disappeared by the mid-century and, after the reign of Henry VIII, one no longer saw the jester in his costume of gay colors.

The costly and delicate escarpin necessitated cork-soled or wooden pattens when outdoors because of the unspeakable filth in the streets. The thick sole was also a protection against the cold, criers selling pattens in the

street advertising their wares as "soles to prevent cold to attach to boots." Too, pattens helped one's vanity in furnishing additional height to one's stature.

In the smart feminine world, the chopine became the rage. The chopine, which reaches back into antiquity, came to Europe from the Orient by way of Venice, that rich city-state whose importance ranked with Paris and London. Even before the Crusades Venice was engaged in enterprises in the East; and thus, from Turkey, came the "chapineys," high wooden stilts which were originally designed for sand and mud. Chopines were eagerly adopted by the Venetian ladies who traveled about in gondolas, walking little more than their chopine-wearing sisters of the harems.

When the Venetians did walk on their pretty stilts, which were hidden under their long skirts, they far outdid the northern ladies in the height and required the support of an escort or maid. The pedestals or "cow hoofs" were sometimes as high as thirteen inches. The chopine was especially popular in Italy and Spain. A contemporary French writer claims that the vogue in France was due to Anne of Brittany (1477–1514), the wife of two French kings, who found it possible to conceal a slight lameness by wearing the high wedge sole. Chopines were artfully made of wood and elaborately decorated with painted and gilded motifs, some encrusted with mother-of-pearl and other stones and others covered with leather or velvet.

The fashions of all periods have been now and then revived, but we cannot foresee the possibility of a chopine revival in this day and age, except for home and beach wear. And for several reasons: our smooth pavements, our fast-walking pace and, above all, the deadly speed of our mechanized traffic.

From the patten and the chopine, especially the chopine, came the idea of the modern heel. Heels were not new, having been in use for centuries back in the Orient for practical reasons. We have noted that the ancient Egyptian butcher wore heels when slaughtering cattle, the Persians used heels to raise the foot off the burning sand and the East Indian and Mongolian horsemen kept the foot in the stirrup by means of a small heel.

The modern heel was first worn at the Italian and Spanish courts; and when in 1533 the Florentine Catherine de' Medici went to France to marry the Duke of Orleans, he who became King Henri II, she carried shoes with heels in her trousseau. No doubt some smart Venetian lady and her shoemaker got the idea from the chopine. One writer suggests that it was the

invention of Leonardo da Vinci (1452–1519). That could very well be, since he was not only a great painter but sculptor, architect, musician, engineer, scientist and mechanic as well.

The cork wedge was the first form of the heel, placed between the leather sole and upper, and higher under the heel. Then the slipper with real heel evolved, but retained the sole of the clog. It was in this period that the gracefully curved heel known as the French or Louis XV heel first appeared. The masculine heel was of a medium height, usually of leather, and the shaped feminine heel of wood. The red heel, of Venetian origin, at this time of painted wood and which was to become the sign of the gentleman in the following centuries, first appeared late in the sixteenth century on the black leather shoes of royal valets and pages.

Heels changed the whole idea of shoemaking in that the flat shoe could be cut single, but the heel necessitated the shaping of a right and a left. The French had several descriptive names for the new shoe, such as chaussure à pont, à pont-levis and à cric, meaning bridge shoes, drawbridge shoes and clicking shoes, the latter because of the click made when walking.

Women had two new difficulties to master when walking on their toes, the mincing steps and the management of the farthingale or "cage" then in fashion. It was considered an art to walk moving the hips so that the hooped skirt would swing forward and backward. Another part of the gesture consisted in lifting the skirt to display the heeled foot and the silk stocking. The new ankle-length skirt also permitted a view of the costly foot tire.

Although black hose were the most fashionable, brilliant color was the rule in red, violet, blue and green. Women wore the same long stockings that men did, either gartered above the knee or attached by laces and points to a fitted underbodice. They also wore the shorter-length hose laced to "trunk hose," a piece of apparel to be later known as "drawers." Their garters were of ribbons, with those of fastidious ladies bejeweled and matching their bracelets.

The beautiful mistress of the French Henri IV, Gabrielle d'Estrées (1573–1599), whose short life was one of scandal and luxury, left a record of the purchase of shoes of pale-carnation color embroidered with gold, six pairs of green velvet slippers and eight pairs of divers other colors.

The Italian pantofola and the Venetian heeled slipper replaced the escarpine

in Elizabeth's time. Pantoffle was the English name for the mule, from the word of Greek origin, pantophellos. The root phellos tells us that these mules had cork soles. They were for lounging and outdoors, to protect the handsome fabric slipper.

Pumps are mentioned for the first time in the Elizabethan era. Pumps were thin-soled leather shoes worn principally by footmen, a reason which gave rise to the English fashion of calling such a servant "pumps."

It seemed as if in this period of discovery, exploration and settling of new lands shoes became more beautiful and extravagant than ever. Elizabeth was a decidedly dress-conscious person and her passion for elegant shoes equaled her love of exquisite gloves. Every youngster knows that Sir Walter Raleigh (1552–1618) laid his handsome cloak in the mud to save the pretty shoes of Good Queen Bess.

In the last quarter of the century the new style in shoes with tongues and side pieces called for latchets or straps and colored shoestrings, the latter tied in a lover's knot and eventually hidden under a shoe rose. This was the beginning of the costly, lavish vogue of the shoe rose of the following century. Shoe roses are still part of the picturesque costume of the Beefeaters of the Tower of London, the Guard Extraordinary that originated in the reign of Edward VI in the mid-century.

Looking over the expense accounts of the French King Charles IX (1560–1574), we find that he bought ten pairs of white moroccan slippers, six pairs in gray, blue, green, black and red, and all at forty sous the pair.

The boots of the period were confined to hunting, traveling and military use. They displayed a tendency to widen at the top, for pulling over the knee to meet the trunk hose, and were fastened with buckles, buttons and laces. Fabric boots for court wear, of brocaded velvet, were still occasionally worn but leather more and more fashioned the boot, especially deer and buckskin. White or pale gray was the height of the mode but smart too were black morocco and cordovan in "tawny Spanish" and "red Spanish."

The tops of some boots were scalloped or pinked for elasticity; others turned down, revealing a colored lining; and some boots acquired red heels. Startups, leggings of linen or cloth, continued to form part of the costume of English rustics.

"To be put to the boots" was a form of torture of the sixteenth and seventeenth centuries. It was practiced to extort information from suspected

persons, and originated in Scotland. The boot, made of iron, wood, or both, was fastened to the leg. A wedge was then placed between boot and leg, usually against the calf, and driven down by blows from a mallet. The prisoner was questioned after each blow, the blows repeated until the man confessed or fainted. Another form consisted of an iron boot which was heated upon the leg; and there was a leather boot put upon the leg when wet and dried by fire. "Spanish boots" was a like form of torture used in the Spanish Inquisition and in Germany.

The galosh in leather, with wooden sole in boot or low-shoe form, continued to be the general foot-covering for the poor, particularly in winter. The work shoe of the peasants in France and the Low Countries was the clumsy sabot, shaped from a solid block of wood. Cleverly carved and painted shoes were worn for dress. They were a facsimile of the pumps and heeled shoes of the wealthy, even finished with shoe roses. Such shoes were worn especially in France and England and continued part of French peasant dress to the twentieth century.

The ladies of the harems of the Near East wore slippers and boots of morocco leather, as did the Turkish man of rank. They were peaked-toed and in beautiful colors—red, blue, yellow and purple. Feminine footgear was flat, but the masculine shoe had a heel shod with iron. When indoors, the Turkish woman discarded her slippers, revealing her toes henna-stained like her fingertips. Her pair of clogs was at hand if wanted, of decorated wood with a wide velvet bride in red or blue embroidered with glittering stones.

The Slavic peoples all wore the peaked toe, but the nobles wore the shoes and boots of modish Europe. The poor people still went about in the footwear of antiquity, sandals of matted bark of trees, with coarse cloth stockings or bandelettes of woolen cloth. An ancient peasant piece of Russian footwear for summer and indoors, and worn today, is a low, flat slipper of plaited straw, fabric or leather. Fashioned like a babouche, it is secured by long flat bands cross-gartered up the leg over a heavy white felt stocking.

The boots of wealthy Slavs, both men and women, and worn to modern times, were of colored morocco in red, yellow or violet, the leg often of velvet or satin embroidered with brightly colored motifs encrusted with simulated jewels. The small heel was reinforced with a crescent of steel, copper or silver and the sole studded with nails. While the metal-shod sole facilitated walking over snow and ice, it also provided the cadence of the music for

their stirring national dances. Horsemen carried their cutlasses in the leg of the boot.

Going farther north into the Arctic Finlandic region, we note in contemporary drawings the natives wearing snowshoes of wood or of bone covered with leather. Snowshoes were in use for traveling and hunting over frozen lands by the Lapps, Finns, Scandinavians and Mongols of northwestern Asia for centuries before the Christian era. The long boatlike wooden shoe with pointed upturned toe of the sixteenth century is the first pictorial record of the ski, derivative of the Icelandic word "scidh," meaning a piece of wood. The wooden shoe or slider, which was worn by men and women, was usually about three feet in length but sometimes measured as long as eight feet, and enabled the wearer to attain the speed of animals in gliding over the ice.

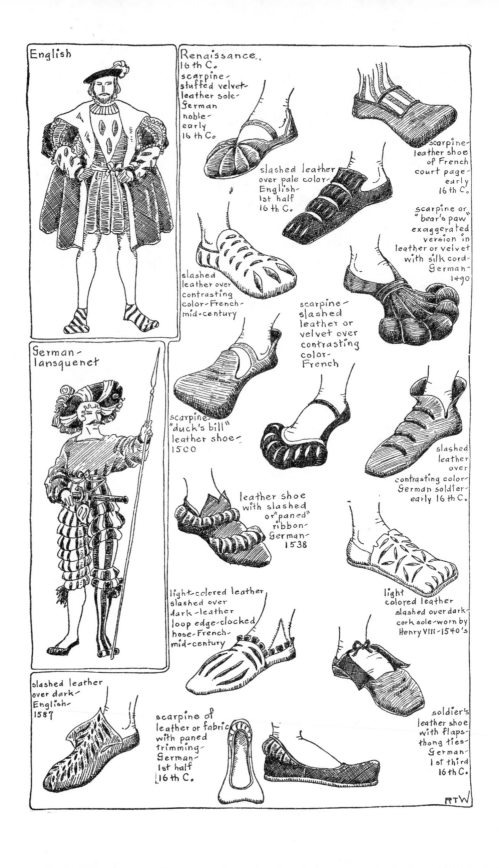

English

Renaissance.
16th C.
scarpine-
stuffed velvet-
leather sole-
German
noble-
early
16th C.

slashed leather
over pale color-
English-
1st half
16th C.

scarpine-
leather shoe
of French
court page-
early
16th C.

scarpine or
"bear's paw"
exaggerated
version in
leather or velvet
with silk cord-
German-
1490

slashed
leather over
contrasting
color-French-
mid-century

scarpine-
slashed
leather or
velvet over
contrasting
color-
French

scarpine-
"duck's bill"
leather shoe-
1500

slashed
leather
over
contrasting color-
German soldier-
early 16th C.

leather shoe
with slashed
or "paned"
ribbon-
German-
1538

German-
lansquenet

light-colored leather
slashed over
dark-leather
loop edge-clocked
hose-French-
mid-century

light
colored leather
slashed over dark-
cork sole-worn by
Henry VIII-1540's

slashed leather
over dark-
English-
1587

scarpine of
leather or fabric
with paned
trimming-
German-
1st half
16th C.

soldier's
leather shoe
with flaps-
thong ties-
German-
1st third
16th C.

RTW

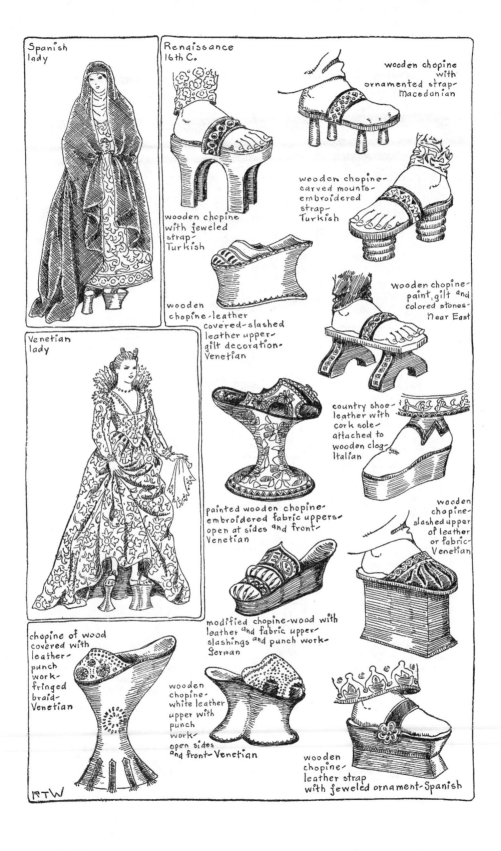

Spanish lady

Renaissance 16th C.

wooden chopine with ornamented strap-Macedonian

wooden chopine with jeweled strap-Turkish

wooden chopine-carved mounts-embroidered strap-Turkish

wooden chopine-leather covered-slashed leather upper-gilt decoration-Venetian

wooden chopine-paint, gilt and colored stones-Near East

Venetian lady

country shoe-leather with cork sole-attached to wooden clog-Italian

painted wooden chopine-embroidered fabric uppers-open at sides and front-Venetian

wooden chopine-slashed upper of leather or fabric-Venetian

modified chopine-wood with leather and fabric upper-slashings and punch work-German

chopine of wood covered with leather-punch work-fringed braid-Venetian

wooden chopine-white leather upper with punch work-open sides and front-Venetian

wooden chopine-leather strap with jeweled ornament-Spanish

RTW

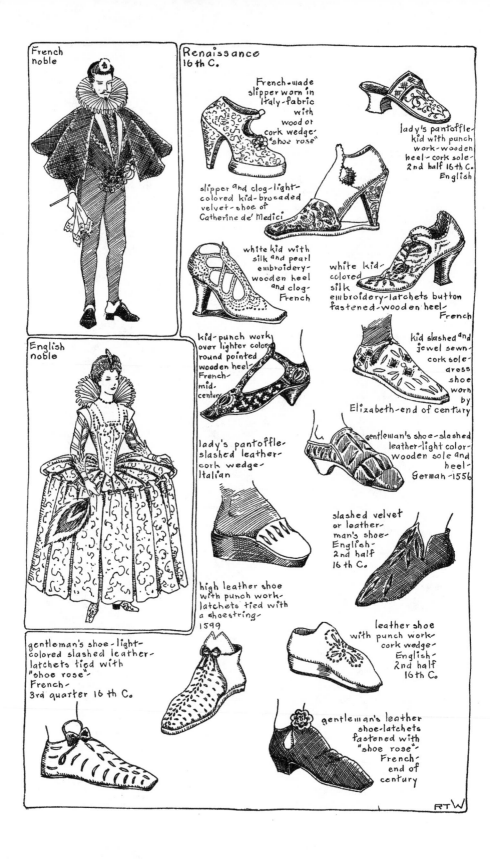

French noble

Renaissance 16th C.

French-made slipper worn in Italy - fabric with wood or cork wedge - "shoe rose"

lady's pantoffle - kid with punch work - wooden heel - cork sole - 2nd half 16th C. English

slipper and clog - light-colored kid - brocaded velvet - shoe of Catherine de' Medici

white kid with silk and pearl embroidery - wooden heel and clog - French

white kid - colored silk embroidery - latchets button fastened - wooden heel - French

kid - punch work over lighter color round pointed wooden heel - French - mid century

kid slashed and jewel sewn - cork sole - dress shoe worn by Elizabeth - end of century

lady's pantoffle - slashed leather - cork wedge - Italian

English noble

gentleman's shoe - slashed leather - light color - wooden sole and heel - German - 1556

slashed velvet or leather - man's shoe - English - 2nd half 16th C.

high leather shoe with punch work - latchets tied with a shoestring - 1599

leather shoe with punch work cork wedge - English - 2nd half 16th C.

gentleman's shoe - light-colored slashed leather - latchets tied with "shoe rose" - French - 3rd quarter 16th C.

gentleman's leather shoe - latchets fastened with "shoe rose" - French - end of century

RTW

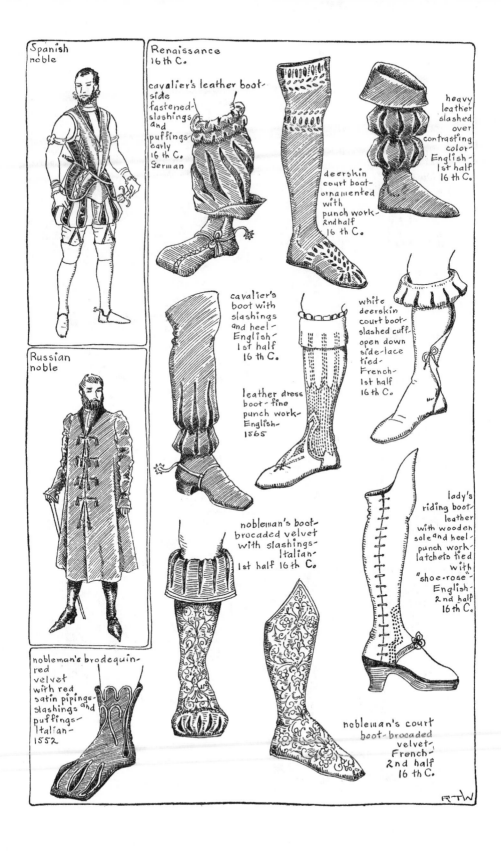

Spanish
noble

Russian
noble

nobleman's brodequin-
red
velvet
with red
satin pipings-
slashings and
puffings-
Italian-
1552

Renaissance
16th C.

cavalier's leather boot-
side
fastened-
slashings
and
puffings-
early
16th C.
German

heavy
leather
slashed
over
contrasting
color-
English-
1st half
16th C.

deerskin
court boot-
ornamented
with
punch work-
2nd half
16th C.

cavalier's
boot with
slashings
and heel-
English-
1st half
16th C.

white
deerskin
court boot-
slashed cuff-
open down
side-lace
tied-
French-
1st half
16th C.

leather dress
boot-fine
punch work-
English-
1565

nobleman's boot-
brocaded velvet
with slashings-
Italian-
1st half 16th C.

lady's
riding boot-
leather
with wooden
sole and heel-
punch work-
latchets tied
with
"shoe-rose"-
English-
2nd half
16th C.

nobleman's court
boot-brocaded
velvet-
French-
2nd half
16th C.

R.T.W.

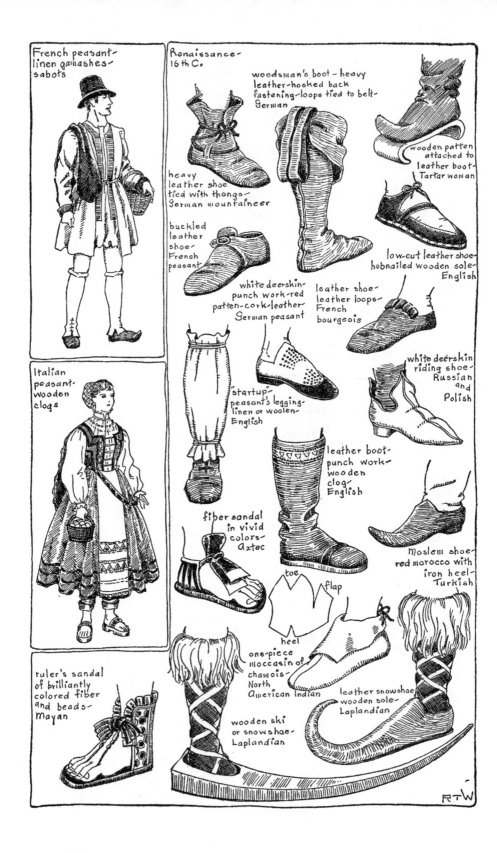

French peasant-
linen gamashes-
sabots

Italian
peasant-
wooden
clogs

ruler's sandal
of brilliantly
colored fiber
and beads-
Mayan

Renaissance-
16th C.

woodsman's boot - heavy
leather-hooked back
fastening-loops tied to belt-
German

heavy
leather shoe
tied with thongs-
German mountaineer

buckled
leather
shoe-
French
peasant

wooden patten
attached to
leather boot-
Tartar woman

low-cut leather shoe-
hobnailed wooden sole-
English

white deerskin-
punch work-red
patten-cork-leather-
German peasant

leather shoe-
leather loops-
French
bourgeois

white deerskin
riding shoe-
Russian
and
Polish

"startup"
peasant's legging-
linen or woolen-
English

leather boot-
punch work-
wooden
clog-
English

fiber sandal
in vivid
colors-
Aztec

toe

flap

heel

Moslem shoe-
red morocco with
iron heel-
Turkish

one-piece
moccasin of
chamois-
North
American Indian

wooden ski
or snowshoe-
Laplandian

leather snowshoe-
wooden sole-
Laplandian

RTW

SEVENTEENTH-CENTURY FOOTWEAR
CHAPTER FOURTEEN

THE SEVENTEENTH CENTURY carries our chronicle to America, with a group of English planters arriving in 1607 and building a fortified village in Virginia, a settlement they named Jamestown. Of the company of one hundred men many were Cavaliers, wearing the very latest mode—farthingale breeches, silk stockings, low shoes with shoe roses, or boots with "French falls" and frilled, lace-edged, linen boot hose. Very important was the boot to the Virginia planter, who practically lived in the saddle.

The Dutch settled New Netherlands in 1614, the Pilgrims landed at Plymouth in 1620 and the Massachusetts Bay Colony group came in 1628. The Pilgrim Colony was poor, having already spent an exile of twelve years in Holland, a very good reason for their plain clothes. The Massachusetts Bay Puritans comprised a wealthy organization, and each one of the one hundred men was furnished with an adequate wardrobe. Each man came with four pairs of shoes and shoes of the best quality: "Well Neat Leather shoes crossed on the outside with seams. To be good substantial over-leather

of the best, and two soles; the under sole of neats-leather, the outer sole of tallowed backs."

In general, the early colonists dressed as they dressed in Europe, wearing their best clothes on Sundays and important occasions and their simpler, more sturdy clothes every day and for work, even to the use of wooden-soled shoes. The mode did not change with the frequency of modern times, but the mode was carefully followed, and a plain elegance and richness of fabric were very important features. Eventually, the many English ships, making frequent trips from London, were to bring fine clothes made upon order, wigs from the fashionable wigmakers and many household comforts and luxuries.

Though simplicity in apparel was preached by the religious leaders, only a few fanatics fully observed the teachings. The Puritans came here in search of freedom; but the bigots among them almost immediately instituted and practiced religious intolerance, and laid down sumptuary laws to control individual dress. Offenders were severely punished. Among the many persecutions one reads that in 1652 a certain man "was presented for excess in bootes, ribands, gould and silver laces, and Ester Jynks for wearing silver lace." In sharp contrast was the Dutch settlement of New Amsterdam, with its religious freedom and no dress restrictions. This freedom of thought and dress lured many of the discontented individualists from the New England colonies.

This is the century in which the art of shoemaking had its beginning in the New World. In 1629, on the third trip of the *Mayflower* to these shores, came Thomas Beard, a shoemaker from Saint Martin's, London, accompanied by his famous apprentice, Isaak Richman. With them they carried the tools of their craft and a supply of leather. Beard settled down to making shoes in Salem, Massachusetts, that locale thereby becoming the birthplace of the American shoe business. The new country not to his liking, Richman eventually returned to England while Beard, after fourteen years in Salem, moved to Portsmouth in New Hampshire.

The first tanner to settle in America was Francis Ingalls, of Lincolnshire, England. He arrived in 1630 and settled in Lynn, Massachusetts. These craftsmen were followed in 1635 by Henry Elwell and Philip Kirkland, both shoemakers. This group laid the foundation of a manufacturing business in our country which, in a few centuries, was to surpass in volume and perfection the making of shoes in all history. They also taught the colonists how to

make utility footwear, a not too difficult job, since the ordinary shoe was indeed a crude affair, fashioned "straight," that is, neither right nor left.

Families were large, foot-covering was a vital necessity and the colonists spent many of their long winter evenings making shoes in the large living-room kitchen. A father would apprentice his son to a master shoemaker, who would teach the boy the craft in return for the young fellow's services or other considerations or, perhaps, some cash. There also developed the journey-man shoemaker, who traveled from farm to farm carrying his kit of tools and leather, equipped to repair the old and to make new shoes.

The itinerant shoemaker did not confine his services to just shoemaking either. He was also proficient in pulling teeth, cutting hair, sharpening tools and whatnot. And very, very important were the news and gossip which his traveling about furnished. His yearly visit to a farm was no doubt eagerly looked forward to and planned for. His pay, whether working in his own shop or working out, was limited to twelve pence a day under the Massa-chusetts laws of 1633.

The wealthier colonists were not so frugal, sending their lists for new clothes and shoes periodically to England. And others, with large landhold-ings, kept their own shoemakers on their estates. In a tract sent out by England to lure people to the colony of Virginia, a bit of propaganda, de-scribing an English lord's plantation in America, runs thus: "He sows yearly stores of hemp and flax, and causes it to be spun, he keeps weavers and hath a tan house, causes leather to be dressed, hath eight shoemakers employed in their trade."

It did not take long for the settlers to recognize the superiority of the footgear of the American Indian and, particularly, the comfort it afforded the woodsman. The friendly Indians taught the newcomers to make moc-casins, which became so popular that, by the middle of the century, great quantities were being shipped to England. The Indian legging was also adopted, proving not only a most comfortable substitute for stocking and shoe in winter but an ornamental accessory.

Moccasins and leggings were made by the Indian women, who were excellent tailors. The foot-piece of the eastern Indian was of one piece, while the plains Indian preferred a shoe fashioned of two pieces, a soft one for the upper and a strong hard piece for the sole. Porcupine quills cut into tiny beads and dyed with brilliant vegetable colors and wampum beads made

from shells ornamented the seam and the flaps. The embroidered motifs were founded upon traditional beliefs, and the cut of the shoe varied with each tribe, so that the settlers could very often designate the Indian's tribe by his footwear. The plain moccasin was worn every day, the ornamented one saved for dress.

Indian leggings or "leather stockings" were indeed picturesque and practical attire. The leather, reaching from ankle to the middle thigh, was usually shaped to the leg, and held up by a thong tied to the belt of the breech-clout. The seams were exposed to the outside with fringed edges and decorated with embroidery like the moccasin. Young warriors liked their leggings form-fitting, the women sewing the coverings up on the legs where they often remained until reduced to rags.

The leggings, which protected the horseman's legs from trees and brush, have ever remained part of the plainsman's or western cowboy's outfit. Chaparajos, or "chaps" as they call them, are strong leather breeches or overalls open in back.

The Indian tanned deer and buckskin to the consistency of the finest chamois with the use of animal brains, a secret which he gave the colonist. Men, boys, servants and workmen found leather jackets and breeches comfortable and durable. Leather was also used for pails, pitchers, bottles, tankards and drinking cups. Very substantial containers were made of heavy black leather, waxed and often tipped with silver.

Tanneries began to appear, and in 1668 Massachusetts got to work separating the industry of tanning from that of currying and shoemaking. A charter was granted by the Colony of Massachusetts Bay in 1648 to the "Shoemakers of Boston," really the first American guild, and by 1676 Lynn was the center of the shoe-manufacturing business.

The Indians in the warmer climate of the South and the Southwest wore grass or fiber sandals. Going centuries back we know that the Arizona cliff dwellers, the ancestors of the Pueblo Indians, also wore a vegetable sandal. The sole was fashioned of yucca leaves, with an insole of corn husks. Marginal loops of braided grass around the edge were threaded with strings which were drawn up and tied round the leg.

And now, back to Europe, where the modish dress of the day originated, and where footgear reached a great elegance and extravagance, the like of which could be seen in the new colonies. Outstanding in masculine attire

was the boot. In the earliest decades, when worn with the very short French mellon hose or breeches, it fitted snugly. Made of soft, supple leather, it was so tight-fitting that the dandy would soak his legs and feet in cold water before dressing in order to reduce the size. Evidently stockings were not worn under such boots, because in a satirical poem of the period the boots are described with the comment "that they save the wearer all sorts of silk stockings."

The tight-fitting boot was made of Russian leather, a soft skin with the rough side turned out. Henri IV of France (1589–1610) sent a tanner to the Danubian provinces to study the process of dressing leather for which the craftsmen of Hungary were famous. The workman succeeded in bringing back the secret of preparing this particular kind of boot leather. His name was Roze, prompting the French to call the leather "cuir de roussy" but which became generally known as Russian leather.

Henri practically lived in his camp boots and in compliment to a favorite groom he even wore his boots in his Louvre apartment. This occurred in 1608, but English gentlemen had already been appearing booted indoors for some two years. The next move was the wearing of boots to balls, necessitating the raising of the spur rowels to prevent their catching in the women's skirts. "Horseless horsemen," some wit said; and the Spanish ambassador to the court of James I (1603–1625) wrote home that all Englishmen appeared ever ready for departure, being booted and spurred.

Breeches lengthened to the knees and longer, those to the knees called slops and the longer ones pantaloons. The latter, worn in the 1630's, acquired the name pantaloon by way of Venice, where, for a long time, the common man of the republic wore long, full breeches, which aroused the mirth of foreigners. Pantalon, the comedian of the Venetian stage, adopted the amusing garb; thus furnishing the origin of the word pantaloons.

Low boots appeared about 1625, accompanying the long breeches of the élégant; the boot, at first, a simple style, spreading at the top, and called funnel or bucket top. Then came those astounding, fashionable boots, with the wide tops folded down, known as "French falls." They were of buff leather, heavy but pliant, with the courtier flaunting his social position by his red heels and sole edges. Light colors were the rage: in beige, yellow, pale blue and, very often, white, the most general color buff. These are the boots we picture the Cavalier and the musketeer wearing in Dumas' exciting

tales. But when the Cavaliers practiced their prowess with the sword at the Académie of Arms in Paris, they wore slippers with soles of beaver which they protected with pantoffles or galoshes when going outdoors. Pattens or clogs were quite usual with boots and sometimes attached to the boot.

The frivolous, wide boot top consumed so much leather that in London in 1629 the leather workers of other trades than shoes petitioned Parliament to restrict the making of boots. The common wearing of boots was condemned in the following preamble: "For the general Walking in Boots it is a Pride taken up by the Courtier and is descended to the Clown. The Merchant and Mechanic walk in Boots. Many of our Clergy either in neat Boots or Shoes and Galloshoes. University Scholars maintain the Fashion likewise. Some Citizens out of a Scorn not to be Gentile go every day booted. Attorneys, Lawyers, Clerks, Serving Men, All Sorts of Men delight in this Wasteful Wantonness."

Courtiers were extravagant fellows in the size of their wardrobes. Of note was that of the Marquis Cinq-Mars (1620–1642), a young favorite of Louis XIII, who became grand master of the royal wardrobe and grand master of the horse. He owned no less than three hundred pairs of boots, causing the king to remark that a kingdom would not suffice for the young man's expenses. He met an early death upon the scaffold for conspiring against Richelieu.

To add to the fashionable bulky leg, large quatrefoil spur leathers over the instep concealed the fastenings of the spurs. Boots were especially affected by young blades, who delighted in a military air and the accompanying clanging sound. The spurs were gilded, and the large rowels of fantastic shapes had additional jingles attached, to increase the pleasing clanking noise. Some lines of the poem written in 1600 go as follows:

"How cocke-taile proude he doeth his head advance!
How rare his spurs do ring the morris-dance!"

And this is not the whole story of the Cavalier boot! One fine young gentleman had sage placed between the soles of his boots; the chronicler wondering whether for its perfume or as a health measure. The "smart" or "top" wore boot hose to protect his costly silk hose. Boot hose were of sheer-white linen, finished with deep frills of fine lace and gold and silver embroidery, the frills falling over the tops of the boots. More serviceable hose

were of colored cloth or thin deerskin, and sometimes the boot tops were lined simply with the frills minus the hose. All this fashionable exaggeration around the calf of the leg compelled the wearer to adopt a gait or stride which the satirists of the day termed the "Cavalier swagger." Boots with falling tops were not spurned by the Puritans, who, during the Commonwealth, wore them shorn of trimming.

By 1660 the vogue of the frilly boot, or as a French writer put it, the "bastard boot," had greatly dimmed. It was relegated to its original place on the foot of the horseman and the cavalry officer. By mid-century leather boots began to replace the jambs or leggings of armor. The hunting boot was brown while black became regulation for military use. Boots lost their red heels, low shoes retaining that sign of aristocracy; in fact, the term "red heels" became the sobriquet for the seventeenth- and eighteenth-century noble.

The soft, shapely boot was replaced by the hard, shiny black, clumsy cowhide boot known by various names: such as, great boot, strong boot, kettle or jack boot. It was built to last a lifetime. In Massachusetts, when the boot first came into fashion, the wearing was a privilege enjoyed only by the gentleman with an income which met the requirements of the laws of that colony. Its most popular name—that of jack boot—came from the jack leather of which it was made: a waxed leather coated with tar or pitch the same as that employed for the blackjack, a huge jug or tankard which held beer or ale.

It became the generally worn boot of the seventeenth and eighteenth centuries. The advantage of the jack boot and the reason for its clumsy appearance were that it was large enough to wear a shoe or slipper inside it. This accounts for its great popularity, because when the horseman or postilion arrived at his destination he could pull off the heavy boot and be comfortable in his shoes before the fire. The inside top of the boot was lined with small pockets, enabling the wearer to carry papers and small objects.

In the polished black boot we find the origin of the word "blackguard," that ignominious term which, in the reign of Charles II of England (1660–1685), simply meant the fellow who blackened the officers' boots. Blackguard was the general name for the menial who did the scullery work and he was usually clothed in black.

The oxford comes down to us from this period about mid-century. The half boot or "boot shoe," as it was then called, of polished black leather, either

laced or buckled, filled a need for school use and took its name from Oxford University, where it was most generally worn. There were also tight-fitting hunting boots laced at the small of the leg which were called buskins.

Quite a story is connected with a pair of seamless boots belonging to Louis XIV (1643–1715) which earned for the maker the position of master cordwainer to the king. Nicolas Lestrange, while working in Bordeaux, had the clever idea of making a pair of shoes for the king without ever having seen his Majesty or knowing his size. The shoes were a great success, very handsome and of such perfect fit that the king wore them at his wedding in 1660.

Lestrange came to Paris, where he made the footwear for the royal household, shoes so costly as to be worn only to the most important ceremonies. In 1663 he made the famous pair of seamless calfskin boots which he presented to Louis XIV. The king was so delighted and intrigued with them that he forbade Lestrange duplicating the feat.

The shoemaker became a celebrity and his portrait was included in the king's private collection. He was given a coat-of-arms, a gold boot on azure surmounted by a crown and the lily of the royal house of France. A book of poems written in his honor was published in 1677. But all this glory created much envy among his confreres, making him so unhappy that he returned to Bordeaux. Not until the late eighteenth century did the ingenious idea come to light: The skin was taken from the leg of the calf without splitting, then shaped to form in the tanning and dressing of the leather.

The masculine shoe developed a long square vamp and by the 1640's heels were high, rather like the modern Cuban heel. The courtier's shoe was generally of gray or brown leather, with the red heel and red-edged sole. Louis, being short of stature, had his heels built up with cork. A famous pair of his shoes belong to the latter part of his reign. The heels of this particular pair of royal shoes were decorated with scenes depicting his victorious Rhenish battles, and the miniature paintings were the work of no less an artist than the Flemish painter Van der Meulen. Heels were also embellished with more gentle subjects, love scenes, shepherdesses and flowers.

Wide silk shoestrings, in red, green or white, spangled and gilded, paved the way for the huge shoe rose which, in the first quarter of the century, blossomed into a most conspicuous ornament. It grew to quite a size, upon which large sums of money were lavished. Lace as fine and expensive as

that used for neck ruffs was employed, and further decorated with needle-work in gold and silver thread. Often jewels were centered in the rosette. Such accessories ranged in price from thirty shillings to thirty pounds a pair, and a contemporary writer complained that some with jewels cost as much as the yearly budget of a family. Sir Walter Raleigh, a very dressy individual, sported a special pair of lace and begemmed shoe roses which was valued at an enormous sum. All of which prompted the English "Water poet," John Taylor (1580–1664), to pen the following words:

> "Wear a farm with shoe-strings edged with gold,
> And spangled garters worth a copy-hold."

For court wear the shoe was frequently in delicate color and of leather, satin or brocade, in the 'sixties the dandy tying his dress shoes with wide, stiff bows of taffeta and lace—butterfly and windmill bows they called them. In the 'seventies the ultra-smart gentleman added an extra rosette over the toe of his shoe. Then came the high tongue which turned over, revealing a red lining, and latchets forsook ties for a small oval buckle.

The buckled shoe is of the second half of the century, buckles being noted about 1659 and becoming general in the 'eighties. The new ornament was fashioned of brass, steel or silver while some were set with pearls and diamonds, either real or false.

Late in the century leather gaiters, both high and low, called "gamashes" or "spatterdashes," were often worn with shoes instead of riding boots. From spatterdash comes our abbreviated word "spats." Linen leggings were still the distinguishing mark of the peasant or farmer.

The passing vogue of gold and silver embroidered gaiters with low shoes for the gentleman necessitated his wearing many pairs of silk stockings for warmth in winter. Ordinarily, three pairs were worn, one over the other, but we read of some individuals wearing as many as nine pairs. Practical folks wore several pairs of knit yarn under the silk but, of course, for the Cavalier, silk stockings were *de rigueur*.

Spain retained her reputation for the finest knit stockings to the eighteenth century, when the French usurped the honor. A special master-craftsman in Spain worked exclusively for Anne of Austria, the wife of Louis XIII (1610–1643). At this period the smartest color was red, with yellow next in favor. Others were: green, russet, peach, carnation, black and

white. There were also worsted, thread and linen knits, with some hose striped or figured. Still to be had, and much worn, were hose of cloth in kersey, cotton and calico, some with calico lining. The bourgeoisie wore black, white or scarlet woolen hose for every day, silk for special occasions.

The color red in daily dress was confined to stockings, accessories and ornamentation, because the all-red costume was the hunting habit, which was first worn in France in the early seventeenth century. This is the origin of the brilliant "pink" hunting jacket.

Many gentlemen matched their hose to the varying muted shades of the fashionable claret and brown habits, but dress stockings were usually white silk. An event of importance was the appearance about 1680 of white cotton knits. Barbary stockings they were called because that is where they were made. Frequent reference is made in the seventeenth century to the durable, warm, Irish stockings of cloth worn by men and women in England and the colonies.

It was not till the late century that the machine-knit hose were generally available. They were not comparable to the hand-knit article; but, even so, the business of producing stockings on Lee's knitting frames developed to such a degree that the London Framework Knitters Company set up shop in 1657. There the frames were bought and sold—frames composed of two thousand parts, and so well-made that the machines in work lasted well over a hundred years. Making hosiery furnished a living to the people of almost every village in Nottinghamshire, the knitting frame most often occupying the second floor of the stockinger's sturdy cottage.

The penalties set by the English laws prohibiting the exportation of the frames abroad were severe, despite which, however, the machinery was smuggled out of the country piece by piece. Many a crock of English butter concealed some part of a knitting frame, needles, bobbins and such. Flourishing knitting centers developed at Troyes, in France; Chemnitz, Germany; and Germantown, in Pennsylvania, where in 1689 thirteen Mennonite families from Prussia settled.

The feminine style in shoes followed that of the opposite sex, except in heels, which were usually higher and made of wood. In this century the making of wooden heels became a separate craft apart from shoemaking; and, in the same period, the curved three-inch heel was first called the "Louis heel." There were slippers of fine leather, velvet, satin, brocade; striped fabric

and gold and silver tissue, often with elaborate embroidery. Colors ran to blue or deep rose, worn with silk stockings in apple-green, sky-blue or deep rose. "Soulier à la Choisy" was the name for the fashionable shoe, after François Timoléon de Choisy (1644–1724), the French ecclesiastic and littérateur, a person of singular manners who delighted in wearing women's clothes.

En negligée, the ladies wore high-heeled mules of Turkish or moroccan leather or satin, in violet, beige and white. Mules and pantoffles had red heels, and, sometimes, a frill of lace over the instep.

Fashion decreed small feet and a lady simply had to have tiny feet at any cost. Bindings of waxed linen tape were resorted to; and one day at the French court, during a ceremony, several of the queen's maids of honor fainted away from pain occasioned by tightly bound feet. The snug-fitting shoes of the seventeenth and eighteenth centuries were drawn on not by means of a shoehorn but with a long strip of calfskin. The strip, with fur retained, was placed in the shoe, the fur side to the shoe, which drew on the shoe as it was pulled.

Women of the beau monde walked very little because the comfortable English sedan chair had arrived. This form of conveyance, in use in Spain and Italy from Medieval days, became popular in London and Paris in this century. Appearing first in London about 1634, the chair crossed the channel to Paris in the 1660's. The sedan was often carried right into the rooms at Versailles. Some ladies, however, must have walked—because a fashion account of the period holds forth on velvet pattens mounted on thick cork soles to protect the delicate slippers.

The feminine shoe of the populace resembled the man's shoe of heavy black leather with medium heel and latchets tied over a tongue. Such shoes, called "batts," were shipped from London to the colonies as early as 1636. For dress, there were slippers that simulated the dainty shoe of the aristocrat but made of wood. They were really sabots, cleverly carved and painted to imitate brocaded fabric and jeweled ornaments, and finished with real lace and ribbon shoe roses. Home-knitted cotton or wool stockings were worn, silk a luxury only for the rich.

A sentence will suffice for the footwear of children by saying it was the same as that of their elders.

When women went abroad on horseback they often wore the soft leather

boot, and protected their gowns by a "safeguard" or foot mantel also known as a weather skirt or overpetticoat. It was of red, gray or black homespun. Men on horseback protected their fine leather breeches by long stirrup hose or "sherry-vallies," the name an English adaptation of the Spanish "zaraguelles." Sherry-vallies were as wide as two yards around the top, and buttoned over the breeches. Of thick cloth or leather, they were held to the belt by laces threaded through eyelets.

It was in 1660, in the reign of Charles II, that Irish gentlemen adopted English dress, but the lower classes clung to their brogues of rawhide. In fact, the commoners more often went barefoot even as late as the twentieth century. Perforated and pinked edges continued as part of the design of the Highlander's shoe, a writer of the period commenting, with surprise, that "new good shoes are thus cut for the water to flow out when fording streams."

Women of Europe and the colonies made use of the wooden patten and the cork-soled pantoffle to protect their shoes. There were also wooden-soled galoshes, which an English writer in 1688 explains as "galloshios that are false shooes or covers for shooes." That the high chopine was still in vogue is attested to by no less a person than Shakespeare. In *Hamlet,* first performed around 1600, the hero exclaims, "Your ladyship is nearer heaven than when I saw you last, by the altitude of a chopine."

Very high chopines were still worn in Spain and Venice. An amusing bit is from a letter of an English visitor to Venice in 1648: "Venice is much frequented by walking May-poles; I mean the women, they wear their coats half too long for their bodies; being mounted on their chippines (which are as high as a man's leg) they walk between two handmaids, majestically deliberating every step they take."

On the same subject wrote John Evelyn (1620–1706), the English author and traveler: " 'Tis ridiculous to see how ladys crawle in and out of their gondolas by reason of their choppines and what they appear when taken down from their wooden scaffolds. Of these I saw nearly thirty together stalking halfe again as high as the rest of the world." Some one else said that Venetian ladies were composed of three things: one part, wood; another, their clothes; and the third, woman. The senate attempted to do away with the stilts but met with total failure, the fashion dying only of its own volition by the end of the century.

An English countess, visiting Spain in 1679, recounts that the pattens worn

out-of-doors by Spanish ladies were "a sort of little sandal, made of brocade or velvet, set upon plates of gold which raise them half a foot. They walk very ill in them and are apt to fall down." Speaking of the young women she says, "I have already told you that their feet are so small that their shoes look like those of our babies. They are made of black Spanish leather cut upon colored taffety, without heels and fit as closely as a glove."

The aristocratic Spanish maiden concealed her feet under many wide skirts, making it a great privilege to permit a glimpse of them even to her fiancé. Only married women were permitted to wear high heels and paint their faces, privileges of which all gentlewomen availed themselves.

The "alpargata," a rope sandal, was the common shoe in Spain, the name derived from esparto grass, of which it was made. The grass was also used for cordage, baskets, floor-coverings and many other purposes. The French people, too, had a rope-soled shoe with canvas upper, theirs called the "bobeline." The early twentieth century saw this type of shoe or espadrille made smart by the fashionable world at Lido Beach and the Riviera.

Among the Slavic peoples, the nail-shod, soft leather boots were usually black for ordinary wear but of colored morocco for dress. Red appears to have been the favorite color of the Russians, the tops often of satin or velvet, ornamented with bright-hued embroidery, beads and glass. Polish boots were either red or yellow, as also were Hungarian boots. Many peasants, men and women, went barefoot, especially when working in the fields. A common shoe was the low, flat sandal of felt or rawhide, with thongs or felt ribbons cross-gartered to the knees over felt stockings. Young women wore red stockings with sandal or boot, the soft Turkish slipper or heeled shoe being permitted only after marriage.

Turkish boots and slippers were of yellow morocco—yellow the color of the footgear of the followers of Mohammed. They resented unbelievers wearing that color, and Christians, en route to the East, were warned against committing the error. According to Oriental etiquette, the lady of the harem was required to conceal her feet when seated.

Ice skating became very popular in England about mid-century, all classes taking up the recreation. This very ancient sport of the Norsemen, Swedes, Danes, Finns and the Dutch was known in England in Medieval times, but its modern popularity dates from the seventeenth century, Pepys and Evelyn both giving it mention in their diaries. Though bone slides were known to

some Eskimo tribes in America, skating, as we know it, by means of a metal runner, was first introduced to the New World by the European colonizers.

The American Indian snowshoe was an ingenious foot-piece and varied in construction, according to its use on hard or soft snow, in the open or in the woods. The frame was of ash, steamed and shaped, with a netting of sinew, moose intestine or rawhide strips. When caught in an emergency, the Indian could easily fashion temporary snowshoes of green saplings and bark strips.

In our Medieval chapter we explained the English origin of the thirteen shoe sizes used today. Founded upon those measurements, and also of English origination, was the size stick, the invention of a monk at Saint Andrews, in Northampton, in this period.

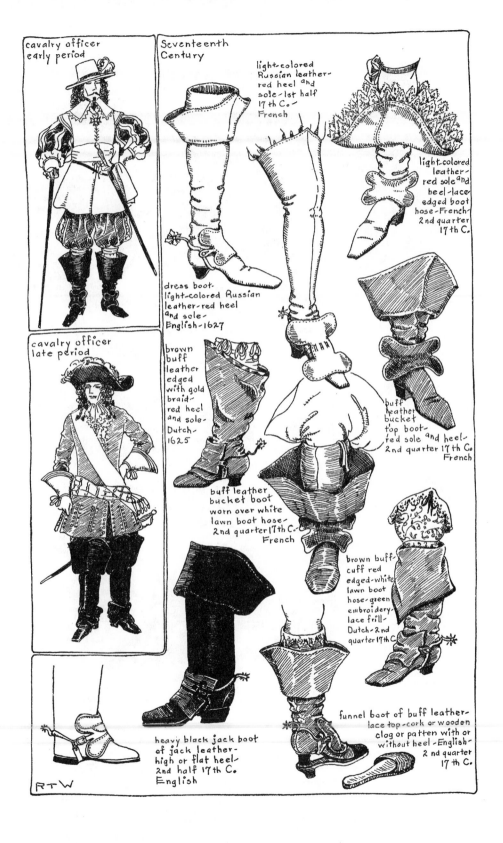

cavalry officer
early period

cavalry officer
late period

Seventeenth
Century

light-colored
Russian leather-
red heel and
sole-1st half
17th C.-
French

light-colored
leather-
red sole and
heel-lace-
edged boot
hose-French-
2nd quarter
17th C.

dress boot-
light-colored Russian
leather-red heel
and sole-
English-1627

brown
buff
leather
edged
with gold
braid-
red heel
and sole-
Dutch-
1625

buff
leather
bucket
top boot-
red sole and heel-
2nd quarter 17th C.
French

buff leather
bucket boot
worn over white
lawn boot hose-
2nd quarter 17th C.
French

brown buff-
cuff red
edged-white
lawn boot
hose-green
embroidery-
lace frill-
Dutch-2nd
quarter 17th C.

heavy black jack boot
of jack leather-
high or flat heel-
2nd half 17th C.
English

funnel boot of buff leather-
lace top-cork or wooden
clog or patten with or
without heel-English-
2nd quarter
17th C.

RTW

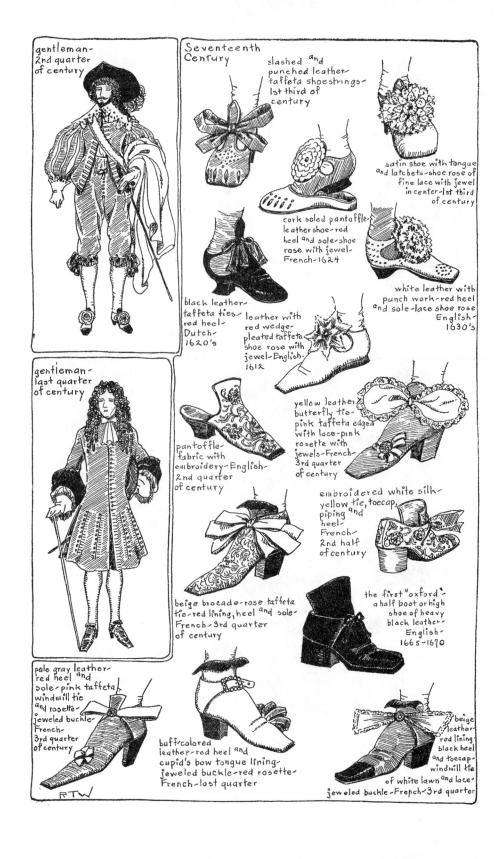

gentleman-
2nd quarter
of century

Seventeenth
Century

slashed and
punched leather-
taffeta shoestrings-
1st third of
century

satin shoe with tongue
and latchets-shoe rose of
fine lace with jewel
in center-1st third
of century

cork soled pantoffle-
leather shoe-red
heel and sole-shoe
rose with jewel-
French-1624

white leather with
punch work-red heel
and sole-lace shoe rose
English-
1630's

black leather-
taffeta ties-
red heel-
Dutch-
1620's

leather with
red wedge-
pleated taffeta
shoe rose with
jewel-English-
1612

gentleman-
last quarter
of century

pantoffle-
fabric with
embroidery-English-
2nd quarter
of century

yellow leather
butterfly tie-
pink taffeta edged
with lace-pink
rosette with
jewels-French-
3rd quarter
of century

embroidered white silk-
yellow tie, toecap,
piping and
heel-
French-
2nd half
of century

beige brocade-rose taffeta
tie-red lining, heel and sole-
French-3rd quarter
of century

the first "oxford"-
a half boot or high
shoe of heavy
black leather-
English-
1665-1670

pale gray leather-
red heel and
sole-pink taffeta
windmill tie
and rosette-
jeweled buckle-
French-
3rd quarter
of century

buff-colored
leather-red heel and
cupid's bow tongue lining-
jeweled buckle-red rosette-
French-last quarter

beige
leather-
red lining
black heel
and toecap-
windmill tie
of white lawn and lace-
jeweled buckle-French-3rd quarter

RTW

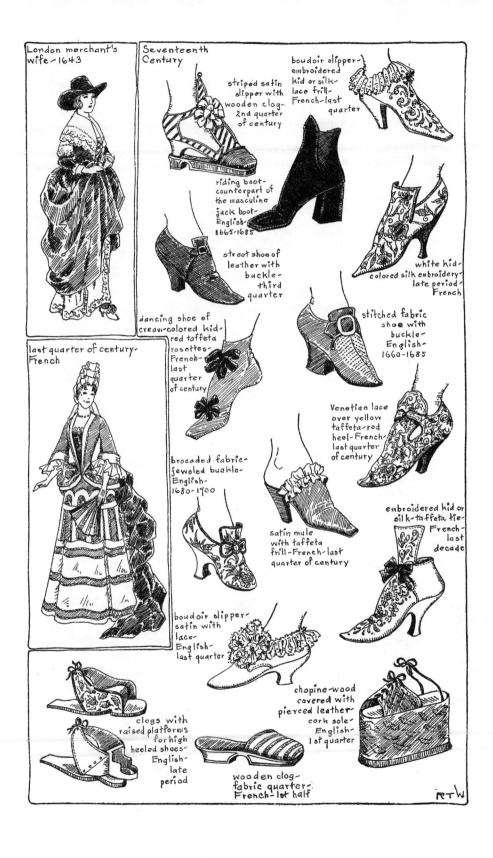

London merchant's wife - 1643

Seventeenth Century

striped satin slipper with wooden clog - 2nd quarter of century

boudoir slipper - embroidered kid or silk - lace frill - French - last quarter

riding boot - counterpart of the masculine jack boot - English - 1665-1685

street shoe of leather with buckle - third quarter

white kid - colored silk embroidery - late period - French

dancing shoe of cream-colored kid - red taffeta rosettes - French - last quarter of century

stitched fabric shoe with buckle - English - 1660-1685

last quarter of century - French

Venetian lace over yellow taffeta - red heel - French - last quarter of century

brocaded fabric - jeweled buckle - English - 1680-1700

satin mule with taffeta frill - French - last quarter of century

embroidered kid or silk - taffeta tie - French - last decade

boudoir slipper - satin with lace - English - last quarter

clogs with raised platforms for high heeled shoes - English - late period

chopine - wood covered with pierced leather - cork sole - English - 1st quarter

wooden clog - fabric quarter - French - 1st half

RTW

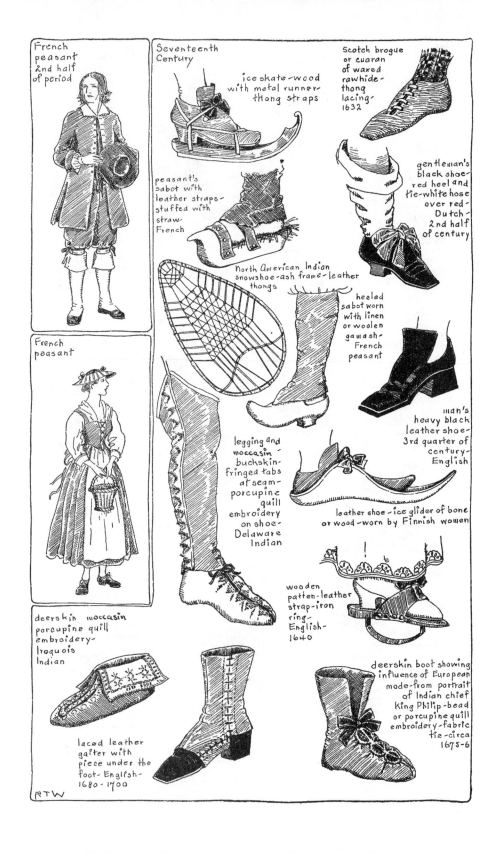

French
peasant
2nd half
of period

French
peasant

Seventeenth
Century

ice skate-wood
with metal runner-
thong straps

Scotch brogue
or cuaran
of waxed
rawhide-
thong
lacing-
1632

gentleman's
black shoe-
red heel and
tie-white hose
over red-
Dutch-
2nd half
of century

peasant's
sabot with
leather straps-
stuffed with
straw-
French

North American Indian
snowshoe-ash frame-leather
thongs

heeled
sabot worn
with linen
or woolen
gamash-
French
peasant

man's
heavy black
leather shoe-
3rd quarter of
century-
English

legging and
moccasin-
buckskin-
fringed tabs
at seam-
porcupine
quill
embroidery
on shoe-
Delaware
Indian

leather shoe-ice glider of bone
or wood-worn by Finnish women

wooden
patten-leather
strap-iron
ring-
English-
1640

deerskin moccasin
porcupine quill
embroidery-
Iroquois
Indian

deerskin boot showing
influence of European
mode-from portrait
of Indian chief
king Philip-bead
or porcupine quill
embroidery-fabric
tie-circa
1675-6

laced leather
gaiter with
piece under the
foot-English-
1680-1700

RTW

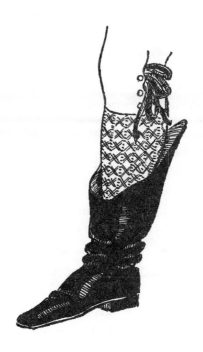

EIGHTEENTH-CENTURY FOOTWEAR

CHAPTER FIFTEEN

OF THIS CENTURY was the Rococo Period, with its refined characteristics in architecture, costume and manners. It is synonymous with the reign of Louis XV, a long one from 1715 to 1774, in which the French now set the mode for the fashionable world. From 1774 to 1793 fashion soared to giddy heights in the short unfortunate years of Louis XVI. Then came the crash!

The French shoemaker of the eighteenth century was looked upon as an artist, who attained great beauty and perfection in his craft. He built his fine shoes for the right and for the left foot. Some Parisian individual conceived the idea of having plaster casts made of his feet and his shoes built to fit them—an idea which several shoemakers copied.

To Beau Nash goes the credit for making shoes and stockings popular in this period, Englishmen being fond of wearing boots at all hours and all places. This English dandy, who was born Richard Nash, was made master-of-ceremonies at Bath in 1705, and devised a new code of rules upon manners and dress.

The masculine shoe attained its modern design in this century, the low, broad heel appearing in the 'thirties. The gentleman's shoe was frequently finished with a red wedge or welt, and the red heel was still required for court wear. Red heels, which first denoted aristocracy, then dandyism, were worn for over a century in America too, disappearing in France with the Revolution. In England and on the continent they lasted to the early years of 1800.

Flowers, rustic and love scenes were done in miniature on the fashionable heels, the painter and engraver Jean Antoine Watteau (1684–1721) placing his signature to such works of art. Louis XV, like his great-grandfather, had his heels decorated with battle scenes, signed by the painter Parocel.

By the mid-century men's shoes had settled down to the modern conservative colors of black and brown, but, principally, black. Buff was the color for gala days. Buckles either fastened or concealed the tied fastening of the latchets. The fashionable shoe buckle worn by men and women enjoyed a vogue of over a century. In France the shoe with large buckle was the "Artois shoe," named for one of the brothers of Louis XVI, the Count of Artois, born in 1757 and destined to become king as Charles X from 1824 to 1830.

Buckles were fashioned of gold, silver, bronze and cut-steel, engraved, enameled and encrusted with diamonds, pearls, marcasite or paste jewels, according to one's wealth. New in the eighteenth century, and a metal of which buckles were largely made, was pinchbeck. It was an alloy of copper and zinc plated with gold or silver, and the invention of a London watchmaker Christopher Pinchbeck.

During the terrible upheaval in France, cord and ribbon ties replaced buckles; and, at the court, only a few faithful followers, who had not fled the country, observed etiquette in wearing formal dress. When in 1792 Louis' newly appointed minister Roland appeared, his shoes tied with laces, the king considered it an insult to his position. The master-of-ceremonies, who was very shocked at the laxity, could not refrain from remarking to the poor king, "Alas, Monsieur, all is lost," as indeed it was.

In England, Birmingham and the small neighboring towns supplied the fashionable buckles to the elegants of Europe and the colonies; and when, in 1792, historical events led men to adopt the so-called "effeminate shoe-lace," the bucklemakers became alarmed. An appeal was made to the Prince of Wales to save a craft employing twenty thousand workers, and the fol-

lowing year a further appeal was made to the Duke and Duchess of York. Those worthy people forbade the wearing of strings in their household; but, fashion being the fickle jade she is, the buckle disappeared from the mode, and the Birmingham buckle industry passed out of existence before the end of the century.

The last decade saw the feet of the smart world encased in pumps or escarpins—soft, pointed, heelless slippers cut décolleté and usually black in color.

For the greater part of the century boots were reserved to the use of the soldier and the sportsman. By the end of the first quarter the heavy jack boot became the protective riding gear of the courier and the postilion, a more elegant and comfortable version taking its place as the military boot. The new feature was the top cut out at the back of the knee. This model was widely adopted by the officers of the European armies; and, though worn throughout the century, it today bears the names of Wellington and Napoleon, who wore it at the end of the century.

In the 'seventies a trend towards reason and simplicity in living manifested itself also in clothes, and the boot returned to favor for general wear. The top boot or English jockey boot, a smartly cut gentleman's boot which had appeared in the 'thirties, was the very last word with young English "bucks and bloods," especially for walking. It has lasted over two centuries in the wardrobe of the horseman and the jockey. When imported to France in 1779 it did not meet with immediate success, but by the 'nineties it was widely worn.

This boot was fashioned of grain leather, the flesh side being left brown and the grain outside blackened. It was made to fit round the small of the leg in almost a stocking fit, the leather treated to a special currying to give it "life." In general, the brown flesh side formed the turned-down cuff, but there were also cuffs of lighter color and snowy white chamois. An attempt was made to introduce boots of colored leathers, principally in red or blue, but that idea did not take.

The finest top boots were quite often made in one piece, the skin taken from the leg of the calf without slitting—bringing to mind the famous pair which Lestrange, in the previous century, had made for Louis XIV. A seamless boot was also simulated, by the use of a special paste which concealed the back seam.

It was at this time that the hussar boot entered the mode. It was introduced to the European armies in the seventeenth century by the Hungarian hussars. When the boot appeared in London in the 1770's on the legs of the Hessian mercenaries hired by George III to fight the American colonists, it was first called the Austrian boot, but, eventually, it became the Hessian boot to the English and the Americans. To the French, it was the hussar or Souvaroff, so named after the great Russian general of the period (1729–1800).

The boot was first looked upon with derision, in comparison with the handsome top boot; but, as happens time and time again, the scoffed-at newcomer became the very height of fashion by the end of the century. Hessians were worn over the tight-fitting pantaloons, of shiny black leather, the top finished with gold or silver braid, and a silk tassel jauntily swinging from the up-peaking center front.

In general, boot legs were polished to a dull finish with a viscid dressing composed of the white of an egg and lamp soot, this English cream much in demand all over Europe. Bootblacks or, by the French name, "artist polishers" opened small shops for the purpose. In London, where they were especially necessary because of the ill-paved streets and lack of drainage, there were bootblacks or "boots" stationed at most street corners, ready to clean the footwear of gentlemen and beaux.

A contemporary writer notes that the wearing of boots was so general that they were worn by merchants who never rode. In the last decade there were low, walking boots of soft leather, "in the Russian style," short, shiny black boots, which delighted the hearts of the French incroyable and the English macaroni.

Cowhide and buckskin shoes with large buckles made up the general masculine footwear in the American colonies, a description of the brave minute-men making note that "not a pair of boots graced the company." The soldiers of the Continental Army wore high leggings or gaiters of leather or cloth, dyed black or leather color, while the officers wore black leather boots.

Pertaining to men's hosiery of the early part of the century, scarlet or blue silk stockings, embroidered with gold or silver clocks, accompanied the dress red heels for ceremonial occasions. Ordinarily, the well-dressed gentleman wore delicate colors or the favored gray, and always of heavy silk. White became the universally worn color about 1736, of silk or cotton, but of

knitted wool for every day. White silk hose were most often clocked with black silk and woolen hose with color. It was during the reign of Louis XV that the French usurped the Spanish mastery in the making of silk stockings, the French producing the coveted hosiery of the European countries.

The winter fashion of wearing several pairs of stockings still prevailed, but protection against the cold was also afforded by high, leather or cloth leggings or spatterdashes. Those, reaching to the knees, and which were worn from the early decades by the infantry, were called dragoon gaiters. In the last decade of the century huntsmen took to wearing the still shorter, but comfortable, gaiter of the rustic. Besides leather and cloth, there were gaiters of "thread and cotton."

From about 1700 to the 'sixties a jack-boot style of spatterdash was popular. It was of black leather but of a lighter quality than that used in the boot.

When boots late in the century returned to civilian wear, the white stockings were often visible between boot top and the breeches. Of this period was the silk stocking striped in color on a white ground, a fashion which especially pleased the dandy.

Here in America the stocking trade did a brisk business. A traveler in 1759 noted that Germantown thread stockings were highly esteemed, that they manufactured 600,000 dozen pairs a year, which retailed at one dollar a pair. Such a large production would appear to have been other than handmade; but, until the nineteenth century, there is no authentic information available as to the weavers possessing frames. We know that the frames were smuggled out of England; but, on this side of the water, the possession was discouraged by a heavy fine placed against the ownership of an English knitting frame.

The feature of feminine footgear was the French or Louis heel, today the Louis XV heel; which brings to mind such grandes dames as the Comtesse du Barry (1713-1793) and the Marquise de Pompadour (1721-1764), both favorites of Louis XV. Late in the period there was the lovely and unfortunate Marie-Antoinette, the wife of Louis XVI and queen of France from 1774 to 1793.

The great French dancer of the ballet was Madame Camargo (1710-1770). She was famed not only for her exquisite dancing but for her tiny feet. The court copied her shoes, as they did her coiffure, and 'tis said that

her shoemaker made a fortune. Ballet slippers in those days were not the little, flat shoes of more modern times but real slippers with French heels.

The slim, gracefully curving heel had an exquisite line from the back of the slipper to the floor, a dainty pedestal which typified the gay, charming and light-hearted aristocrat, whose foot it graced. In those days only fine ladies wore such heels—wore them until the French Revolution forced them to shun the frivolous stilts. The pretty wooden heel, if not covered with the fabric of the shoe, was often painted red, or covered with white kid.

Slippers were made of kid in all colors, thin morocco and many fabrics, particularly velvet, brocade, damask and satin—striped, flowered and embroidered, and finished with a narrow galloon. And, of course, a beautiful buckle enhanced the value of many a shoe. One reads that London exported very handsome shoes to the colonies, but they also sent the durable, less expensive kind. In the list we find mentioned: red or "drab" (a brownish gray) cloth; russet, a woolen twill; everlasting, a kind of satin; calamanco, a glossy woolen fabric (for women's and maids' shoes); and children's morocco pumps. Slippers often carried the words "Rips mended free," along with the maker's name.

All the world was not in favor of elegant slippers, anyway, for young women, because there is recorded the following mandate issued in 1709 by the Censor of Great Britain: "The Censor having observed that there are fine wrought ladies' shoes and slippers put out to view at a great shoemaker's shop towards St. James end of Pall-Mall, which create irregular thoughts and desires in the youth of this realm; the said shopkeeper is required to take in these eyesores, or show cause the next court-day why he continues to expose the same; and he is required to be prepared particularly to answer to the slippers with green lace and blue heels."

The feminine silk stockings of delicate color worn in the early decades changed to white in the 1720's, with clocks embroidered in silk on silk and colored wool on cotton.

Clogs and pattens were not only a necessity as a bad-weather protection but made it possible to traverse the cobbled pavements, when on foot, in the fragile thin-soled slippers. Dressy slippers had pattens to match the straps of the shoe fabric, with a thin wooden or thick leather sole. A built-up section fitted under the arch created by the high heel, and patten soles were frequently in two pieces, hinged together for easier walking. Oak and poplar

were the preferred woods for ordinary pattens, with leather straps and an iron ring raising the patten off the ground. Pattens were very noisy things, and notices were posted in the church entrances asking women to remove them before entering.

When Louis XVI mounted the throne in 1774, with his dainty young wife, the stage was already set for the Revolution; but fashion was having its last and most extravagant fling. Both heels and coiffures rose to extreme height; and women took to carrying picturesque long walking sticks which, one cynical writer said, they needed to keep their balance. A poet of the day wrote:

"Mount on French heels when you go to a ball—
'Tis the fashion to totter and show you can fall."

A pretty conceit was that of encrusting the back seam of the slipper with emeralds, a fashion called "venez-y voir" or "come hither!" A blond shade of satin was very smart for slippers, the tone named "queen's hair color," after Marie-Antionette's lovely blond hair. The queen's wardrobe was indeed an extensive one, each costume complete with matching accessories, her shoes requiring an index with notations as to the style and color of each pair.

A feminine fashion of the 1780's was a peaked-toe slipper, called the Chinese sabot, having a thin wooden sole with upturned toe and uppers of kid or satin decorated with a small jeweled buckle or a ribbon ruche.

Heels began to moderate in height, becoming low enough to afford comfort in walking—and walking actually became fashionable. Color took on a somber hue, the lady of quality encasing her feet in silk slippers of a pigeon-gray or a reddish brown color. Leather shoes were for the demi-monde and lower classes. White was the stocking color, with silk for dress and cotton for general wear. For horseback, ladies usurped the tailored coat and waistcoat of their menfolk, with powdered hair or wig, tricorne and boots. These boots were of soft leather and rose halfway to the knee, were laced in buskin fashion and sported a ribbon shoe rose on the toe.

Early in the 'eighties, the skies darkening with coming events, fashion executed a turn-about, changing to simple dress, which was adopted by the nobility and the bourgeoisie. Rationalism in dress was first apparent in children's clothes, and in England, with the youngsters wearing heelless shoes

long before their elders. In France, the new, simple mode acquired various names, à l'anglaise, à l'américaine and milkmaid fashions. An English fashion article of 1790 mentions shoes of white kid and red morocco, but the red heels of the French aristocrat disappeared. Heels, jeweled buckles, silk stockings and all such badges of nobility were dangerous accessories to wear during the Reign of Terror.

The reaction, after the Revolution, was toward a classic way of life, in government and dress. The "Directoire" was set up; and, under the influence of the painters of the day, especially Jacques-Louis David (1748-1825), the mode turned to ancient Greece and Rome for inspiration. The ladies of this neo-classic style in slim, high-waisted gowns adopted the sandal, the buskin and the cothurnus.

The new national French colors were blue, white and red, the latter a predominant footwear color. The classic shoes were of soft kid, velvet, silk, moiré and satin in red, apple-green and black, ornamented with embroidery and fastened with gold laces and tassels. Most generally worn was the flat, soft, heelless slipper, cut décolleté and finished with a tiny bow of ribbon. It was a fragile piece of foot-tire often made at home. This vogue of the escarpin lasted more than half a century. Today, this type of slipper is again in vogue, and a modern fashion journal displays a pattern in its pages urging ladies "to make their own."

There is record of a slipper made in 1791 for the Duchess of York, a slipper so tiny that a life-size colored print of it was published. The English pottery makers copied it in china, with cupids hovering over it, as a mantel or table ornament for the drawing room. The green silk slipper bound with scarlet had a flat, scarlet heel, and was decorated with gold stars. This fairy slipper, which was probably the beginning of all those Victorian china shoes, measured in length five and three-quarter inches, the sole only one and one-half inches in width.

During the Greco-Roman craze silk stockings returned to enjoy a surprising display. Long, slim, pointed inserts of pink or mauve satin took the place of embroidered clocks. Some smart ladies wore diaphanous gowns over flesh-colored tights; others carried their trains over their arms, revealing their silk-covered legs to the knees; and there were some Parisian society women who dared to appear publicly in sandals and no stockings at all! These compromised by wearing jeweled anklets and toe rings.

Tremendous notoriety in gossip and print attended a prominent fashionable member of society, Madame Tallien, later Princess Chimay, when she went to a ball attired in sandals, her bare feet bedecked with jeweled rings, and gold bands above and below her knees. Madame's costume would be nothing unusual in these 1940's, but in those days it was daring, sensational and shocking.

The European bourgeois class wore stout black leather shoes shod with heavy soles, which, for best, were adorned with a large silver buckle—a style which survived to the twentieth century in peasant costume. Thick leather soles attached by nails were really a luxury to the lower classes, who were poor and quite often went barefoot. Peasant footwear, in general, consisted of sabots, clogs and sandals.

The French sabot was of two styles, the clumsy one sometimes lined with cloth or stuffed with straw, and a dressy type for women, a painted black wooden slipper, which was a replica of the fashionable slipper of fine fabric or kid. Klompen was the name of the Dutch sabot of scoured ash worn by the peasantry of the Low Countries for outdoors and field work. The Dutch merchants and people of the wealthy class have always followed the mode, wearing rich and handsome apparel. Their shoes were usually black, with red heels and enormous silver buckles.

It is interesting to find that, as late as this century, the customs and costumes of the Scotch and Irish Highlanders were those of the Celtic Period. Many went bare of leg and foot, even gentlemen who adopted the European mode in dress. Some wore cloth hose without feet, cross-gartered in the ancient style.

Certain Scotch clans wore long, form-fitting breeches like the Medieval chausses. They were made of the clan's tartan, and known by the ancient Gaelic word "trews," whence our word trouse or trousers. More general was the calf-high woolen knit hose, secured by tied garters, leaving the upper leg bare and a convenient place to carry the bidag or dagger. Gentlemen Highlanders, who wore the modern blouse, waistcoat and coat with their kilts and tartans, also adopted the shoe with ribbon ties, buckles and red heels.

The primitive thong-laced brogue or cuaran remained the general footpiece, but instead of untanned leather it was now made of tanned cowhide prepared for the purpose. It was a very heavy leather and never lined, and so was often stuffed with hay or straw to fit snug. This heelless shoe, centuries

and centuries old, continues to be worn as the dancing shoe when executing the ancient Highland dances.

The broguemakers took great pride in their craft, the sewing done entirely with a horsehide thong instead of the usual hemp, wax and bristles. There were two kinds of brogue, the single and the double pump, the single consisting of uppers and sole, and the double made with a welt between the upper leather and the sole. When heels were added they were made of tanners' shavings or "jumps," glued and pressed together, and then dried in the sun or before the fire. The finished shoe was well-rubbed with a rag saturated with tallow, the brogue then ready for wear.

The shoe had open spaces between the lacings; and a traveler's letter written somewhere between 1715 and 1745 remarks upon the "perforated shoes" worn with short stockings and says, "This they do to keep their feet from galling." The brogue, while an inexpensive foot-covering, was, at the same time, a much more durable piece for field work than the shoemaker's product; so that many folk, especially women, had an extra pair of black buckled shoes for best wear. Also to be noted was an elegant Highland buskin of buckskin, with the fur retained as lining. This boot was laced from the top almost to the toe.

Cross-gartering was still worn by the peasants of many European countries. In the Spanish Basque provinces, men wore gray or black woolen hose, cross-gartered with alpargatas, the sandals of rush described in the last chapter. The better classes wore leather shoes and over them bottines or leggings of turned calfskin. Very handsome were these "bottines of Seville," fastened with leather loops on the outside of the leg. They were worked with gay silk embroidery and flowers of leather while others were in black leather decorated with gilt nailheads.

Portuguese peasants wore low, flat shoes outdoors, leather with wooden soles, a contemporary writing describing them as "a kind of patten several inches off the ground and fastened with clasps."

The eighteenth century found the shoes of the farmer's family in the American colonies still being made in his kitchen over the winter months. All the family took a hand in the work, the men cutting the heavy leather and attaching the soles, and the women binding the edges. The soles were attached by small wooden pegs handmade of maple. The shoes were interchangeable, not shaped right and left. Many a cobbler's bench used in the

farmer's kitchen has, today, become a collector's piece, serving proudly in the modern living room as an accessory table.

Some enterprising farmers set up small, ten-foot shops near the house or farm or in the back yard. Such little workshops, each with three or four assistants, soled and finished shoes, the parts of which had already been stitched by the village cobbler. These tiny, wayside shops, which produced "bespoke orders," were the very beginnings of the great American shoe industry.

In 1750 a workshop was opened in Lynn, Massachusetts, where each individual operation in the making of a shoe was handled by a man trained for the specific job. Then followed the idea of keeping the workers busy in dull periods by making "unordered" or "sale shoes," such shoes then displayed in the windows of local shops where the housewife did her marketing.

It took time to overcome old customs, such as the customer bringing in his own leather; but, in 1793 in Boston, the first retail shop appeared, where one might purchase ready-made shoes on Wednesdays and Saturdays. It was run by the Harvey brothers, who, until this momentous event, had sold their wares traveling in their horse-drawn wagon.

The Indian, through his contact with the white trader, had discarded the use of furs in his dress, but had retained his leather moccasins and leggings, which he often traded to advantage for woolen blankets and cloth. But we now find him, in this period, wearing mostly leggings of blue or scarlet cloth.

Very popular was the woodsman's shoe, called the "shoepak," the name a derivative of the Lenape Indian word "shipak." It was made like the Indian moccasin, without separate sole, ankle-high and of oil-tanned leather, usually white. A heavy half boot, worn by loggers today in winter, is known as a shoepak or "pac."

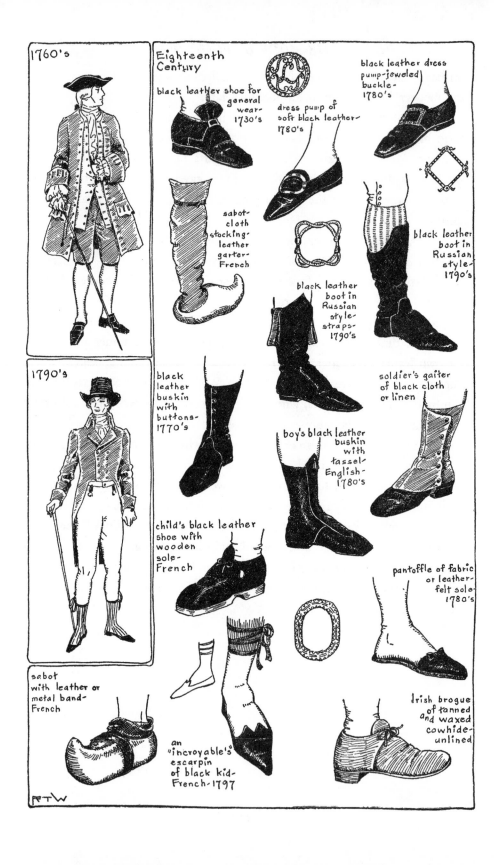

1760's

Eighteenth Century

black leather shoe for general wear- 1730's

dress pump of soft black leather- 1780's

black leather dress pump-jeweled buckle- 1780's

sabot-cloth stocking-leather garter-French

black leather boot in Russian style- 1790's

black leather boot in Russian style-straps- 1790's

black leather buskin with buttons- 1770's

soldier's gaiter of black cloth or linen

boy's black leather buskin with tassel- English- 1780's

1790's

child's black leather shoe with wooden sole- French

pantoffle of fabric or leather-felt sole- 1780's

sabot with leather or metal band- French

an "incroyable's" escarpin of black kid- French- 1797

Irish brogue of tanned and waxed cowhide- unlined

FTW

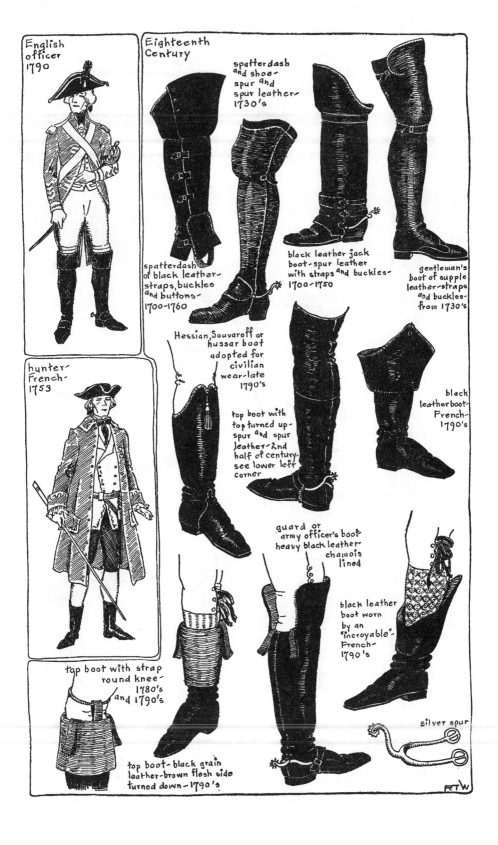

English
officer
1790

Eighteenth
Century

spatterdash
and shoe-
spur and
spur leather-
1730's

spatterdash
of black leather-
straps, buckles
and buttons-
1700-1760

black leather jack
boot-spur leather
with straps and buckles-
1700-1750

gentleman's
boot of supple
leather-straps
and buckles-
from 1730's

Hessian, Souvaroff or
hussar boot
adopted for
civilian
wear-late
1790's

top boot with
top turned up-
spur and spur
leather-2nd
half of century-
see lower left
corner

black
leather boot-
French-
1790's

hunter-
French-
1753

guard or
army officer's boot-
heavy black leather-
chamois
lined

black leather
boot worn
by an
"incroyable"-
French-
1790's

top boot with strap
round knee-
1780's
and 1790's

top boot-black grain
leather-brown flesh side
turned down-1790's

silver spur

RTW

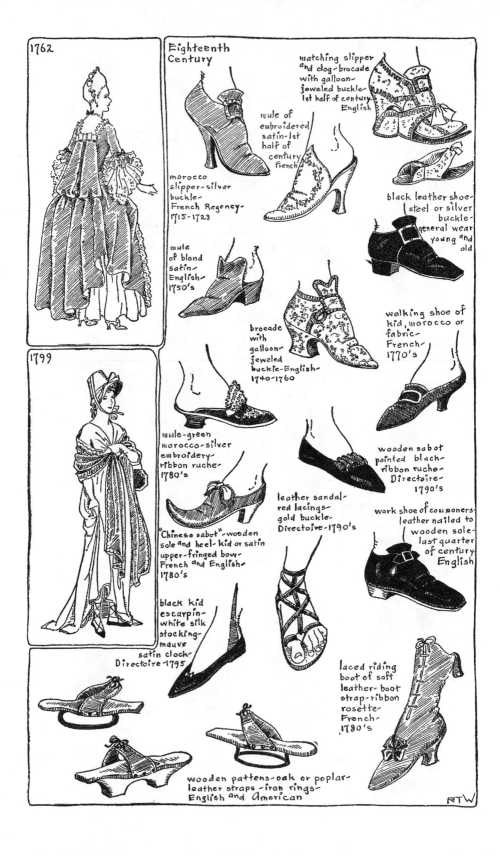

1762

1799

Eighteenth Century

matching slipper and clog-brocade with galloon-jeweled buckle-1st half of century-English

mule of embroidered satin-1st half of century-French

morocco slipper-silver buckle-French Regency-1715-1723

black leather shoe-steel or silver buckle-general wear young and old

mule of blond satin-English-1750's

brocade with galloon-jeweled buckle-English-1740-1760

walking shoe of kid, morocco or fabric-French-1770's

mule-green morocco-silver embroidery-ribbon ruche-1780's

wooden sabot painted black-ribbon ruche-Directoire-1790's

leather sandal-red lacings-gold buckle-Directoire-1790's

work shoe of commoners-leather nailed to wooden sole-last quarter of century-English

"Chinese sabot"-wooden sole and heel-kid or satin upper-fringed bow-French and English-1780's

black kid escarpin-white silk stocking-mauve satin clock-Directoire-1795

laced riding boot of soft leather-boot strap-ribbon rosette-French-1780's

wooden pattens-oak or poplar-leather straps-iron rings-English and American

RTW

NINETEENTH-CENTURY FOOTWEAR

CHAPTER SIXTEEN

WITH THE nineteenth century, we find ourselves at the most important period in the history of shoemaking, a handicraft to the middle of the century and which, from then on, was almost completely revolutionized by the machine. True, in some outlying districts the shoes of the farmer's family were still made at home over the winter, as late as the end of the century. At the same time, the bespoke or custom handmade article retained its select clientele.

The American talent for ad-writing was already in full bloom, as a newspaper announcement of 1809 well proves. The following piece of writing is too delightful to pass over; we must give it to our readers.

Mr. Young of Philadelphia advertised his "Patent anatomical dancing shoes to the ladies and gentlemen of Philadelphia," saying it would be a crime in the author not to delineate the admirable qualities of the shoe. "Hyperbole upon Hyperbole," continues he, "Corns, twisted heels and lacerated insteps shall no more agonize human nature; no more shall the aged witness the aid of crutch, the middle aged shall walk with certain sure and easy step, the young shall skip as an hart, and never know their accumulated horrors: wonderful! that the genius of Crispin should have made so happy

a discovery; the boot looses in its appearance one third of its size, as to a side view thereof, making it to appear exceedingly neat."

He offered an added attraction to the ladies, a private apartment where they could be measured by one of their own sex. And, topping it all, was the price of fitting, since it was imperative that every lady and gentleman have his own individual last for the modest sum of five dollars.

In the first half of the century the boot, most often black, was firmly entrenched in the masculine mode in civilian and military life and worn by all classes. The most elegant boot was of English make. There were all styles in heavy, lightweight, high, short, plain and fancy models in black and colors, and each particular style tagged with a special name. All had fairly high heels.

Under the influence of the important military events of the time, boots were typed as the Napoleon, Wellington, Souvaroff, Blücher and Hessian. Even in Paris, articles of attire were named for former enemies, a sentiment fostered by the returning émigrés. The Hessian boot, the guard boot and the top boot of the eighteenth century retained their popularity; but there were many others—the cavalier, the groom, the page, the Murat and the hunting boot—to name a few.

Both Napoleon (1769–1821) and Wellington (1769–1852) wore the military guard boot high over the knee and cut out in back. In many of his portraits Wellington is shown wearing Hessians. The real "leg boot" or Wellington, popular from about 1815 to the mid-century, was supposed to have been designed by that famous British general and statesman. It was a modified Hessian, a snug-fitting, shiny black calfskin boot, worn under the breeches, which also fitted closely and had a strap under the foot. The breeches, too, were known as Wellingtons because the Duke introduced the style into the army during the Peninsular War. Half-Wellingtons were shorter boots for under-trouser wear.

Wellington's German ally commander at the Battle of Waterloo in 1815, the famous Field-Marshal Blücher (1742–1819), was the originator of the blücher shoe. He designed a boot with lacing over instep in which the quarters lapped over the vamp. Although the idea had long been in use in a low shoe, he was the first to utilize it in a boot.

Fashionably booted gentlemen, like their forebears of the seventeenth century, wore spurs even when not on horseback; and a lot of fun was poked

at them, especially in newspaper cartoons. The last of both boot and shoe, in fact, of all the fine shoes of the nineteenth century, was narrow, long and tight-fitting; thereby fulfilling every smart man's and woman's desire to display a very small foot.

No reference to the mode of this period can be approached without recalling the greatest of all dandies, Beau Brummell (1778–1840), born George Bryan Brummell. A leader at Oxford, and later of London's beau monde, he brought to men's dress a perfection of detail, creating a perfect whole, with a fine taste for conservatism which has ever since marked the attire of the well-dressed Englishman. With his tight-fitting evening pantaloons of black cloth he wore black pumps, smartly set off by silk hose, either striped or plain white. His morning pantaloons were of powder-blue cloth, very tight and worn with immaculate black boots which, according to a lyric of the day, were polished with a concoction called "vin de champagne."

> "My top-boots, those unerring marks of a blade—
> With champagne are polished, and peach marmalade."

The French leather dressers had been experimenting with enamels for several centuries, and around 1800 the man's pump of varnished, lacquered or enameled leather made its debut in Paris. A fine accent was given the costume by the shoe of brilliant black leather which has become established as patent leather.

Here, in America in 1822, Seth Boyden, a harness maker of Newark, New Jersey, observed some harness blinders which had come from Paris. The shiny black leather led him to experiment with japanning or lacquering leather, with his resulting product eventually equaling the European article. With this beginning, Newark, in time, became the world's largest manufacturer of patent leather.

Leggings or spatterdashes of cloth or leather were still worn in the early period, but were, eventually, to survive in the costume of the military, peasants and hostlers. Sportmen's leather leggings now took the name of galligaskins, a name, one will recall, that was given the full slops of Dutchmen's breeches of the sixteenth and seventeenth centuries. Long, black cloth gaiters are part of the dress of the clergy of the Church of England of today, a reminder of the horseback travel of olden times.

An evolution of gaiters was the very smart-looking cloth-top shoes, a style known as gaiters and the origin of the modern high shoe or, as the British say, "half-boots." The nankeen cloth top rose above the ankle and was laced in back, or on the inner side, and sometimes in front. Side lacing forced a right and left cutting of the uppers, but as far as the sole was concerned, it was generally cut straight to the middle of the century.

Evening footwear of the gentleman was confined to the heelless or low-heeled black kid or patent-leather pump with flexible sole and ornamented with a ribbon bow or buckle. Apropos of our own country a British visitor to Washington in 1820 wrote home that knee breeches and silk stockings were frequently seen in the evening with pumps decorated with gold buckles.

A new design for the masculine foot was the d'Orsay pump with its cut-down sides. This style of slipper, a classic in our day in lady's pumps, is accredited to the dandy Count Gabriel d'Orsay (1801–1852), a leader of society in Paris and London. He settled in England in 1821, was a "swell dresser" and an amateur in the fine arts. Many articles of dress acquired his name and are with us today, notably the top hat with the "d'Orsay roll" and the "d'Orsay pump."

A particular house slipper worn by the gentleman of the so-called Romantic Period (1815–1840) was a mule "à la chinoise" graced with the Oriental peaked toe.

Spring heels are first noted about 1835, the outcome of a desire to retain the flat-soled look but with the comfort of a slight rise under the heel. This was accomplished by inserting a wedge between the outer and inner sole at the heel just before nailing. Another shoe note of the early century was that buckles, buttons and shoelaces were imported from England.

White silk stockings continued to hold their own for dress but gray, brown and sheer black were coming to the fore. There were also white cotton and worsted for day wear and gay stripes for the beau.

Despite great opposition to long trousers in England, not only by fashionable men but also the universities and the clergy, long breeches were in to stay, and that brought in short hose for men. The English Prince Regent George IV in 1815 decreed the wearing of trousers for day wear which made "small clothes" an old fashion. Knee breeches remained in use for ceremonial wear. Trousers were of light neutral colors in elastic cloth, drill, white piqué, fine white corduroy and the very popular nankeen. The latter,

a very durable, buff-colored Chinese cotton, came originally from Nanking.

An innovation in footgear was the gored shoe, which was first designed in 1836 for a lady of high degree in the person of Queen Victoria (1819–1901). Elastic cloth or webbing, the first elastic fabric woven with rubber, was invented by T. Hancock of Middlesex, England. The shoe was the origination of J. Sparkes Hall, bootmaker to the queen, and was followed in the 'forties by a gored boot for men. Inserted webbing at the sides permitted drawing on the comfortable shoe without the need of fasteners. In America the style became known as the Boston or congress gaiter boot.

Soft, dainty, fragile shoes made up the foot-tire of the weaker sex of the first half of the century. Low, flat ribbon-tied slippers were termed Greek, and Roman sandals and ankle boots secured by ribbon laces were called cothurni. The ankle boots of the first decade were especially chic if made of white, red or blue morocco and if made by Coppé the foremost "cothurnus maker of Paris." In the second decade we meet fabric bottines which rose several inches above the ankles and were laced in back, front or at the side.

Slippers and bottines were made to match every costume of that great élégante of her day, the Empress Josephine, wife of Napoleon from 1796 to 1809. She delighted in a vast wardrobe upon which she spent a fortune. One day she exhibited to her shoemaker a pair of slippers which, after a hard day's wear, developed some holes. His examination of the worn shoes brought forth the horrified exclamation, "But Madame, you have walked in them!" Josephine wore only brand-new silk stockings in this period of white or pale-colored ones.

Slippers were made of jean, a twilled cotton fabric, Spanish silk and a new kind of morocco leather called Turkish satin. What were considered stout walking and working shoes, were of nankeen. A new note was the leather toe-cap on fabric shoes. For cold weather there were velvet fur-lined boots in blue-green, pale amber or mazarine blue and tied with ribbons. Brocaded or satin boots were embroidered with a design of colored flowers.

An English visitor in 1832, writing home, criticizes American women for not wearing boots over their fragile slippers even when stepping over snow and ice to their sleighs. She added that her own sensible woolen hose and sturdy boots were frowned upon by the beauties. The English lady commented further and herein revealed the reason for such unwise dressing, "that American women have universally extremely pretty feet."

Fabric slippers and half boots served the fair equestrienne on horseback. True, they were more conservative in color than her dress shoes, but they were enhanced with bowknots of bright green or purple ribbon to match her habit. Frequently, and quite properly too, she wore boots of yellow kid. The lioness of this period, the counterpart of the earlier merveilleuse, loved horseback riding but her costume resembled the masculine outfit and her mannish boots were armed with silver spurs.

Evening and house slippers often made at home were of almost any fine fabric such as velvet, satin, brocade and gros de naples, in shades of pink, sky-blue, lavender, yellow, green, gray and buff. They were ornamented with tiny bowknots and bead motifs of pearl and white bugle. Pretty indeed were the doll-like feet peeping out from under the full skirts, but for the greater part of the Victorian Period feet were more or less concealed. Even later, when women became athletic and took to playing croquet, lawn tennis and archery, skirts did not rise above the ankles. One spoke of limbs, not legs; for, like the story of the queen of Spain in the sixteenth century, women simply had no legs.

A bit on the ballet is fitting at this point because of the slipper and the short skirt. Ballet dancers until this period had always danced with heels but now they adopted the ribbon-tied escarpins, retaining them to the present time. Italy of the fifteenth century was the home of the ballet as court entertainment; but it was in France under Louis XIV that it was first performed on the stage. It reached its present form in the Italian and French schools in the second half of the nineteenth century.

The short skirt to the calf of the leg was introduced by the great French ballerina of the eighteenth century, Madame Camargo. Americans witnessed their first ballet performance in the 1820's, and incredible is the account of reaction of the audience. A French troupe of dancers appeared in the shocking short skirt which, though weighted with bits of lead, rose to a horizontal line during the pirouettes, revealing legs in pink tights. Women shrieked and left the theater while men fairly went into hysterics over the scene. Within a few years, however, people learned to admire the perfection of the art, which became very popular in the theater.

In men's attire spring heels appeared round the 'forties. Shoe colors changed to black, prunella and brown, though white kid was the thing with the all-white costume. New Yorkers and Londoners wore Kemble slippers

named in honor of the popular Anglo-American actress and author, Fanny Kemble (1809–1893). A French journal of this period mentions heeled boots and gaiters of lambskin as a protection against the Parisian mud.

In general, stockings were white, of Scotch thread and silk for dress, frequently hand-embroidered. The sheer silk stockings were often worn over flesh-colored cashmere, and intriguing indeed were those of coarse, black mesh worn over flesh silk.

Children's shoes were like those of the grownups and, too, like grownups, they wore the fragile shoes in all seasons. Little girls' legs were covered with frilled lingerie pantalets, a fashion popular from 1815 to 1850. Pantalets were the result of the necessity of leg-covering under the sheer cotton empire gown, but only a few French ladies ever wore them. Some English and American women adopted the style but it really became a children's fashion and, after 1820, just for girls.

An event of tremendous importance occurred in the 1830's when an American manufacturer, Charles Goodyear (1800–1860), turned his attention to the commercial production of rubber. His process of vulcanization was discovered in 1839, after years of experimentation which reduced himself and his family to poverty. In 1844 he secured his first patent, and upon this was founded the American rubber industry, including the manufacture of rubber shoes, fishing boots and outer soles.

Like so many remarkable inventions, the great secret was revealed to him when he accidentally dropped a bit of the gum on the hot stove. The word vulcanize is derived from the name of the mythological Vulcan, Roman god of the fiery element.

The milky juice of the tropical tree had been known for centuries. When the Spaniards first reached these shores they found the Mexican Indians not only playing ball with the substance but also wearing rubber shoes. The Spaniards called it gum; but from the Tupian Indian word "cau-uchu," meaning weeping wood, came the French word of the Jesuits, "caoutchouc." The English word "rubber" reaches back to the 1770's, the result of the discovery that the gum would rub out pencil marks—and that's just what it was used for in that period. A common name was India rubber because of its association with the Indians.

Not until the invention in 1820 of a process for cutting rubber into thread for the manufacture of tissue did rubber assume commercial importance.

From then on one reads of various experiments for practical use. The rubber-soled shoe was on the way when, in 1832, a New York man applied for a patent for attaching India-rubber soles to boots and shoes. An Englishman in the 1840's worked to elasticize leather with rubber. And an item of 1853 notes that a Boston sea captain imported five hundred pairs of rubber boots into this country.

Rubber heels, which appeared in the 'fifties, were in the form of a leather heel with a small, protruding insert of rubber. The first all-rubber heel dates from 1895, and, despite being very hard, heavy and attached by means of screws, was nevertheless considered a boon to humanity.

Before proceeding to the second half of the nineteenth century, it would be well to talk about some of the most important mechanical inventions for shoemaking. The growth of the use of machinery created mass production, and in time forced styles to change often in order to stimulate sales.

Inventors were at work upon a sewing machine as early as the middle of the eighteenth century, but the first one intended principally for leather work was the contrivance of the Englishman, Thomas Saint, in 1790. Simply put, his process consisted of a vertical awl which pierced a hole in the leather for the thread to pass through.

The problem of joining the upper to the sole by metal pins, nails or clamps instead of wooden pegs was solved by several men early in the century. In England, Sir Isambard M. Brunel built a clamping press for such an operation. This was during the Napoleonic campaigns, and with the aid of invalided soldiers he produced four hundred pairs of shoes a day. But when the war ceased, the shoemakers returned to their old methods and the machines were discarded.

An American produced a like invention in 1810, while about the same time in Paris two Frenchmen, one named Gengembre and the other Jolicière, also perfected machines. In 1822 a German shoemaker, one Brecht of Stuttgart, conceived the use of screws for joining soles and uppers. But it was an American, Nathaniel Leonard, of Merrimac, Massachusetts, who perfected a shoe-nailing machine in 1829.

Some New England inventions of the early period assisted greatly the process of shoemaking. The manufacture of shoe nails, replacing wooden pegs, dates from 1812. About the same time appeared a lathe by Thomas Blanchard of Sutton, Massachusetts, which turned out gunstocks and extra

handles, and because the lathe could shape irregular forms it proved valuable for making wooden lasts. Another New England idea, first used in the 1830's, was a complete set of diagram patterns for the cutting of shoes, instead of relying upon the skill of the cutter. A departure in the 1840's was the manufacture of counters for boots and shoes. A great step forward was the rolling machine which compressed leather in a minute, doing away with lapstone and hammer which required an hour of time and laborious effort.

In 1846 Elias Howe of Spencer, Massachusetts, patented his sewing machine which, though at first intended for cloth, was soon adapted for sewing leather with plain thread and then a waxed thread. Isaac M. Singer in 1851 patented his machine with a foot treadle. But the biggest advance in shoe sewing came in 1858 with the machine invented by Lyman B. Blake for sewing soles and uppers together. This greatest of all shoemaking inventions was ultimately perfected as the McKay sole-sewing machine and patented in 1860, Blake and McKay jointly securing the monopoly for twenty-one years of machine-made boots and shoes. This machine lightened shoe construction by making it possible to build shoes with thread instead of pegs and nails.

A severe test of the machine-made shoe came with the outbreak of the Civil War and the tremendous demand for soldiers' shoes. The army brogans, or "fadeaways"—as the soldiers called the McKay shoes—proved astoundingly durable. "Straights," that is, neither rights nor lefts, disappeared and "crooked shoes" first worn by the soldiers became so popular that they were adopted by civilians. But there were still only two widths, slim and wide.

Many improvements in machines followed, an outstanding one the Goodyear welt machine, the first device which, by means of a curved needle, sewed the welt to the upper and the outer sole at the same time. It came about through the invention in the 'sixties by Auguste Destouey, who lived in the United States, of a machine for making a turned sole. Perfected in the 'seventies under the direction of Charles Goodyear, Jr., it became the Goodyear welt stitcher.

Power to run the machine was first furnished by several husky men, replaced later by horsepower and in the last decade by electric motor. Contrary to the expected disastrous result, handworkers found that by operating machines they could produce more goods, thereby increasing their earnings.

Boots and shoes with cemented soles got under way in the 1850's, but the successful manufacturing of cemented shoes did not take place until the

1920's. The process is now applied to men's, women's and children's shoes, totaling a third of the annual output.

Until the second half of the past century a single wooden last in a given size served to shape either right or left shoe. Each size had two widths, slim and wide—wide being produced by a shell or padding placed over the last. An innovation in the 'eighties was the creation of half sizes, and also in the 'eighties, the standardization of last sizes was settled in the United States by the adoption among the retailers of a chart of fixed measurements.

The vogue of high-buttoned and laced shoes was responsible for the invention of an eyelet-setting machine in 1874, followed by a buttonhole maker in 1881.

The English continued to make footwear entirely by hand until the latter part of the century when economic conditions forced them into mechanical production. By this time they found that all necessary machinery was American-controlled and that they must needs hire from and pay royalties to the Americans for the use of their machines. While the machine-made shoe was a remarkable accomplishment which benefited many, many people, in all fairness one must state that the bespoke handmade English shoe of beautifully tanned leather was still the most desirable piece of footgear and the English boot—using a modern expression—was truly "tops."

Short Wellington boots were worn to the 1860's with strap or gaiter breeches, but the fashion event of the 'fifties was the laced-up shoe or half boot with closed throat, called the "balmoral." It made its appearance about 1853, introduced to the mode by the consort of Queen Victoria, Prince Albert (1819–1861). He erected a new castle of Balmoral as a royal residence in Aberdeenshire, Scotland, and it followed that everything new and smart was named "Balmoral."

This style was known to the French as the "Richelieu" while they called the blucher style of lacing the "Napolitain." The name "oxford" from here on signifies, in general, any low shoe laced over the instep. Gaiter fabric-topped shoes were also cut in balmoral style. Men, women and children adopted the new fashion, which reached us in the 1860's. Black patent-leather shoes had uppers of light-colored kid, and a novelty of the 'sixties was the box one.

Black or russet leather ankle boots were general for winter wear and the oxford for summer. Next men took to wearing oxfords in winter too, but accompanied by short gaiters or spats. The dude first appeared in white oxfords

for sports wear about 1880. The evening shoe was that classic the black patent-leather pump with black grosgrain bow and black hose. In fact, black hose were worn with all shoes, even white, though some gay young blades did flaunt black hose striped with color.

The mule continued to be the lounging slipper of men and women, in colored morocco or kid for the man and of soft leather and dainty fabric for his lady.

Sports came to the fore in the second half of the century, creating of necessity many new styles of footwear. The game of croquet, a popular pastime of the Victorian Period, was responsible for the first real sports model, a croquet sandal, later to be known as the "sneaker." It appeared in the 'sixties, and both men and women of that day wore the laced, fabric-topped, rubber-soled shoe.

Archery and lawn tennis became even more popular, and the 'seventies witnessed the beginning of intercollegiate football, the American national sport of baseball and the adoption of "bicycling" by both sexes. In the 'eighties the royal Scotch game of golf took hold, all such sports calling for sturdy light-weight shoes. In general, it was an ankle-high, laced leather shoe, the sole shod with protruding nails or buttons to prevent slipping. The shoe was worn with dark woolen hose and full slops—those very same breeches worn by the early Dutch settlers—thus the modern name, "knickerbockers."

The gaiter or legging of cloth, canvas or leather was seen in all walks of life, including that of the soldier. It fastened on the side, and was especially smart with the hunting outfit of either sex. They both wore knicker-bockers, but the feminine ones were concealed beneath the knee-length skirt of her tweed habit.

Puttees appeared in the Anglo-Indian Army late in the century. Puttees are of East Indian origin, as the name implies, "paṭṭī," a Hindu word which signifies a strip of cloth. It was a form of legging consisting of a woolen strip wound spirally from ankle to knee. A legging of the end of the period reached from ankle to knee but lacked foot-covering and the understrap. It too was called a puttee.

Boots were confined to horseback riding, worn by army officers, horsemen and polo players. The latter wore high boots and also an ankle-high laced style, which in the twentieth century has been adopted by men as a smart walking boot under the names of "chukka" and "jodhpur."

The revival of polo, a sport some two thousand years old, dates from 1862, when an exhibition was played in Punjab by two teams of four horsemen each. In the late sixteenth century India became the stronghold of the game, arriving by way of Persia, where the earliest records are known, having previously spread to Constantinople, Turkestan, China and Japan. Polo is from the Tibetan word, "pulu," meaning ball. So great was the enthusiasm of the British officers that in 1869 the Tenth Hussars introduced the sport to England, and thus it reached America.

It was in the mid-nineteenth century that the settling of the American West took place and produced the wild-riding cowboy. The men who rode the range have always worn their clothes for comfort and practicability which, coupled with Spanish and Indian influence, led to a picturesque, durable costume. Their riding boots are equipped with the same high heels of the ancient Asiatic plainsman, and for the same reason, to prevent the rider's foot from slipping out of the stirrup. Another reason, however, is that of bracing the foot against the ground when roping an animal. Unlike many of today's ornamented cowboys' boots, the earlier ones were of solid color.

Modern moccasin shoes originated in the 1880's, with the introduction of skiing into this country by a group of Norwegian enthusiasts in Minnesota. It was in Norway in the district of Telemark in 1860 that skiing developed its modern popularity, the sport eventually spreading all over Scandinavia. It invaded other countries with severe winters, especially Switzerland, the sport finally reaching this country.

From Montreal, Canada, in 1857 came our first snow boots or Arctic overshoes, fashioned of leather with uppers of cloth or felt with fur lining. Western lumbermen and farmers wore an overshoe made of buffalo hide with the fur retained as lining.

Plantation owners of the South ordered shoes for their Negroes by the simple expedient of a stick of the length from toe to heel, a separate size stick for each slave. Bundled together, the sticks or stogas were then shipped to the northern manufacturer for the broad, stout shoes and boots which were also called "stogas" or "stogies."

High heels returned to grace the feminine foot in the second half of the century on boots, shoes and slippers. Until this period most separate wooden heels came from France, but in the 1870's an American concern undertook the manufacturing of heels from cottonwood and Canadian basswood. Quan-

tity production of heels was inaugurated in the 'eighties when a French heel-maker named Bailey settled in Massachusetts.

Laced ankle boots, invariably of soft black leather and thin-soled, were for winter street wear and gray kid for warm weather. Those laced on the inner side became outmoded in the 'sixties by the balmoral with front lacing. This latter fashion was considered especially appropriate for the seashore and croquet.

Buttoned boots appeared, buttoned to the side of the center front or to both sides of the front. There were handsome shoes for carriage use, done in brocade, satin, kid or patent leather or in combination materials. These dainty boots often had leather tips, ribbon bowknots and tassels; and the new sewing machine was responsible for quantities of fancy stitching.

An outstanding fashion was the pretty Hessian boot of black patent leather topped by a swinging tassel and worn with a short crinoline-lined walking skirt. The shiny black boot was to be seen on the foot of the Victorian horsewoman, but more usual was the elastic gored boot for riding. Pumps with ribbon bows were quite correct for horseback. The Victorian horsewoman wore a full white muslin petticoat, starched and edged with fine embroidery, over long dark cloth pantaloons and under a full but hoopless skirt. From 1870 the masculine type of boot became *de rigueur* with a severely tailored habit. It went without saying that such boots were English, made to order, beautifully fashioned and very, very expensive.

Worn with stockings which matched the gown, evening slippers of satin or kid were ornamented with large bows and jeweled buckles. White or light-colored were the stockings for day wear, even with black shoes and most generally of thin lisle with cotton or worsted for common wear. Silk was a real luxury.

Silk was uncommon even in the wardrobe of the wealthy woman, fine lisle thread the smart thing as late as the end of the nineteenth century. Lisle is a modern product first made in Lille, France, but the name is the original spelling of that old Flemish town. Lisle is combed Egyptian cotton made fine and silky by a mercerizing process, the result known as mercerized cotton.

Bright-colored silk petticoats came into fashion, particularly red or violet, and stockings then took to matching the gay skirt. That led to candy stripes, the stripes running round the leg first, red on gray, followed by more vivid

combinations. After passing through the gamut of color, a vogue for black stockings occurred in the 'eighties, black then being worn with all shoes regardless of their color. A shapely feminine leg sheathed in sheer black was considered the very height of allure, the black stocking holding its own to the early 1920's.

Woman's entry into new spheres of life, business, sports and professional, called for a more comfortable and decidedly practical shoe. Many reforms in dress were attempted and one was in shoes. Thus was developed the "common sense shoe," a sturdy, laced boot with a medium-broad heel. In the 'eighties, with the rising enthusiasm for sports, women, like men, wore oxfords in black or russet leather. Many fashionable women adopted the heavy English style. It was the general rule in those days to change to high shoes in winter, not only for the comfort afforded but to slim down one's ankles after the season in unconfining low shoes, an idea still prevalent early in our century.

New shoe leathers appeared in the 'seventies and the 'eighties, alligator and reptile skins being tanned for footwear. From Australia came the hides of kangaroo and other marsupial mammals. Russian leather was reproduced here in America and chrome-tanned box calf was new. This latter was the first of the grain leathers, was black or light brown and had a fine grain finish. Chamoised buck, antelope and kid were newcomers around 1900.

In the last decade of the century the Gibson girl made her debut. She was the charming creation of Charles Dana Gibson (1867-1944), the American artist. With her crisp mannish shirtwaist she wore the plain, heavy oxford, sometimes with short gaiters or a laced boot. High-buttoned boots were for dressier wear. For afternoon affairs there were slippers of black, bronze or brown kid or black patent leather. Satin evening slippers were of the color of the gown, and ornamentation was furnished by straps, pump bows or colonial square buckles of steel or rhinestones.

Stockings were still mostly thread, lisle or worsted, but began to match the brown, black or white shoes about the middle of the decade. Silk stockings, a great extravagance, were to be seen more and more, and truly lavish were those of openwork with exquisite lace motifs inserted over the instep.

Little girls of the Victorian era wore flat, low-cut slippers and gaiters like their mothers, in leather, cloth and morocco—up to the 'seventies these were black, red or bronze with bows or tassels—and for special occasions, pumps

or strap slippers. The long stockings were white and gayly colored and very often bright red; but, from the 'eighties, black or brown became the rule, with perhaps white for dress. Small boys of the mid-century were indeed proud of their picturesque, black patent-leather boots topped with bright-red cloth cuffs.

Late in the century, in France and England, youngsters were dressed in stockings which left the knees bare, but American boys' legs were entirely covered with ribbed black cotton in the summer and wool in the winter. The laced ankle boot was the general shoe, and a black dancing pump for parties.

The mode is ever in pursuit of the new and even the exotic, but it had little effect upon a great part of the world, which adhered to a traditional costume. The boots of the Cossack and the Kamchatkian were of dyed sealskin or dressed leather, beautifully embroidered with an upper section of white leather made from white dogskin and a sole of white sealskin. If an unmarried man wore his handsome boots to call, on any but fête days, it was definitely concluded and noised abroad that the wearer was on courting bent.

Turkish ladies still wore the age-old pattens in their apartment gardens. The high stilts of precious woods were encrusted with mother-of-pearl, ivory and silver and were held on by means of gold-embroidered straps.

The knob sandal of Persia and India continued to be worn by men and women. The sandal was mounted on clogs and held by a knob between the large and second toes. This shoe of many centuries past was of wood, carved and painted, and, for occasions, made of silver. To the Costume Exhibition held in Paris in 1874 were sent several pairs which warrant description. The knob of one sandal was an ivory lotus flower with six petals tinted red, and each time the foot pressed on the sole the petals opened. The white ivory knob of another sandal made tinkling musical sounds when pressed by the foot.

Sandals of thin pieces of wood bound to the feet by leather thongs comprised the footgear of the middle-class Arabian women, those of the wealthier class always wearing slippers. Arabian women stained their feet, like their hands, a brownish-yellow and the nails red, this stain the juice of the plant "el henne" or henna. Turkish women wore slippers of yellow morocco, while Greek women must needs wear a dark neutral color during the period that

Greece was under Turkish rule, which lasted to their War for Independence in 1821.

All classes of East Indian women wore the ancient peaked toe on their slippers and no stockings, but fastened golden chain anklets round their legs. Jewish women of the Near East went stockingless but delighted in red slippers embroidered with gold thread. At the same time, in this part of the world the ancient sandal, the cothurnus and the buskin were also seen.

And in Sicily a superstition of centuries was still followed by the young woman hoping for a husband, the belief that a wish would be fulfilled if she slept with her shoe under her pillow.

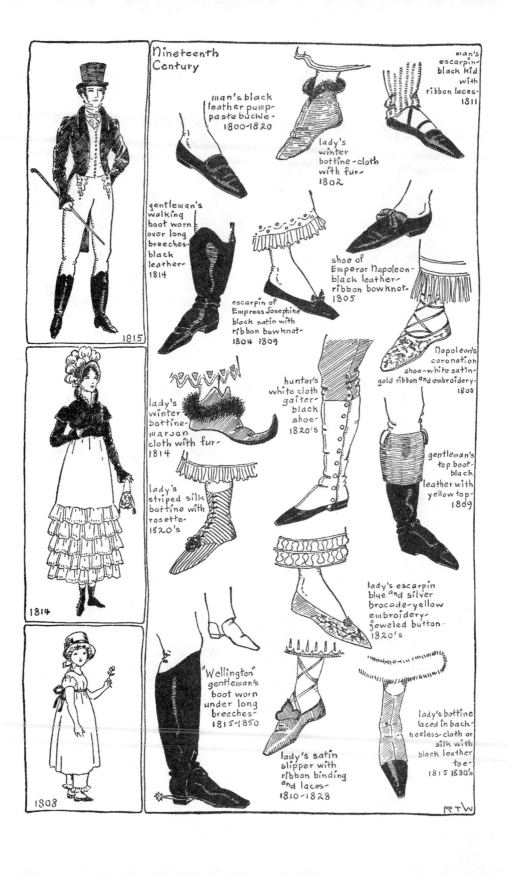

Nineteenth Century

man's black leather pump - paste buckle - 1800-1820

man's escarpin - black kid with ribbon laces - 1811

lady's winter bottine - cloth with fur - 1802

gentleman's walking boot worn over long breeches - black leather - 1814

shoe of Emperor Napoleon - black leather - ribbon bowknot - 1805

escarpin of Empress Josephine - black satin with ribbon bowknot - 1804-1809

Napoleon's coronation shoe - white satin - gold ribbon and embroidery - 1805

lady's winter bottine - maroon cloth with fur - 1814

lady's striped silk bottine with rosette - 1820's

hunter's white cloth gaiter - black shoe - 1820's

gentleman's top boot - black leather with yellow top - 1809

lady's escarpin blue and silver brocade - yellow embroidery - jeweled button - 1820's

"Wellington" gentleman's boot worn under long breeches - 1815-1850

lady's satin slipper with ribbon binding and laces - 1810-1828

lady's bottine laced in back - heeless - cloth or silk with black leather toe - 1815 1830's

1815

1814

1808

RTW

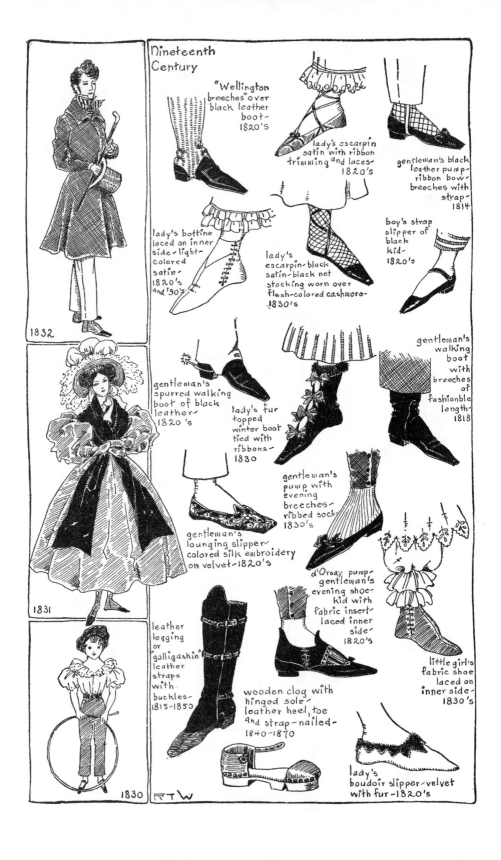

Nineteenth Century

"Wellington breeches" over black leather boot—1820's

lady's escarpin satin with ribbon trimming and laces—1820's

gentleman's black leather pump—ribbon bow—breeches with strap—1814

lady's bottine laced on inner side—light-colored satin—1820's and '90's

lady's escarpin—black satin—black net stocking worn over flesh-colored cashmere—1830's

boy's strap slipper of black kid—1820's

gentleman's spurred walking boot of black leather—1820's

lady's fur topped winter boot tied with ribbons—1830

gentleman's walking boot with breeches of fashionble length—1818

gentleman's lounging slipper colored silk embroidery on velvet—1820's

gentleman's pump with evening breeches—ribbed sock—1830's

leather legging or "galligaskin" leather straps with buckles—1815—1850

wooden clog with hinged sole—leather heel, toe and strap—nailed—1840—1870

d'Orsay pump—gentleman's evening shoe—kid with fabric insert—laced inner side—1820's

little girl's fabric shoe laced on inner side—1830's

lady's boudoir slipper—velvet with fur—1820's

1832

1831

1830

R T W

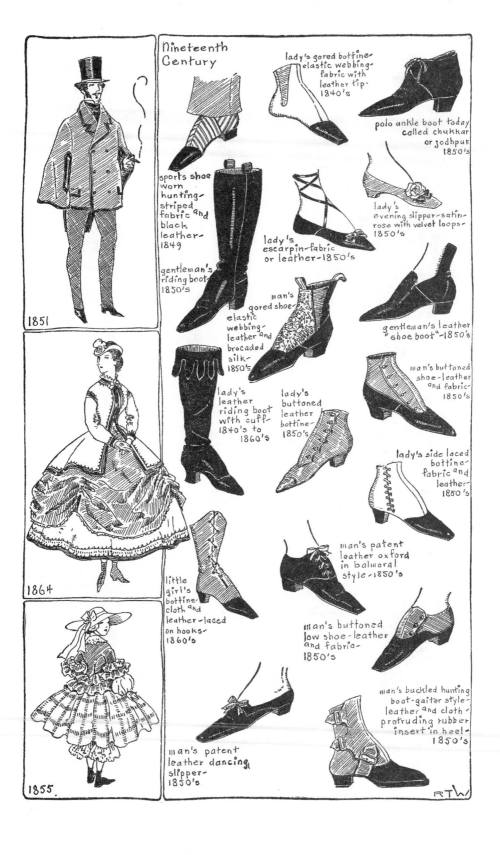

Nineteenth Century

1851

1864

1855.

lady's gored bottine-elastic webbing-fabric with leather tip- 1840's

polo ankle boot today called chukkar or jodhpur 1850's

sports shoe worn hunting-striped fabric and black leather- 1849

gentleman's riding boot 1850's

lady's escarpin-fabric or leather-1850's

lady's evening slipper-satin-rose with velvet loops- 1850's

man's gored shoe-elastic webbing-leather and brocaded silk-1850's

gentleman's leather "shoe boot"-1850's

lady's leather riding boot with cuff-1840's to 1860's

lady's buttoned leather bottine-1850's

man's buttoned shoe-leather and fabric-1850's

lady's side laced bottine-fabric and leather 1850's

little girl's bottine-cloth and leather-laced on hooks-1860's

man's patent leather oxford in balmoral style-1850's

man's buttoned low shoe-leather and fabric-1850's

man's buckled hunting boot-gaiter style-leather and cloth-protruding rubber insert in heel-1850's

man's patent leather dancing slipper-1850's

RTW

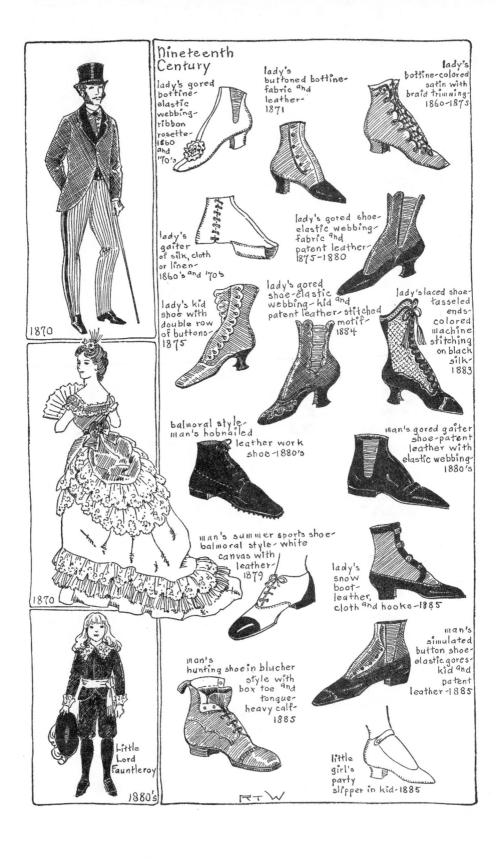

Nineteenth Century

lady's gored bottine-elastic webbing-ribbon rosette-1860 and '70's

1870

lady's buttoned bottine-fabric and leather-1871

lady's bottine-colored satin with braid trimming 1860-1875

lady's gaiter of silk, cloth or linen-1860's and '70's

lady's gored shoe-elastic webbing-fabric and patent leather-1875-1880

lady's kid shoe with double row of buttons-1875

lady's gored shoe-elastic webbing-kid and patent leather-stitched motif-1884

lady's laced shoe-tasseled ends-colored machine stitching on black silk-1883

1870

balmoral style-man's hobnailed leather work shoe-1880's

man's gored gaiter shoe-patent leather with elastic webbing-1880's

man's summer sports shoe-balmoral style-white canvas with leather-1879

lady's snow boot-leather, cloth and hooks-1885

Little Lord Fauntleroy 1880's

man's hunting shoe in blucher style with box toe and tongue-heavy calf-1885

man's simulated button shoe-elastic gores-kid and patent leather-1885

little girl's party slipper in kid-1885

RTW

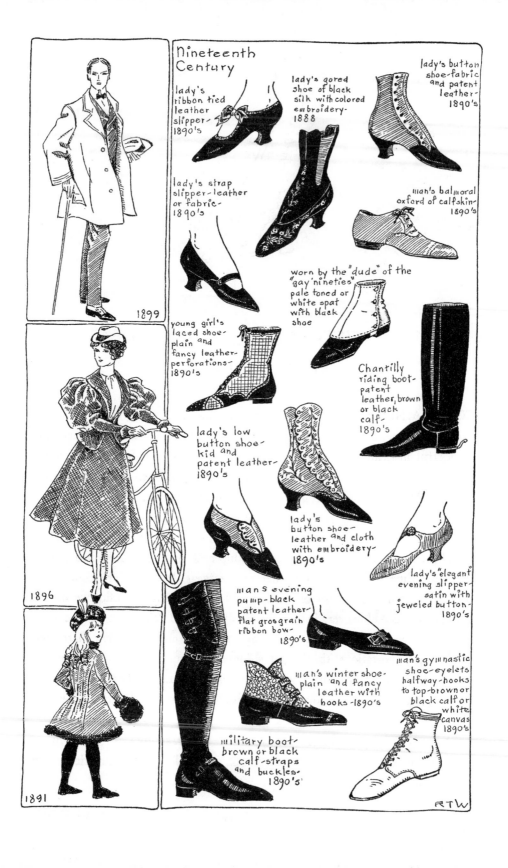

Nineteenth Century

lady's ribbon tied leather slipper - 1890's

lady's gored shoe of black silk with colored embroidery - 1888

lady's button shoe - fabric and patent leather - 1890's

lady's strap slipper - leather or fabric - 1890's

man's balmoral oxford of calfskin - 1890's

worn by the "dude" of the "gay nineties" pale toned or white spat with black shoe

young girl's laced shoe - plain and fancy leather - perforations - 1890's

Chantilly riding boot - patent leather, brown or black calf - 1890's

lady's low button shoe - kid and patent leather - 1890's

lady's button shoe - leather and cloth with embroidery 1890's

lady's "elegant" evening slipper - satin with jeweled button - 1890's

man's evening pump - black patent leather - flat grosgrain ribbon bow - 1890's

man's gymnastic shoe - eyelets halfway - hooks to top - brown or black calf or white canvas 1890's

man's winter shoe - plain and fancy leather with hooks - 1890's

military boot - brown or black calf - straps and buckles - 1890's

1899

1896

1891

RTW

TWENTIETH-CENTURY FOOTWEAR
CHAPTER SEVENTEEN

CORDWAINERY in this twentieth century has attained a height in design and volume never before reached in all its history. Skilled craftsmen and wonderful intricate machinery produce shoes appropriate for the individual in every walk of life and at a price to fit every pocketbook. The revolutionized craft of shoemaking from scientifically tanned leather has made modern shoewearing a real comfort along with modishness. Any uniform fit in width and length can be had in an almost unbelievable range of sizes.

The United States is the largest producer of shoes in the world and at the same time the largest consumer of footwear. Its shoes are conceded a high position in the realm of fashion and have a definite influence on the European shoe. However, before the Second World War, not all the shoes worn here were produced here. During the 1920's and the 1930's there were increasing importations, the largest shipments coming from Czechoslovakia, followed by Great Britain, France, Switzerland, Austria, Canada and Germany. At the same time our exports also increased, the largest amount of shoes going to Cuba and Canada.

A very important center in today's foot-tire is gay, sunny California, whence come many shoe novelties which are not only colorful, but practical, comfortable and downright sensible.

For the first two decades men adhered to the high shoe for winter and the oxford or low-button for summer wear. Black and tan were the standard colors in calf and patent leather with the white canvas or buck oxford for resort wear. The turned-up cuffs of the trousers revealed socks of vivid hue, striped and patterned in all kinds of designs. The conservative dresser wore black even with his white oxfords. Lisle was the general thing for socks, silk still on the luxury list.

Sporty young men were fond of high or low-buttoned shoes with white or pearl-colored kid tops. A conspicuous and inelegant style of the first decade was a shoe of yellowish-tan calf with an exaggerated box toe. Such shoes, called "bulldog toes," were known in Europe as the American last and adopted for machine-made shoes. Eventually, a compromise was effected when the box toe was lowered and shaped right and left, and the last lengthened and narrowed.

In the second decade men began to wear low shoes all year round, accompanied by gaiters or spats for winter weather and linen ones in the summer. Pearl-gray spats were smart with the cutaway for formal dress. Short gaiters were also in form for golf and hunting with brogues and heavy woolen hose topped by knickers. The stout oxford for country wear in brown or black with full brogan ornamentation often carried the slashed kiltie tongue.

The black patent-leather evening pump with tailored ribbon bow was rivaled by an oxford of the same leather, having a turned sole. The laces were of a wide black-silk military braid, often finished with tasseled ends. A leather with a new deep rich tone appeared for day shoes, cordovan it was called. And the process of cementing rubber soles and heels to leather shoes became perfected, employed first, principally, for bathing and athletic shoes.

For the very first time in the history of the boot, elegant ready-to-wear models for riding, hunting and military use could be purchased in smart shops. The English boot retained its position of superiority. New in military boots was the field boot laced over the instep, the basic design of which was more than a century old, the same that General Blücher introduced to army wear. The aviator's boot of World War I was laced from top to instep, a design adopted for hunting and sports.

Those strips of khaki cloth bound round the leg, the puttees of the Anglo-Indian Army, were quite generally worn by the private soldiers of the First World War, the officers wearing leather boots. Puttees of leather of one piece

and with front closure were worn with ordinary shoes for horseback and by chauffeurs in livery, but were definitely a substitute for the costlier boot.

A special boot was produced for mountain climbers or "Alpinists," a sport with ever increasing devotees. It was a very sturdy, roomy, leather shoe for wear over thick woolen hose. The strong sole was shod with bent nails, affording the climber, especially the amateur, a definite amount of grip. When indoors, ski enthusiasts wore a moccasin type of slipper in place of the heavy boot, a slipper now generally known as the Norwegian shoe. Founded upon the American Indian shoe but made with a firm sole, it has gradually worked its way to a staple and popular casual foot-piece.

The open motor car of the early century necessitated warm foot-covering which brought out the fleece-lined lambskin boot. It was large enough to be worn over one's shoes and was in demand for attending football games. This type of boot staged a revival in our decade, worn alike by men and women. In the same category are fleece-lined lounging slippers for winter use.

Notable in feminine footgear of the first two decades was the increasing number of different shoe leathers consisting of box calf, white calf, colored kids, buck and antelope. A new leather which proved very popular was "turned or reversed calf." It was chamoised buck or antelope, dressed on the flesh side in a suède finish, a finish also applied to goat, kid and lamb. Such leathers were dyed the new sand, brown and gray shades. In fact, all leathers forsook the traditional black and tan for the newer colors of beige, bronze and taupe. Green kid and brown patent leather met with little approval.

Oxfords and brogues were worn for sportswear, and the high button or laced shoe finished out its life as a dress shoe of fine leather cut very high, often reaching to the calf of the leg. Fashioned of kid, patent leather or suède, the shoe top was of contrasting cloth, suède, kid or even silk in the light neutral tones.

New and American was the feminine adoption of the man's evening pump, which milady took over as a carriage-and-street shoe. It appeared about 1904, and was at first considered a startlingly décolleté slipper for street wear. It succeeded in establishing itself as the classic woman's shoe of our era, the particular version varying according to the mode of the moment. The shoe was eventually made in all leathers with high or low heel, ornamented with ribbon bow or buckle or unadorned. Some young women, not content with the lady's shoe, purchased their pumps in the boy's shoe department.

Cloth spats of light neutral color were smart in the second decade with slippers and oxfords. Dressy oxfords of patent leather had very high French heels and were ribbon-laced. Although walking shoes were built with the Cuban or common-sense heel, fashionable women favored the high Louis Quinze heel or a lower model known as the "baby French heel."

The dancing craze began about 1912, with every one performing the tango, the Maxixe and other dances at afternoon teas or "Thé Dansants" and evening parties. This furor was responsible for all manner of fancy, beaded and bejeweled slippers, intricately cut. Slippers acquired ribbon ties bound round the ankles in cothurn fashion. The ballet slipper was worn, and tied in the same manner. Evening slippers were of the same fabric as the gown or, more generally, of black or bronze satin. Buckles, popular both day and night, were of cut-jet, cut-steel, marcasite, silver, gold and aluminum, sparkling with rhinestones.

Pumps and oxfords for summer were white in buck or linen. The flat rubber-soled, white canvas tie was the shoe for tennis and yachting. In 1915 one notes white buckskin sports shoes strapped with black or brown leather —the saddle oxford; and the fashion writer suggests that stockings with a delicate stripe are permissible to wear with them. This arbiter also says that polka-dotted or plaid stockings are in "good taste" with plain shoes.

The light shoe tops tended to influence the color of stockings, the latter matching the gray and sand colors of the former. Silk was *de rigueur* for dress and lisle or wool for sports. White was a summer fashion, worn with colored or black pumps. Evening slippers were matched in color, while stockings of gold or silver tones accompanied lamé slippers.

Evening stockings were made elaborate and costly with inserted lace motifs, embroidery and drawnwork. Those with real lace panels cost up to a hundred dollars a pair. There were such novelties as fish-net stockings, the thread tied by hand, and we read of a mouse-gray silk pair with a full-sized mouse embroidered on the instep. Another pair boasted an embroidered lizard on the instep, his back studded with rhinestones—"a very artistic effect," says the ad writer. Black was rare by the 1920's, especially for evening, flesh color or "nude" having supplanted the somber hue.

To protect her evening shoes in the winter, the lady wore carriage boots of velvetine or quilted satin edged with fur. Day shoes were protected in bad weather by galoshes and rubber overshoes.

For horseback, the rider wore black or tan boots according to her habit—tan with tweeds and black with dress. For golf, the sportswoman wore brogues with rubber soles, and, perhaps, the decorative fringed kiltie tongue hanging over the laces. Then came World War I, and many women followed their men into the conflict, wearing mannish laced boots or oxfords, with leather puttees or high cloth gaiters. The war created a scarcity in leather, leaving only kid, suède and patent leather for the civilian.

The rising hem line in the second decade was responsible for the drastic change in feminine shoe design, because it was apparent that the French shoe with short and round toe proved a more appropriate foil with the new short chemise frock.

Color became very important, the sand shades giving way to those matching the ensemble, all of which added many pairs of shoes to a woman's wardrobe. The gracefully curved, wooden Louis heel was covered with kid or celluloid or, for evening, with fabric, and very often encrusted with sparkling simulated jewels. Bejeweled heels, costing quite a sum, were to be purchased separately to replace the self heel.

By 1920 the low shoe had ousted the high for general wear among men and women, with designers creating many new styles suitable to any and every occasion. Men became almost as frivolous as the weaker sex in their choice of models. A profusion of new leathers appeared, the result of the new methods of tanning discovered by the chemists. Out of the laboratories came old leathers with a new richness. New masculine colors were rust, dark brown cordovan and the dark-brownish red of Russian leather, this latter called mahogany.

The visit of Edward the Prince of Wales, now the Duke of Windsor, in the 1920's did much to help popularize sports styles, especially reverse calf and the crepe-rubber sole, the latter sole and heel in one and of natural rubber without an alloy. He sponsored the gillie for men, the ancient Scotch shoe, with its distinct manner of lacing—the thongs drawn through slots which are part of the quarters.

A style of riding breeches, new to the Occidental world, came into fashion in the second decade. They are jodhpurs, originally from Jodhpur in Rajputana, India, full above the knees, tight from knee to ankle and held by a strap passing under the foot. Under the breeches is worn the ankle-high boot which, by the 1930's, was being made in men's wear as a walking boot. The

boot with military last and simple cut is known by two names of East Indian origin: first, "chukka"—signifying a period of play in polo; the second, "jodhpur"—after the breeches. A more popular name, resulting from the use of the shoe in the past war, is the navy term, "flight boots."

Most popular of men's sports shoes are the saddle oxford and the Norwegian slipper—or, by its more recent name, "loafer shoe." A modern improvement in the golfer's shoe consists of removable spikes with rubber cushion inserts which remove shock. But men, like women, now wear a variety of comfortable summer styles or "play shoes," which hail from the French Riviera, the Basque Riviera and our own California, the home of many happy ideas. And we must not forget the Mexican "huarache," the sandal of woven steerhide thongs, which made its American debut in Miami in 1934. This sandal, in its primitive form, was worn by the Mexican Army until quite recently, when it was ruled out as non-regulation.

New in the masculine mode in the late 'twenties and the 'thirties were pigskin and a color called "saddle-leather color." The patina of the carefully aged leather of fine English shoes was the result of much polishing, shoes sometimes dressed for as long as a year before delivery. This suggested an idea to our manufacturers; and, about 1936, they hit upon the scheme of "antiquing" new leather to a rich worn brown hue, which met with public fancy at once. Today, suède oxfords in dark blue, brown or black are not unusual in the masculine wardrobe, and even wedge soles, in a very low version, have invaded man's domain.

For formal day wear, the well-dressed man wears the black, waxed calf oxford, with which gray or beige spats are very smart. His gaiters would be of linen for summer. In evening shoes, the black patent-leather oxford has for a time eclipsed the classic pump.

The year 1920 marked the total disappearance of the high shoe in the feminine mode. A last attempt, however, was made to popularize the dress boot of calf, kid or patent leather. The boot reached to the calf of the leg, had a Louis Quinze heel and was named the Wellington. A few women of fashion, here and on the Continent, wore it; but the boot did not survive. The black silk stocking was no more. The flesh-colored stocking led to tones of beige, varying seasonally from a rose beige to a yellowish cast, a fashion which still holds in these 1940's.

The vogue of the pump, either mannish, opera or d'Orsay, continued

unabated. Another name for the opera pump with French heel is the Goya (1746–1838), recalling the dainty slippers worn by the Spanish ladies in that great artist's paintings. The spectator sports model was a newcomer for the summer, a white buckskin or suède pump with brown or black leather trim. What made it a spectator was the high built-up leather heel, known to the French as the "bootmaker's heel."

Of heels, there were the low mannish, the Cuban heel of medium height in leather, the covered French wooden heel, but, newest, was the high spike or spindle heel. In 1924 an English bootmaker designed a hexagonal-sided heel, which was followed by one with pentagon sides, of American origin. Heels of the new transparent galilith were tried, but did not reach the store shelves until the 1940's.

From then on, day shoes turned to the fanciful, appearing in almost any color with the preference for light neutral shades. The variety of leathers and combination of leathers were amazing. Suède, alligator and lizard were especially good, but a further list includes antelope, pigskin, ostrich, dolphin, sharkskin or galuchat. An iridescent kid did not meet with favor. Gabardine proved a good shoe fabric. The fashion of matching shoe, bag and gloves originated in the 1920's.

Sharkskin or "galuchat"—the fine pebbly-grained skin of certain sharks, was a novelty after the First World War—but, really, was not new, having been used in the eighteenth century in the days of Louis XV. A Parisian master-casemaker covered all kinds of boxes with the skin which he softened, dyed a brilliant green and gave a beautiful polish. He produced a mosaique metallic finish, despite its delicate quality. The little cases became very fashionable, and brought high prices to the maker, whose name was Galuchat.

An imitation of sharkskin was shagreen, of Russian origin and, like galuchat, dyed brilliant colors, principally green. An untanned leather, it was prepared from the hides of the horse, camel and ass. Seeds pressed into the grain or hair side of the skin when wet caused the tiny, protruding granulations which were later polished down. Shagreen was used for the decorative cases of the ornamental watches carried in Elizabeth's day. The name is now applied to like types of shark or ray skin, whether artificially produced or otherwise.

The dance of the mid-twenties was the Charleston, a name given the slipper having two eyelets tied with ribbon. Evening slippers went their merry way, becoming more and more exotic in design and fabric—velvet, satin, crepe

de Chine, bengaline and metal tissues in gold and silver. Mules and boudoir slippers followed suit, and of the latter we note that the d'Orsay cut was the favored style.

Women wore the gillie for sports with the long laces tied in cothurn fashion and, like the men, added the slashed tongue to their oxfords and gillies. A new, hot-weather model was the shoe of plaited or woven raffia in gay color.

After the acceptance of the many shoe novelties in the 'twenties, it would seem that anything could happen in footgear—and it did! Came platform soles, open soles, backless shoe and spike heels. And do not be mistaken, these were not really new but came down to us through the ages by way of the Riviera, the Lido, Miami and California. Then arose the summer fashion of going barelegged with painted toes, a fashion which illustrates more than any the gay abandon of our modern way.

Open-toed sandals appeared about 1934 as play shoes, to be worn either with beach or indoors lounging pajamas; wedge soles about 1937. It was as surprising to the makers of such frivolities as to the fashion-designing world when milady refused to give up the amusing accessories. Some authorities of the mode even instigated a crusade against the inartistic cut-off toes but to no avail. The fad became the fashion. True, the style was a help to the shoe merchant, because it made fitting a simpler problem.

Of course, there were many well-dressed women who ignored the foolish shoes; but the fragile, toeless slipper was generally worn in all seasons, day and evening. There were, however, handsome variations of the pump in novelty leathers and a form-fitting elastic twill cloth. A new form of ornamentation was that of gilt nailheads. The vogue made low heels popular and revived the ballet slipper. Fairylike slippers were fashioned of transparent plastic sheeting with galilith heels. An outstanding color of our period is red, of all shades, used for all types of shoes whether dress or sports.

Women's riding boots, like those of the men, observed the traditional English style but other boots intended for house and the outdoors ran riot in design and fabric. The open-toed and heelless shoe had its share in making the overshoe boot a necessity. Many of the fur-lined boots are not made, as formerly, to wear over the shoe, but to fit the foot in place of shoes. There are soft soles for indoors and heavy ones for the outdoors. We have boots of rubber, lambskin, ponyskin, of deep-piled fabrics, some fleece-lined, some fur-

lined, some fastened with buckles, some tied, some pull-on, and of varied color.

In the early years of this century children's shoes were definitely of the common-sense type: broad-toed with low or spring heels, of black or tan leather—high shoe or oxford, laced for boys and buttoned for girls. Black patent-leather pumps or strap slippers were for dress, also patent-leather shoes with light kid or cloth tops. The sandal entered the picture for play and summer wear, children adopting the classic shoe long before their elders. It was Isadora Duncan (1880–1927), the American dancer, who revived the ancient sandal which she wore with the Greek costume. She introduced barefoot dancing into the twentieth century, reproducing the classic poses of figures found on beautiful Greek vases.

Tiny tots wore laced or buttoned shoes in white suède or kid with white lisle stockings. Children wore socks in the summer, but, by the second decade, the European fashion of socks all year round was adopted here, with leggings and rubber overshoes for winter weather.

In the 1920's, children, like their elders, took to the low shoe for all seasons. Boys and girls of the 1930's fairly lived in saddle oxfords—the white summer shoe with brown or black leather trim. They wore the shoe even in winter, and a collegiate fad—which was truly a curious one—was that of the teenager wearing the white shoes without ever cleaning them though ever so dirty. Young people wore white woolen or cotton socks with them, a fashion still with us, and which designates especially the girls as "bobby soxers."

The moccasin loafer in brown or dark red elk-tanned leather is the favorite shoe of the 1940's for boys and girls. Today, young folks have as many models as have grownups to choose from, and as varied in leathers and colors.

The stockings of this period have reached perfection—or so it seems. Silk, wool, lisle, cotton and the synthetic yarns are woven in beautiful textures, patterns and color combinations. Perfected synthetic yarns are of this age. Artificial silk was first made of wood fiber, which proved unsatisfactory for stockings. Then came rayon which, today, is more successful in fit when combined with lisle or cotton. The finest of such yarns is nylon, which is woven into a gossamer sheer stocking, possessing not only great beauty but remarkable wearing quality. Nylons came on the market in 1939; but the war soon curtailed the use of the yarn for needs other than those vital to the war effort. Silk had ceased coming from the Orient, and women took to rayons and lisles, many

going barefoot in the summer. Only women in the service could secure nylons, which were furnished them by the government.

Those females, who felt naked with their bare white legs, covered them with "stockings out of a bottle," so a wit said. Leg paint enjoyed a boom, being made and sold by every cosmetician. An interesting bit concerning bare legs on city streets in our day is that the English actress Gertrude Lawrence was responsible for the fashion. She astounded the dressy world when, one hot day in July, 1926, she boarded the *Mauretania* in patent-leather shoes and no stockings—and that over twenty years ago.

For the past decade, the powers that be have been trying to change the stocking mode in color: gun metal in the 'thirties, and, now, attempts at smoky or muted colors. It may be that the vogue of the nude is on its last legs.

The well-dressed man wears socks in dark blue, brown or black, or heather mixtures in silk, lisle or cashmere in a wide rib, an English style of weaving known as three-by-six gauge.

World War II wartime measures controlled all civilian production. In 1943 the American was rationed to two pairs of new shoes a year, and leathers were limited. One could have brown or black; soles were thinner, while soles and heels of sport shoes could be made only of plastic or reclaimed rubber. A successful synthetic sole was developed of cotton fiber, reclaimed rubber and plastic, and was found to outwear several pairs of the best rubber soles. This proved a definite advantage in children's footwear. Women's casual shoes were of wool, linen, crochet-string, wood—everything and anything.

Great strides were made in producing substitutes. Natural liquid latex was successfully replaced by a synthetic rubber cement. It was found that synthetic waterproof soles are more flexible than rubber, are lighter on the feet and will outwear leather.

That remarkable vegetable, the soybean, originally from India and China, furnished sixty-million pairs of shoe soles during the war. These were black; but, today, the soles are being produced in colors such as chartreuse, fuchsia and electric blue, and shoes retailing from ten to fifty dollars are being shod with them. And platform-style soles of compressed rubber, which are very light, are also made in colors.

In the spring of 1946 an important branding iron was displayed, an iron with which the bootblack or shoemaker may repair instantly the new type of sole. Thus, the wearer will be able to have his shoes shined and mended

all at the same time. Or he can be his own cobbler by possessing the gadget.

During the war, the military forces claimed 40 per cent of the available shoe leather; but, now, that has ended, and practically all leather will again go into civilian footwear. It is said that two-hundred-million pairs of shoes alone will be produced in one year in the United States. In the post-war shoe mode, fantasy will have free rein in design, fabric and color. Both sexes will indulge in combinations of leathers with stitchery, pipings and perforations. The conservative man and woman will, again, find beautiful leathers in rich colors. Styles are of every conceivable design; and a news item is that the "closed toe" is the smartest thing. From London comes a really new idea in heels, a product of our machine age. A woman's sling-back sandal is graced with a high heel in the form of a steel spring, a drawing of which we show.

Sports, casual clothes and flat-soled shoes have contributed to a natural, beautifully formed feminine foot and carriage, a thing unknown among fashionable women since ancient times. Unlike her mother and forbears, the athletic, modern young woman cares naught for a Cinderella foot. She changes her footgear to suit her work or play, from low or no heel to high spindle, wearing either a heavy protective boot or a thong sandal as befits her requirements. She does not indulge in tight shoes; and the result is evident in her Greek-like foot with manicured and painted toenails.

It was not so long ago that only the fortunate few might possess shoes for each costume and every occasion. Today, the shoe designers, working hand in hand with the creators of costumes, make it possible to satisfy one's most fastidious desire in footwear, skillfully and beautifully produced by machine. And for those to whom price means naught, the ever desirable, fine handmade shoe is available.

Today, we wear the shoes of all time. One notes the primitive fur boot, the moccasin, the sandal, the alpargata, the mule, the peaked toe, the sabot, the Chinese theater boot, even the white cotton tabi of Japan—in fact, just about every style that has been worn through the ages. And, at the same time, these shoes are still the footgear of many of the peoples in whose countries they originated.

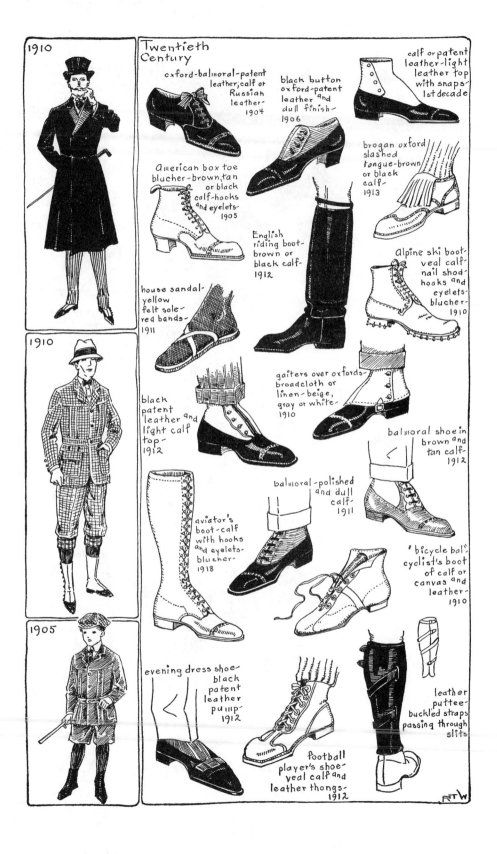

1910

Twentieth Century

oxford-balmoral-patent leather, calf or Russian leather- 1904

black button oxford-patent leather and dull finish- 1906

calf or patent leather-light leather top with snaps- 1st decade

American box toe blucher-brown, tan or black calf-hooks and eyelets- 1905

brogan oxford slashed tongue-brown or black calf- 1913

English riding boot-brown or black calf 1912

Alpine ski boot-veal calf nail shod-hooks and eyelets-blucher- 1910

house sandal-yellow felt sole-red bands- 1911

gaiters over oxfords-broadcloth or linen-beige, gray or white- 1910

black patent leather and light calf top- 1912

balmoral shoe in brown and tan calf- 1912

1910

aviator's boot-calf with hooks and eyelets-blucher- 1918

balmoral-polished and dull calf- 1911

"bicycle bal" cyclist's boot of calf or canvas and leather- 1910

1905

evening dress shoe-black patent leather pump- 1912

football player's shoe-veal calf and leather thongs- 1912

leather puttee-buckled straps passing through slits

RTW

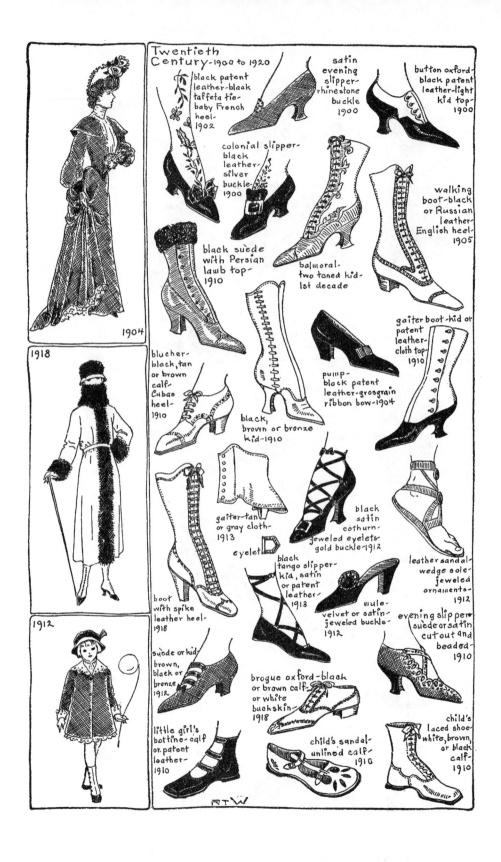

Twentieth Century—1900 to 1920

black patent leather-black taffeta tie-baby French heel-1902

satin evening slipper-rhinestone buckle 1900

button oxford-black patent leather-light kid top-1900

colonial slipper-black leather-silver buckle-1900

walking boot-black or Russian leather-English heel-1905

black suède with Persian lamb top-1910

balmoral-two toned kid-1st decade

gaiter boot-kid or patent leather-cloth top-1910

blucher-black, tan or brown calf-Cuban heel-1910

black, brown or bronze kid-1910

pump-black patent leather-grosgrain ribbon bow-1904

gaiter-tan or gray cloth-1913

eyelet

black satin cothurn-jeweled eyelets-gold buckle-1912

leather sandal-wedge sole-jeweled ornaments-1912

boot with spike leather heel-1918

black tango slipper-kid, satin or patent leather-1913

mule-velvet or satin-jeweled buckle-1912

evening slipper-suede or satin cut out and beaded-1910

suède or kid-brown, black or bronze-1912

brogue oxford-black or brown calf-or white buckskin-1918

little girl's bottine-calf or patent leather-1910

child's sandal-unlined calf-1910

child's laced shoe-white, brown or black calf-1910

1904

1918

1912

RTW

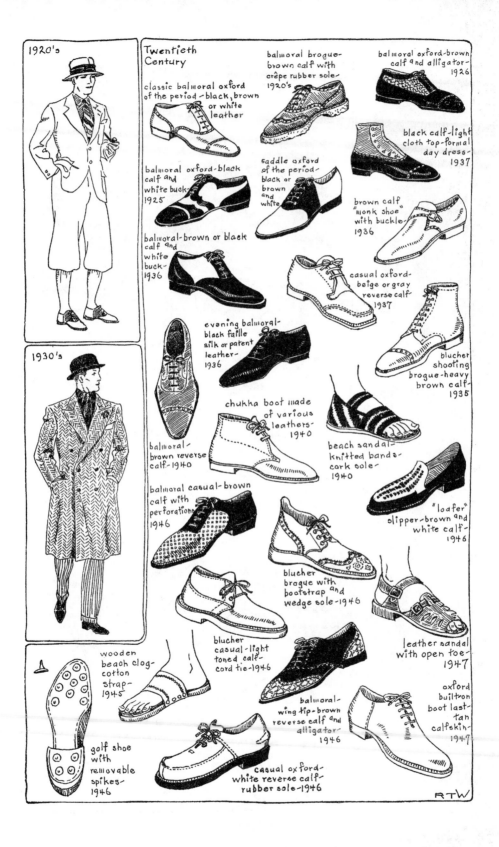

1920's

1930's

Twentieth Century

classic balmoral oxford of the period – black, brown or white leather

balmoral brogue-brown calf with crêpe rubber sole-1920's

balmoral oxford-brown calf and alligator-1926

balmoral oxford-black calf and white buck-1925

saddle oxford of the period-black or brown and white

black calf-light cloth top-formal day dress-1937

balmoral-brown or black calf and white buck-1936

brown calf "monk shoe" with buckle-1936

casual oxford-beige or gray reverse calf-1937

evening balmoral-black faille silk or patent leather-1936

blucher shooting brogue-heavy brown calf-1935

balmoral-brown reverse calf-1940

chukka boot made of various leathers-1940

beach sandal-knitted bands-cork sole-1940

balmoral casual-brown calf with perforations 1946

"loafer" slipper-brown and white calf-1946

blucher brogue with bootstrap and wedge sole-1946

wooden beach clog-cotton strap-1945

blucher casual-light toned calf-cord tie-1946

leather sandal with open toe-1947

golf shoe with removable spikes-1946

balmoral-wing tip-brown reverse calf and alligator-1946

casual oxford-white reverse calf-rubber sole-1946

oxford built-on boot last-tan calfskin-1947

RTW

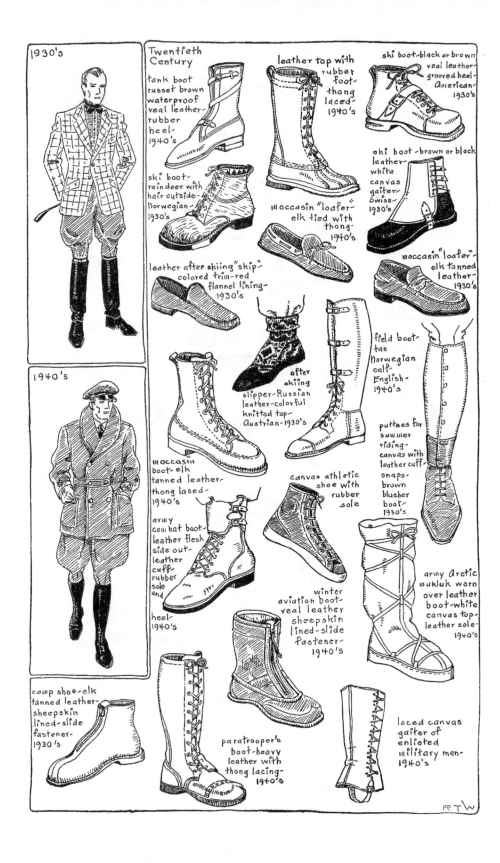

1930's

1940's

Twentieth Century

tank boot russet brown waterproof veal leather-rubber heel-1940's

ski boot-reindeer with hair outside-Norwegian-1930's

leather after skiing "skip" colored trim-red flannel lining-1930's

leather top with rubber foot-thong laced-1940's

moccasin "loafer"-elk tied with thong-1940's

after skiing slipper-Russian leather-colorful knitted top-Austrian-1930's

moccasin boot-elk tanned leather-thong laced-1940's

army combat boot-leather flesh side out-leather cuff-rubber sole and heel-1940's

canvas athletic shoe with rubber sole

winter aviation boot-veal leather sheepskin lined-slide fastener-1940's

ski boot-black or brown veal leather grooved heel-American-1930's

ski boot-brown or black leather-white canvas gaiter-Swiss-1930's

moccasin "loafer"-elk tanned leather-1930's

field boot-tan Norwegian calf-English-1940's

puttees for summer riding-canvas with leather cuff-snaps-brown blucher boot-1930's

army arctic mukluk worn over leather boot-white canvas top-leather sole-1940's

camp shoe-elk tanned leather-sheepskin lined-slide fastener-1930's

paratrooper's boot-heavy leather with thong lacing-1940's

laced canvas gaiter of enlisted military men-1940's

RTW

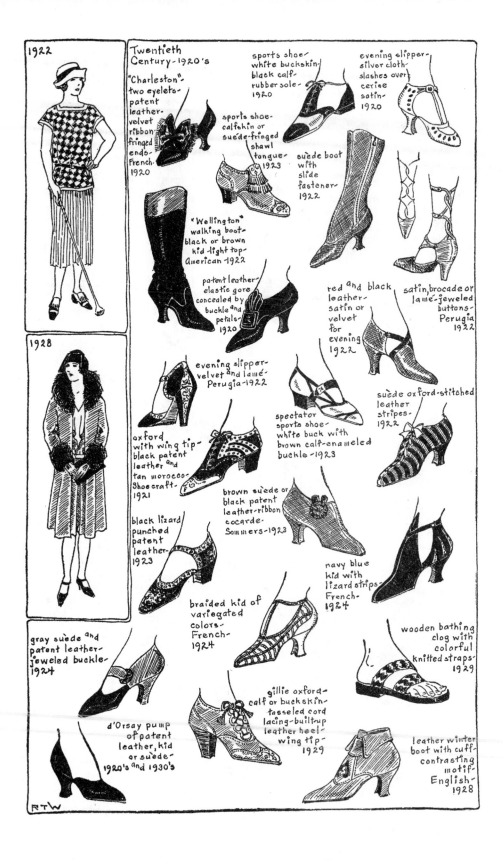

1922

1928

Twentieth Century—1920's

"Charleston"—two eyelets—patent leather—velvet ribbon fringed ends—French—1920

sports shoe—white buckskin—black calf rubber sole—1920

evening slipper—silver cloth slashes over cerise satin—1920

sports shoe—calfskin or suede—fringed shawl tongue—1923

suede boot with slide fastener—1922

"Wellington" walking boot—black or brown kid—light top—American—1922

patent leather—elastic gore concealed by buckle and petals—1920

red and black leather—satin or velvet for evening—1922

satin, brocade or lamé—jeweled buttons—Perugia—1922

evening slipper—velvet and lamé—Perugia—1922

oxford with wing tip—black patent leather and tan morocco—Shoecraft—1921

spectator sports shoe—white buck with brown calf-enameled buckle—1923

suede oxford—stitched leather stripes—1922

black lizard punched patent leather—1923

brown suede or black patent leather—ribbon cocarde—Sommers—1923

navy blue kid with lizard strips—French—1924

gray suede and patent leather—jeweled buckle—1924

braided kid of variegated colors—French—1924

wooden bathing clog with colorful knitted straps—1929

d'Orsay pump of patent leather, kid or suede—1920's and 1930's

gillie oxford—calf or buckskin—tasseled cord lacing—built up leather heel—wing tip—1929

leather winter boot with cuff—contrasting motif—English—1928

RTW

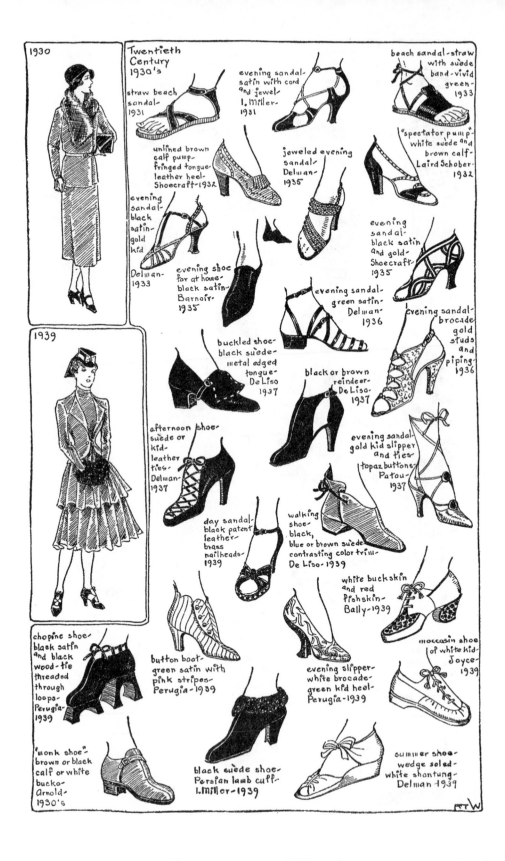

1930

1939

Twentieth
Century
1930's

straw beach
sandal-
1931

evening sandal-
satin with cord
and jewel-
I. Miller-
1931

beach sandal-straw
with suede
band-vivid
green-
1933

unlined brown
calf pump-
fringed tongue-
leather heel-
Shoecraft-1932

jeweled evening
sandal-
Delman-
1935

"spectator pump"
white suede and
brown calf-
Laird Schober-
1932

evening
sandal-
black
satin-
gold
kid-
Delman-
1933

evening shoe
for at home-
black satin-
Barnoir-
1935

evening
sandal-
black satin
and gold-
Shoecraft-
1935

evening sandal-
green satin-
Delman-
1936

evening sandal-
brocade
gold
studs
and
piping-
1936

buckled shoe-
black suede-
metal edged
tongue-
De Liso-
1937

black or brown
reindeer-
De Liso-
1937

afternoon shoe-
suede or
kid-
leather
ties-
Delman-
1937

evening sandal-
gold kid slipper
and ties-
topaz buttons-
Patou-
1937

day sandal-
black patent
leather-
brass
nailheads-
1939

walking
shoe-
black,
blue or brown suede-
contrasting color trim-
De Liso-1939

white buckskin
and red
fishskin-
Bally-1939

chopine shoe-
black satin
and black
wood-tie
threaded
through
loops-
Perugia-
1939

button boot-
green satin with
pink stripes-
Perugia-1939

evening slipper-
white brocade-
green kid heel-
Perugia-1939

moccasin shoe
of white kid-
Joyce-
1939

"monk shoe"-
brown or black
calf or white
buck-
Arnold-
1930's

black suede shoe-
Persian lamb cuff-
I. Miller-1939

summer shoe-
wedge soled-
white shantung-
Delman-1939

FTW

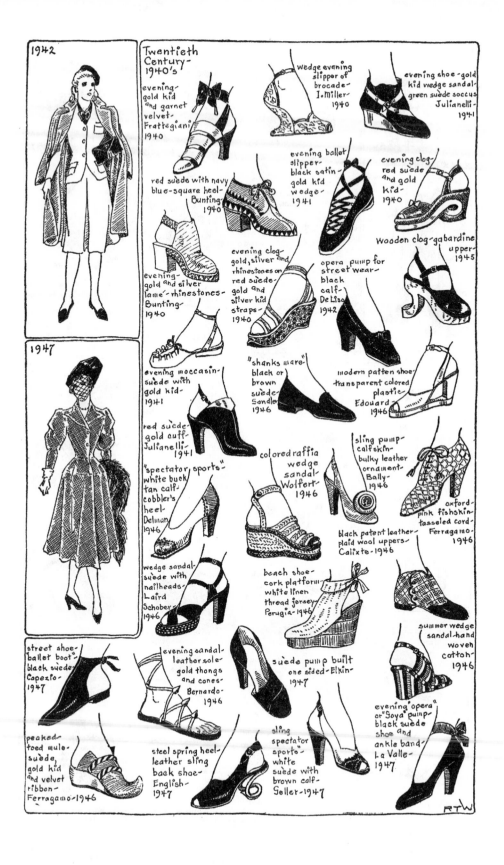

1942

1947

Twentieth Century- 1940's

evening- gold kid and garnet velvet- Frattegiani- 1940

Wedge evening slipper of brocade- I.Miller- 1940

evening shoe- gold kid wedge sandal- green suede soccus- Julianelli- 1941

red suede with navy blue-square heel- Bunting- 1940

evening ballet slipper- black satin- gold kid wedge- 1941

evening clog- red suede and gold kid- 1940

evening- gold and silver lamé- rhinestones- Bunting- 1940

evening clog- gold, silver and rhinestones on red suede- gold and silver kid straps- 1940

opera pump for street wear- black calf- De Liso- 1942

Wooden clog- gabardine upper- 1945

evening moccasin- suede with gold kid- 1941

"shanks mare"- black or brown suede- Sandler- 1946

modern patten shoe- transparent colored plastic- Edouard- 1946

red suede- gold cuff- Julianelli- 1941

"spectator sports"- white buck tan calf- cobbler's heel- Delman- 1946

colored raffia wedge sandal- Wolfert- 1946

sling pump- calfskin- bulky leather ornament- Bally- 1946

oxford- pink fishskin- tasseled cord- Ferragamo- 1946

black patent leather- plaid wool uppers- Calixte- 1946

wedge sandal- suede with nailheads- Laird Schober- 1946

beach shoe- cork platform- white linen thread jersey- Perugia- 1946

summer wedge sandal- hand woven cotton- 1946

street shoe- "ballet boot"- black suede- Capezio- 1947

evening sandal- leather sole- gold thongs and cones- Bernardo- 1946

suede pump built one sided- Elkin- 1947

evening "opera" or "Goya" pump- black suede shoe and ankle band- La Valle- 1947

peaked- toed mule- suede, gold kid and velvet ribbon- Ferragamo- 1946

steel spring heel- leather sling back shoe- English- 1947

sling spectator sports"- white suede with brown calf- Seller- 1947

RTW

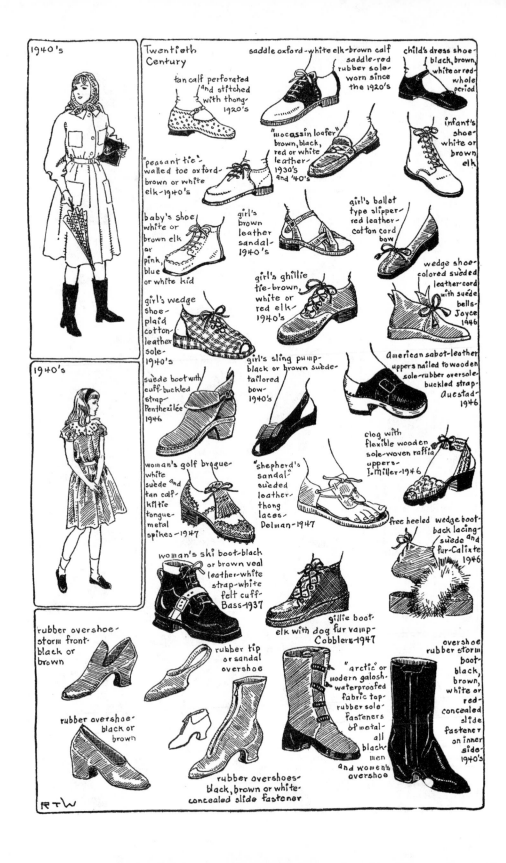

1940's

Twentieth Century

tan calf perforated and stitched with thong - 1920's

saddle oxford - white elk - brown calf saddle - red rubber sole - worn since the 1920's

child's dress shoe - black, brown, white or red - whole period

"peasant tie" - walled toe oxford - brown or white elk - 1940's

"mocassin loafer" - brown, black, red or white leather - 1930's and '40's

infant's shoe - white or brown elk

baby's shoe - white or brown elk or pink, blue or white kid

girl's brown leather sandal - 1940's

girl's ballet type slipper - red leather - cotton cord bow

wedge shoe - colored sueded leather - cord with suede bells - Joyce 1946

girl's wedge shoe - plaid cotton - leather sole - 1940's

girl's ghillie tie - brown, white or red elk - 1940's

American sabot - leather uppers nailed to wooden sole - rubber oversole - buckled strap - Auestad 1946

suède boot with cuff - buckled strap - Penthezilée 1946

girl's sling pump - black or brown suede - tailored bow - 1940's

clog with flexible wooden sole - woven raffia uppers - I. Miller - 1946

woman's golf brogue - white suede and tan calf - kilt tie tongue - metal spikes - 1947

"shepherd's sandal" - sueded leather - thong laces - Delman - 1947

free heeled wedge boot - back lacing - suede and fur - Calixte 1946

woman's ski boot - black or brown veal leather - white strap - white felt cuff - Bass 1937

gillie boot - elk with dog fur vamp - Cobblers 1947

rubber overshoe - storm front - black or brown

rubber tip or sandal overshoe

"arctic" or modern galosh - waterproofed fabric top - rubber sole - fasteners of metal - all black - men and women's overshoe

overshoe rubber storm boot - black, brown, white or red - concealed slide fastener on inner side - 1940's

rubber overshoe - black or brown

rubber overshoes - black, brown or white - concealed slide fastener

RTW

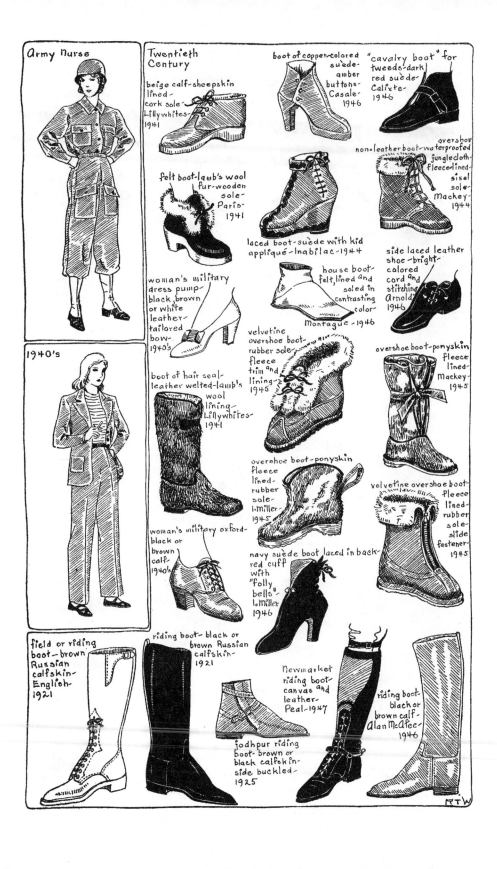

Army nurse

Twentieth Century

beige calf-sheepskin lined-cork sole-Lillywhites-1941

felt boot-lamb's wool fur-wooden sole-Paris-1941

woman's military dress pump-black, brown or white leather-tailored bow-1940's

1940's

boot of hair seal-leather welted-lamb's wool lining-Lillywhites-1941

woman's military oxford-black or brown calf-1940's

field or riding boot-brown Russian calfskin-English-1921

boot of copper-colored suède-amber buttons-Casale-1946

"cavalry boot" for tweeds-dark red suède-Calixte-1946

overshoe non-leather boot-waterproofed jungle cloth-fleece lined-sisal sole-Mackey-1944

laced boot-suède with kid appliqué-Inabilac-1944

house boot-felt, lined and soled in contrasting color-Montague-1946

side laced leather shoe-bright-colored cord and stitching-Arnold-1946

velvetine overshoe boot-rubber sole-fleece trim and lining-1945

overshoe boot-ponyskin fleece lined-Mackey-1945

overshoe boot-ponyskin fleece lined-rubber sole-I.Miller-1945

velvetine overshoe boot-fleece lined-rubber sole-slide fastener-1945

navy suède boot laced in back-red cuff with "Folly bells"-I.Miller-1946

riding boot-black or brown Russian calfskin-1921

Newmarket riding boot-canvas and leather-Peal-1947

riding boot-black or brown calf-Alan McAfee-1946

jodhpur riding boot-brown or black calfskin-side buckled-1925

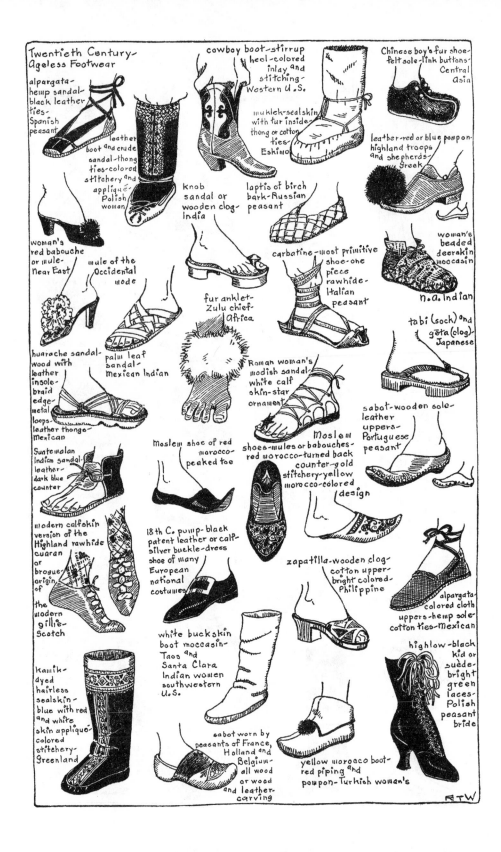

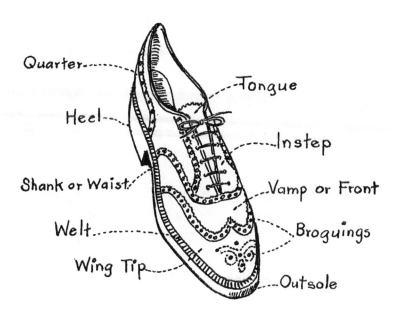

Quarter · · · · · ·
Tongue
Heel · · · ·
Instep
Shank or Waist · · ·
Vamp or Front
Welt · · · · · · ·
Broguings
Wing Tip · · · · ·
Outsole

A BRIEF OUTLINE OF SHOEMAKING
CHAPTER EIGHTEEN

THE SHOEMAKER and his craft carry us back into dim antiquity when on research bent, and one finds practically the same tools in the hands of our modern artisan. Marvelous machines electrically run have replaced the volume of handwork, but even in this mid-twentieth century one can still find the hand craftsman working with the same tools as those employed by the ancient Egyptian. These consist of a wooden mallet and a stone—a lapstone it is called—on which to soften the hide by pounding, and a small tub of water beside the shoemaker in which to steep the leather. There is the leather stirrup which holds the work on the knee, an awl, pincers, nippers, the various rubbing and polishing sticks, the several knives for scraping, paring and skiving, acid, sponge, stitch-marking tool, hog's bristles for sewing and beeswax.

An Egyptian tomb painting of three-and-a-half-thousand years ago shows the curved awl and the crescent-shaped knife of the precise forms of those still in use. And neither did the shoemakers' shops change, always a place of close quarters and open to the passer-by, the workman in his apron seated at a small workbench covered with his tools. When daylight faded a water-filled bottle focused the light of his candle or paraffin lamp upon his work.

While performing a vital service to his fellowmen, his shop the world over,

until the factory came, was a village gathering place, where all the topics of the day were discussed. The shoemaker was always a happy fellow who sang at his work and asked very little of the world. Over the centuries many shoe-makers because celebrities, the craft by the very nature of the quiet, slow, painstaking work which necessitated sitting hour upon hour, forcing the man to think and think. In the list are philosophers, magistrates, priests, statesmen and authors.

The modern factory does not permit the old-time contemplation, by reason of its awe-inspiring machinery, its every-accounted-for minute of working time, its lack of individualism and its tremendous output of perfect mechanical workmanship. But because of regulated hours, high wages and social benefits, the lot of the craftsman is improved in having more time for his private life.

There are two types of shoemaking, one taking in the greater part of the craft where the upper is fastened to the insole and reinforced by an outsole with heel. The other, which comprises "turn shoes," has a thin flexible sole to which the upper is sewed when inside out and then turned right when completed. Today the machine-made shoe vies with the handmade piece, more than two hundred operations being necessary for its production. Some machine work also goes into the handmade article.

The building of a shoe is here given in a most general way, with many minor operations omitted to make the picture easily understood. The upper leather in an oxford, for instance, consists of quarters, tongue, vamp and tip, which are fitted, lined and stitched together by the boot-closers. The heel and toe are reinforced by stiffened leather and fiber pieces, termed counter and box toe, to preserve the shape. The sole "stuff," which is steeped in water to mellow it, consists of a pair of inner soles of soft leather, a pair of outer soles of heavier leather, a pair of welts of flexible leather of about an inch wide and the heel pieces.

In the "lasting operation," the insole is fastened to the solid wooden mold by lasting tacks, and when the leather dries is drawn out with pincers making it conform to the shape of the last. The edges are then pared close to the last, and a channel about one-eighth of an inch deep is cut in the leather. The uppers are then placed on the last, the edges drawn tightly over the insole edges and fastened with lasting tacks. Pliers or mechanical claws pull the uppers and lining taut, after the uppers have been stapled to the insole channel.

Lasting is very important in the fit and life of a shoe, and in the modern factory producing fine shoes the upper remains on the last for at least a week. The welt is put into position in the channel, and the upper, welt and insole are stitched together. After the surplus leather has been trimmed off, the shank which fits under the arch is inserted. The outsole is channeled, through which it is stitched to the welt.

The soles are now molded to the exact shape of the bottom of the last, this accomplished in the handmade shoe by hammering and by steel rollers in the factory. The rubber heel base is attached to the outsole and then the top lift or rubber heel. After this, follow many finishing operations in paring, rasping, scraping, smoothing, blacking and burnishing the edges, soles and heels.

After the shoe has been pulled from the last, the bottom is scoured, waxed and stained. The shoe is then dressed and fitted with pads and laces. The cordwainer is able to produce a handmade shoe in fourteen to sixteen hours, but at the same time a quality shoe, either hand or machine-made, may take as long as two or three weeks for completion.

The shoe is the subject of many of our pet proverbs and especially Latin in origin such as: Each one knows "where the shoe pinches"; "if one lacks slippers, one goes barefoot"; "the shoe on the other foot"; "you can't put the same shoe on every foot"; "dies with his boots on"; and "the shoemaker goes without shoes." The French say a man "is in his slippers" when he appears embarrassed, and to amass riches is "to stuff one's sabots with straw."

From the writings of Pliny the elder, the celebrated Roman naturalist who lived in the first Christian century, we have the following: Apelles, a famous Greek artist, upon the completion of a picture would exhibit the work of art in the front of his studio to the passers-by, concealing himself from view to listen to censure or compliment. One day a shoemaker criticized the omission of a latchet from a sandal. When on the following day the critic again passed by and found that his advice had been acted upon, he immediately acquired self-confidence and began to question the drawing of the leg.

That was too much for Apelles, who showed himself with the retort which has become a proverb in all languages, *"Let the cobbler stick to his last."*

THE PREPARATION OF LEATHER

CHAPTER NINETEEN

THE PREPARATION of leather is the oldest craft, practiced long before the art of weaving. We know that the man of the Stone Age made body-coverings of animal skins, because he left behind numerous specimens of his weapons and tools. His implements for making garments consisted of a scraper for removing the fat, an awl fashioned of bone for making holes, a bone needle and a stone on which to sharpen the needle. Flint with a sharp edge divided the sinews which served as thongs or thread. Such tools were discovered in caves of the various European countries.

The art of making leather from hides or skins is directed toward overcoming putrefaction, rendering the skin impervious to water, acquiring softness and flexibility and securing greater strength to resist wear. This, primitive man accomplished, by drying the hides in the sun, exposing them to fire and smoke and then transforming the texture of the skin by the use of sour milk, urine and fats. By this method Arctic peoples, like the Eskimos of today, still prepare leather.

Urine was also used in dyeing in ancient times. Dyers and tanners were ostracized people, an inscription on an old Egyptian papyrus setting forth that "the hands of the dyer reek like rotting fish"—and no wonder. Leather shoes were scented with perfume, no doubt for that very reason.

It is interesting to observe that the tanning methods of the ancients were followed until the sixteenth century, no real improvement taking place until the nineteenth century. Large tanning yards existed in ancient Egypt, Greece and Rome, and the basic tanning principles of that age are those of today. Tanning was carried on by the leather-working trades, the actual work performed by the peasants in their dwellings. In India to modern times, the leather-sandal maker tanned his hides. A quick job he made of it, too, salting

the skin in the morning, then exposing it to the sun for drying, with the leather ready for use in the afternoon of the same day.

In the Medieval Period leather was made of the skins of sheep, goat, pig and "fish," this latter term comprising porpoise, seal and walrus. Very choice and desirable to European nobility was cordovan, the beautiful, soft leather prepared first by the Moors and then by the Spaniards at Cordova. Originally of calf, goat or split horsehide tanned in sumac, the result was a richly grained, dyed leather, usually red.

Venice produced a similar dyed and embossed leather, and was especially famed for her gilded leather. The artisans of Cordova and Venice who turned out the fine leather never permitted a stranger to enter their studios, and thus the process was kept secret to the Renaissance. Cordova became a general name for the product, and a common saying was "as strong as cordovan." As time passed we find other European countries making the much-sought-after leather, particularly Flanders. Coffers and large wooden chests were covered with the dyed and embossed cordovan and enriched with handsome hand-wrought ironwork.

The Spanish love of fine leather was carried into hunting dress, and the seventeenth-century painter, Velasquez (1599–1660), recorded the persons of Philip IV and his son in such costumes, finished with the costly exquisite lace collar of the period. The handsome leather ensembles were frequently of dyed skins in brown, dull red or dark green. The Spanish Infanta Maria of the same period, affianced to Charles I, ordered suits of amber-perfumed leather embellished with gold, silver and pearl embroidery as an engagement present for Charles.

Late in the sixteenth century the soldier wore a buffalo skin padding under the breast and back plates of his armor, and as armor gradually disappeared the buffcoat or jerkin took its place. About 1630 a pike and sword-proof buffcoat appeared, made by a Frenchman named Nérac. The strong hide was made elastic by a chamois dressing, and rarely dyed, but left the natural light color. The jacket, very often sleeveless, was fastened by thongs or lacings. Buffalo leather was expensive and apparently available only from Germany; but the new coat was soon copied in calf and sheepskin which were much cheaper and served quite as well.

The buffalo or European bison was originally introduced into southern Europe from India and Egypt. In these latter countries, the domestication of

the animal dates far back into prehistoric times. We know from Cæsar's writings that the buffalo roamed the forests of Belgium and Germany, and in the sixteenth century appears to have been fairly common there.

The American bison was wrongly named by the Anglo-Americans. Before the whites came, the herds of bison furnished food, shelter, clothing and weapons to the red man. So-called buff, an oil-dressed leather, is still extensively used in army equipment but the hides are those of deer, oxen and elk. It is usually of the best parts of South American light ox or cowhide, prepared by a special process which leaves the leather pliant and not liable to crack and rot.

Russian leather was fashionable in earlier centuries. The bark-tanned calfskin gave forth a spicy fragrance produced by the long tanning contact with willow and white birch, the oil of the latter furnishing the enticing odor. The scent was duplicated in a toilet water, a secret formula used by the Russian ambassador to Napoleon's court.

Modern Russian leather is produced in Europe and America, the best qualities before World War II coming from Austria. It is the product of horsehide, calf, goat and sheepskin dressed brownish red or black, and given a bit of scent with white birch bark which also makes the leather insect and moisture resistant. Aniline dyes now supply the color, formerly an infusion of Brazil wood applied with brush or sponge.

When the Europeans came to these shores they found that the American Indian had perfected his tanning methods, using the animal's brains to oil-tan deerskin hide. We noted in Chapter 13 the softly tanned leather in white, yellow, red and black resembling fine cloth.

Before tanning, the North American Indian placed the hide of the deer and the brains on the ground to dry. When the hunting season ended, the Indian women softened the hides by soaking them in a pool, then cleaned them of hair and fat by scraping with a knife. The hides with the brains were next placed in a large earthen pot and heated, an operation which plumped and cleaned them quite successfully.

Then the skins were taken from the cauldron, lightly wrung out, stretched on a frame where they were tied. While drying, the women rubbed the skins continuously with a piece of wood or stone, thereby eliminating water and any fat. The Indians also had a medicinal use for the ooze or tannin, apply-

ing it to a sore throat, a cure which, in surprisingly recent times, many country people remembered and believed in.

The tanning methods of the American colonist were those of Biblical times. Long vats of rough-hewn planks were sunk in the ground under the protection of a shed. After the hides were soaked and rinsed, the particles of fat removed and scraped clean of hair loosened by lime, the skins were ready for tanning.

The floor of the vat was sprinkled with finely ground oak bark, and a hide placed upon it. Then another sprinkling and another hide, and so on, until the vat was almost full, then covered with water and left to soak an indefinite period, perhaps six months. Several times during the soaking the spent tan was removed and fresh bark applied.

Today there are three classes of leather: first, tanned leather, the result of its being treated with tannin or tannic acid; tawed leather, when the skins are prepared with mineral salts; and **chamoised** or **shamoyed leather** when impregnated with oils and fats. The processes, all designated as tanning, vary slightly according to the method of the individual tanner. Glove leather is given a much lighter tanning than that intended for boots and shoes.

In preparation for tanning the skins are water-soaked and bathed. The flesh side is covered with a depilatory and then the hair is scraped off. Next comes a cleaning in a lime bath, which also separates the fat and softens the skin—plumping and swelling this is called. Repeated baths reduce the plumping, the hides are again pared, skived or scraped of any remaining fat, and are then ready for tanning.

In **vegetable** tanning, which is used chiefly for heavy leathers such as are employed for soles, the skins are tanned with tan barks or other vegetable substances containing tannin. British scientists, in their tanning experiments of the nineteenth century, proved that the accepted standard group of oak bark, sumac and gall nuts could be augmented by hemlock, mimosa and several other suitable agents. Hemlock was a valuable find to American tanning because of the prolific growth of the tree in this country.

In **mineral** tanning or tawing, the leather, which is used principally where light leathers are required, is the product of pelts tawed with alum, bichromate of potash and other mineral salts. Alum tanning was known to the ancients, the Romans calling the soft tawed leather "aluta." Beauty patches

were made of it and used by both sexes, and it is particularly recorded that orators wore them when speaking from the tribune.

Oil tanning was practiced in antiquity and consists of impregnating the hides with oils and fats instead of tannin. It was formerly known as "shamoying," but today the term is "chamoising."

Chrome tanning is the most important method of dressing leather today, and originated in Germany in the second half of the last century. In this, the skin is impregnated with chromium salts, with or without other metallic salts. It converts pelt into leather in a short time, and has the added advantages of strength, durability and appearance in the finished leather.

Almost any skin with a natural beauty suitable for use can, today, be transformed into a supple, durable leather. In the luxury grade, a volume of leather is obtained from sources formerly not considered practical, such as: monkey, fish, reptile, birds and the cetacean and saurian orders.

After tanning, the currier and the leather dresser take over and the leather is dried, staked, dressed and dyed.

The technique of tanning in the twentieth century has been improved by the use of synthetic tannin, with which it is now possible to produce leather in a few days, as against months and, sometimes, years required by the ancient methods. American ingenuity in the 1920's perfected a process whereby the photographed texture of crocodile, lizard and snake could be printed from the negative on leather. Imitation grain and finish on split calf and sheepskin are accomplished by remarkable printing and embossing machines. And now, as the result of enforced experiments during the war shortages, we are promised many new leather finishes as, for instance, the spraying of leather with colored plastics, and a washable gold leather.

Apropos of these novelties we are sure that the male of the species will be content, and rightly so, with just plain, fine leather in his wardrobe.

GLOSSARY OF SHOE LEATHERS

IN COMMERCIAL language hide is the undressed skin of full-sized animals such as cows, steers and horses, while the undressed skins of smaller animals are kips; those of calves, sheep, goats and the like come under the heading of skins.

Alligator—From United States and India . . . belly and shanks only of baby alligators used for shoes . . . much imitated in embossed sheepskin.

Antelope—Soft, velvety, light leather dressed with suède finish on flesh side.

Antelope Finished Suède—Calfskin, lambskin and goatskin suèded to resemble antelope.

Basil—Sheepskin tanned by various processes . . . used for shoe linings, the use declining.

Box or Boarded Calf—Novelty leather of the late nineteenth century . . . calfskin tanned with chrome salts . . . rolling it crosswise and then lengthwise produces square markings on the grain, thus the trade name "box calf."

Bucko—Reversed calf so-called because of resemblance to buckskin . . . suèded on the flesh side.

Buckskin or Buck—Formerly from deer and elk . . . calves and sheep now also used . . . the skin of the buck made strong, soft and pliable . . . yellowish or grayish white . . . genuine buckskin from small deer of Mexico and South American countries.

Buff Leather or Buffskin—Stout, velvety, brownish yellow leather . . . buffalo skin given oil tanning like chamois . . . elk, deer and oxen dressed same way.

Bull or Cow—Heavy, fibrous leather used chiefly for heels and soles . . . principally sole leather for heavy boots . . . also skived and dressed on flesh side in black and colored box, grained and patent leather.

Cabretta—Species of Brazilian haired sheep finished like kid and used for linings.

Calf or Calfskin—Fine grained leather from cattle a few days to a few weeks old . . . finished in high polish, suède and patent leather . . . dyed all colors.

Cordovan—Soft, fine, grained colored leather made of goatskin at Cordova in the Middle Ages . . . now made of split horsehide, goatskin, pigskin and other skins . . . nonporous, durable and expensive.

Cowhide—Heavy leather from cow's hide used for boots and soles.

Deerskin—Buck or buckskin . . . see above.

Dogskin—Imported from Mongolia and China . . . soft and durable resembling goatskins.

Elk—Originally smoke-tanned hide of elk but now of cowhide and calfskin dressed with smoke-tanned color and odor . . . tanned elk is called buckskin.

Galuchat—The French name for polished sharkskin because first used by Galuchat of Paris in the eighteenth century.

Goatskin—Prepared in all finishes and colors . . . dressed to imitate antelope and deerskin . . . 99 per cent of the goatskins in American-made shoes imported from India, Dutch East India and China.

Grain Leather—Any leather dressed on the grain side of the skin . . . often a split from a thick tanned skin like cowhide.

Hides—Commercial term for pelts over 25 pounds.

Horsehide—Leather of lesser quality used for uppers and imitation Russian leather.

Kangaroo—Soft, supple, durable shoe leather exclusively from Australia, and limited because the animal exists only in the wild state.

Kidskin—Tanned leather of mature goats usually two and a half years old . . . in all finishes and all colors . . . dressed to imitate antelope and deerskin.

Kips—East Indian hides of yearling cattle . . . tight grained leather from a breed of small oxen . . . dressed to imitate box calf and cheaper. Commercial term for pelts 15 to 25 pounds.

Lambskin—Used for shoe lining . . . also the skin tanned white and dressed with the wool.

Lizard—Scaly, decorative and durable leather of lizard from Java and India . . . does not crack.

Morocco—Originally produced by the Moors . . . of goatskin usually dyed red . . . today of calf and sheepskin and other thin leathers . . . graining and finish imitated by printing and embossing.

Ooze—Usually calfskin in suèded or velvety finish.

Ostrich—A newcomer in leathers . . . strong, durable and not given to stretching . . . decorative surface formed by quill holes.

Patent Leather—Japanned or enameled leathers—the dressed flesh splits of white-hair seal which are japanned . . . enameling is done on the grain of the leather.

Peccary or Wild Boar—Native to Mexico, Central and South America . . . fine-grained, light-weight pig leather . . . limited quantity.

Pigskin—Stout, coarse, grained leather made of hog's hide . . . decorative surface caused by bristle holes . . . greater part from China.

Pin Seal—Fine pin-grain seal known as levant morocco . . . strong, durable leather of the white-hair seal, not the fur seal.

Porpoise—Good quality for stout shoes . . . really the hide of white whale . . . dressed for hunting and fishing boots.

Rawhide—Untanned cattle hide that has undergone some preparatory processes.

Reindeer—Heavy, durable leather used for shoe uppers.

Reverse Calf or Bucko—Suède-finished heavy-weight calfskin dressed on the flesh side.

Roan—Low-grade sheepskin dressed to imitate ungrained morocco . . . tanned with sumac . . . dyed and used for boudoir slippers.

Russian Leather—Originally from Russia . . . a light leather from the hide of young cattle dressed brownish red or black . . . fragrant odor . . . tanned in willow bark . . . dyed in cochineal and sandalwood . . . birch-bark oil gives the odor . . . insect and moisture resistant.

Scotch Grain Leather—Usually of cowhide with pebbled grain . . . heavy, durable leather for men's shoes.

Shagreen—Untanned leather originally prepared in Russia to imitate shark-skin . . . dyed vivid colors, especially green . . . name applied to all such leathers whether real or imitation.

Sharkskin—Rough skin of certain sharks and rays covered with small, hard, round granulations . . . with armored surface removed, used principally for toe caps of children's shoes.

Sheepskin—Use for shoe lining declining . . . also chamoised.

Skins—Commercial term for pelts weighing up to 15 pounds.

Skiver—Grain side of split sheepskin tanned in sumac and dyed . . . cheap, soft leather used for lining.

Snakeskin—Elastic leather from farm-raised reptiles in South America on the Amazon . . . cobra, boa, python, watersnake and others.

Suède—Word signifying Swedish . . . velvety finish originated in Sweden . . . formerly from kidskin only . . . now much from baby lamb and calfskin.

Veal Calf—Upper leather from a large-size or partly grown calf . . . soft, heavy, durable, waterproofed leather . . . used principally for ski and woodsmen's boots.

Vici Kid—Trade name for goatskin tanned and finished by special method producing a bright glazed finish.

Wallaby—Kinds of smaller kangaroo . . . see kangaroo.

BIBLIOGRAPHY

Italian—*Habiti Antichi et Moderni*—Cesare Vecellio. 2 vols.

Il Costume di tutti i tempi e di tutte le nazioni—Professore Lodovico Menin

Latin—*Calceo Antiquo et Caliga Veterum*—B. Balduinus

French—*Le costume historique*—A. Racinet. 6 vols.

Histoire du costume en France—J. Quicherat

Le costume français depuis Clovis—Illustrations by L. Massard

Les Arts—Moyen Âge et la Renaissance—Paul Lacroix

Mœurs, usages et costumes—Moyen Âge et la Renaissance—Paul Lacroix

Vie militaire et religieuse—Moyen Âge et Renaissance—Paul Lacroix

XVII^e siècle—Institutions, usages et costumes—Paul Lacroix

XVIII^e siècle—Institutions, usages et costumes—Paul Lacroix

Directoire, consulate et empire—Paul Lacroix

Le costume civil en France du XIII^e au XIX^e siècle—Camille Piton

Les modes de Paris—1797-1897—Octave Uzanne

Le costume en France—Ary Renan

The Old Testament—J. James Tissot

Les grands maréchaux de France—Illustrations by Henri Thériet

Histoire de la peinture classique—Jean de Foville

Histoire du costume—Jacques Ruppert

The History of Costume in France—M. Augustin Challamel

Un siècle de modes féminines 1794-1894—Charpentier et Pasquelle

Mesdames nos aïeules: dix siècles d'élégances—Robida

Histoire du costume—Librairie Hachette

Histoire de Marlborough—Caran d'Ache

Cent ans de modes françaises—1800-1900—Mme. Cornil

La mode féminine 1900-1920—Éditions Nilsson

Chaussures d'Antin—Jérôme Doucet

La Chaussure à travers les âges—J. P. Yernaux

Le costume—Miguel Zamacoïs

Swiss—*Ciba Review*

German—*Le costume chez les peuples anciens et modernes*—Fr. Hottenroth

 Die Trachten der Völker—Albert Kretschmer

 Münchner Bilderbogen—Zur Geschichte des Kostüme

 An Egyptian Princess—George Ebers

 Die Mode im Mittelalter—Max von Boehn

 Die Mode im XVI. Jahrhundert—Max von Boehn

 Die Mode im XVII. Jahrhundert—Max von Boehn

 Die Mode im XVIII. Jahrhundert—Max von Boehn

 Modes and Manners of the XIX century—Fischel and Von Boehn. 4 vols.

 Kostümkunde—Hermann Weiss

 Allegemeine Trachtenkunde—Bruno Köhler

 A History of Costume—Carl Köhler and Emma von Sichart

 Des Ehrenkleid des Soldaten—Martin Lezieus

 Greische Kleidung—Margaret Bieber

 Die Moden des XIX. Jahrhunderts.—Collection Geszler

English—*Manners and Customs of the English*—Joseph Strutt. 3 vols.

 Cyclopædia of Costume—James Robinson Planché. 2 vols.

 Costume in England—F. W. Fairholt, F.S.A. 2 vols.

 Napoléon—J. T. Bailey

 Parliament Past and Present—Arnold Wright and Philip Smith

 Wellington and Waterloo—Major Arthur Griffiths

 Harmsworth History of the World

 Knight's History of England

 Costume of the Ancients—Thomas Hope

 The Art of Heraldry—Arthur Charles Fox-Davies

 Everyday Life in Saxon, Norman and Viking Times—M. and C. H. B. Quennell

 Everyday Life in Roman Britain—M. and C. H. B. Quennell

 History of Everyday Life in Britain—1066-1799—M. and C. H. B. Quennell

 Life and Work of the People of England—16th Century—Hartley and Elliot

 Life and Work of the People of England—17th Century—Hartley and Elliot

 Chats on Costume—G. Wooliscraft Rhead, R.E.

 Historic Costume—Kelley and Schwabe

 A Short History of Costume and Armour—Kelley and Schwabe

 English Costume—Dion Clayton Calthrop

Dress Design—Talbot Hughes

English Costume—XIV–XIX Centuries—Brooke and Laver

Royal Historic Gloves and Shoes—W. B. Redfern

The Evolution of the Shoe—Claude V. White

The Rómance of the Shoe—Thomas Wright

The History of Signboards—Larwood and Hotten

American—*Two Centuries of Costume in America*—Alice Morse Earle. 2 vols.

Social New York under the Georges—Esther Singleton

The Book of the Feet—Joseph Sparkes Hall

Historic Dress in America—Elizabeth McClellan

Early American Costume—Warwick and Pitz

The New World—Stephen Lorant

The Classic Myths—Charles Mills Gayley, Litt.D., L.L.D.

A History of the Ancient World—George Willis Botsford, Ph.D.

Ancient Times—James Henry Breasted, Ph.D., L.L.D.

Aztecs of Mexico—George C. Vaillant

Accessories of Dress—Lester and Oerke

Album of American History—James Truslow Adams. 3 vols.

A Picture History of Russia—John Stuart Martin

Adventures of America—1857 to 1900—John A. Kouwenhoven

Historic Costume for the Stage—Lucy Barton

This Is Fashion—Elizabeth Burris-Meyers

Costume Throughout the Ages—Mary Evans

The National Geographic Magazine—1925–1947

The Encyclopædia Britannica

New Standard Encyclopedia—Funk and Wagnalls

Pacemakers of Progress—Harold R. Quimby

Fairchild Publications

Metropolitan Museum of Art Publications

Museum of Natural History

Godey's Lady Book

Harper's Bazaar

Vogue

Studio

Time

Life

Men's Reporter

Women's Reporter

Apparel Arts

The Language of Fashion—Mary Brooks Picken

A Dictionary of Men's Wear—William Henry Baker

America Learns to Play—Foster Rhea Dulles

A CATALOG OF SELECTED
DOVER BOOKS
IN ALL FIELDS OF INTEREST

STICKLEY CRAFTSMAN FURNITURE CATALOGS, Gustav Stickley and L. & J. G. Stickley. Beautiful, functional furniture in two authentic catalogs from 1910. 594 illustrations, including 277 photos, show settles, rockers, armchairs, reclining chairs, bookcases, desks, tables. 183pp. 6½ x 9¼. 0-486-23838-5

AMERICAN LOCOMOTIVES IN HISTORIC PHOTOGRAPHS: 1858 to 1949, Ron Ziel (ed.). A rare collection of 126 meticulously detailed official photographs, called "builder portraits," of American locomotives that majestically chronicle the rise of steam locomotive power in America. Introduction. Detailed captions. xi+ 129pp. 9 x 12.
0-486-27393-8

AMERICA'S LIGHTHOUSES: An Illustrated History, Francis Ross Holland, Jr. Delightfully written, profusely illustrated fact-filled survey of over 200 American lighthouses since 1716. History, anecdotes, technological advances, more. 240pp. 8 x 10¾.
0-486-25576-X

TOWARDS A NEW ARCHITECTURE, Le Corbusier. Pioneering manifesto by founder of "International School." Technical and aesthetic theories, views of industry, economics, relation of form to function, "mass-production split" and much more. Profusely illustrated. 320pp. 6⅛ x 9¼. (Available in U.S. only.) 0-486-25023-7

HOW THE OTHER HALF LIVES, Jacob Riis. Famous journalistic record, exposing poverty and degradation of New York slums around 1900, by major social reformer. 100 striking and influential photographs. 233pp. 10 x 7⅞. 0-486-22012-5

FRUIT KEY AND TWIG KEY TO TREES AND SHRUBS, William M. Harlow. One of the handiest and most widely used identification aids. Fruit key covers 120 deciduous and evergreen species; twig key 160 deciduous species. Easily used. Over 300 photographs. 126pp. 5⅜ x 8½. 0-486-20511-8

COMMON BIRD SONGS, Dr. Donald J. Borror. Songs of 60 most common U.S. birds: robins, sparrows, cardinals, bluejays, finches, more—arranged in order of increasing complexity. Up to 9 variations of songs of each species.
Cassette and manual 0-486-99911-4

ORCHIDS AS HOUSE PLANTS, Rebecca Tyson Northen. Grow cattleyas and many other kinds of orchids—in a window, in a case, or under artificial light. 63 illustrations. 148pp. 5⅜ x 8½. 0-486-23261-1

MONSTER MAZES, Dave Phillips. Masterful mazes at four levels of difficulty. Avoid deadly perils and evil creatures to find magical treasures. Solutions for all 32 exciting illustrated puzzles. 48pp. 8¼ x 11. 0-486-26005-4

MOZART'S DON GIOVANNI (DOVER OPERA LIBRETTO SERIES), Wolfgang Amadeus Mozart. Introduced and translated by Ellen H. Bleiler. Standard Italian libretto, with complete English translation. Convenient and thoroughly portable—an ideal companion for reading along with a recording or the performance itself. Introduction. List of characters. Plot summary. 121pp. 5¼ x 8½. 0-486-24944-1

FRANK LLOYD WRIGHT'S DANA HOUSE, Donald Hoffmann. Pictorial essay of residential masterpiece with over 160 interior and exterior photos, plans, elevations, sketches and studies. 128pp. 9¼ x 10¾. 0-486-29120-0

FRENCH STORIES/CONTES FRANÇAIS: A Dual-Language Book, Wallace Fowlie. Ten stories by French masters, Voltaire to Camus: "Micromegas" by Voltaire; "The Atheist's Mass" by Balzac; "Minuet" by de Maupassant; "The Guest" by Camus, six more. Excellent English translations on facing pages. Also French-English vocabulary list, exercises, more. 352pp. 5³/₈ x 8¹/₂. 0-486-26443-2

CHICAGO AT THE TURN OF THE CENTURY IN PHOTOGRAPHS: 122 Historic Views from the Collections of the Chicago Historical Society, Larry A. Viskochil. Rare large-format prints offer detailed views of City Hall, State Street, the Loop, Hull House, Union Station, many other landmarks, circa 1904-1913. Introduction. Captions. Maps. 144pp. 9³/₈ x 12¹/₄. 0-486-24656-6

OLD BROOKLYN IN EARLY PHOTOGRAPHS, 1865–1929, William Lee Younger. Luna Park, Gravesend race track, construction of Grand Army Plaza, moving of Hotel Brighton, etc. 157 previously unpublished photographs. 165pp. 8⁷/₈ x 11³/₄.

0-486-23587-4

THE MYTHS OF THE NORTH AMERICAN INDIANS, Lewis Spence. Rich anthology of the myths and legends of the Algonquins, Iroquois, Pawnees and Sioux, prefaced by an extensive historical and ethnological commentary. 36 illustrations. 480pp. 5³/₈ x 8¹/₂.

0-486-25967-6

AN ENCYCLOPEDIA OF BATTLES: Accounts of Over 1,560 Battles from 1479 B.C. to the Present, David Eggenberger. Essential details of every major battle in recorded history from the first battle of Megiddo in 1479 B.C. to Grenada in 1984. List of Battle Maps. New Appendix covering the years 1967–1984. Index. 99 illustrations. 544pp. 6¹/₂ x 9¹/₄.

0-486-24913-1

SAILING ALONE AROUND THE WORLD, Captain Joshua Slocum. First man to sail around the world, alone, in small boat. One of the great feats of seamanship told in delightful manner. 67 illustrations. 294pp. 5³/₈ x 8¹/₂. 0-486-20326-3

ANARCHISM AND OTHER ESSAYS, Emma Goldman. Powerful, penetrating, prophetic essays on direct action, role of minorities, prison reform, puritan hypocrisy, violence, etc. 271pp. 5³/₈ x 8¹/₂. 0-486-22484-8

MYTHS OF THE HINDUS AND BUDDHISTS, Ananda K. Coomaraswamy and Sister Nivedita. Great stories of the epics; deeds of Krishna, Shiva, taken from puranas, Vedas, folk tales; etc. 32 illustrations. 400pp. 5³/₈ x 8¹/₂. 0-486-21759-0

MY BONDAGE AND MY FREEDOM, Frederick Douglass. Born a slave, Douglass became outspoken force in antislavery movement. The best of Douglass' autobiographies. Graphic description of slave life. 464pp. 5³/₈ x 8¹/₂. 0-486-22457-0

FOLLOWING THE EQUATOR: A Journey Around the World, Mark Twain. Fascinating humorous account of 1897 voyage to Hawaii, Australia, India, New Zealand, etc. Ironic, bemused reports on peoples, customs, climate, flora and fauna, politics, much more. 197 illustrations. 720pp. 5³/₈ x 8¹/₂. 0-486-26113-1

GREAT SPEECHES BY AMERICAN WOMEN, edited by James Daley. Here are 21 legendary speeches from the country's most inspirational female voices, including Sojourner Truth, Susan B. Anthony, Eleanor Roosevelt, Hillary Rodham Clinton, Nancy Pelosi, and many others. 192pp. 5³/₁₆ x 8¹/₄. 0-486-46141-6

THE MYTHS OF GREECE AND ROME, H. A. Guerber. A classic of mythology, generously illustrated, long prized for its simple, graphic, accurate retelling of the principal myths of Greece and Rome, and for its commentary on their origins and significance. With 64 illustrations by Michelangelo, Raphael, Titian, Rubens, Canova, Bernini and others. 480pp. 5³/₈ x 8¹/₂. 0-486-27584-1

PSYCHOLOGY OF MUSIC, Carl E. Seashore. Classic work discusses music as a medium from psychological viewpoint. Clear treatment of physical acoustics, auditory apparatus, sound perception, development of musical skills, nature of musical feeling, host of other topics. 88 figures. 408pp. 5³/₈ x 8¹/₂. 0-486-21851-1

LIFE IN ANCIENT EGYPT, Adolf Erman. Fullest, most thorough, detailed older account with much not in more recent books, domestic life, religion, magic, medicine, commerce, much more. Many illustrations reproduce tomb paintings, carvings, hieroglyphs, etc. 597pp. 5³/₈ x 8¹/₂. 0-486-22632-8

SUNDIALS, Their Theory and Construction, Albert Waugh. Far and away the best, most thorough coverage of ideas, mathematics concerned, types, construction, adjusting anywhere. Simple, nontechnical treatment allows even children to build several of these dials. Over 100 illustrations. 230pp. 5³/₈ x 8¹/₂. 0-486-22947-5

GREAT SPEECHES BY AFRICAN AMERICANS: Frederick Douglass, Sojourner Truth, Dr. Martin Luther King, Jr., Barack Obama, and Others, edited by James Daley. Tracing the struggle for freedom and civil rights across two centuries, this anthology comprises speeches by Martin Luther King, Jr., Marcus Garvey, Malcolm X, Barack Obama, and many other influential figures. 160pp. 5³/₁₆ x 8¹/₄. 0-486-44761-8

OLD-TIME VIGNETTES IN FULL COLOR, Carol Belanger Grafton (ed.). Over 390 charming, often sentimental illustrations, selected from archives of Victorian graphics— pretty women posing, children playing, food, flowers, kittens and puppies, smiling cherubs, birds and butterflies, much more. All copyright-free. 48pp. 9¹/₄ x 12¹/₄. 0-486-27269-9

PERSPECTIVE FOR ARTISTS, Rex Vicat Cole. Depth, perspective of sky and sea, shadows, much more, not usually covered. 391 diagrams, 81 reproductions of drawings and paintings. 279pp. 5³/₈ x 8¹/₂. 0-486-22487-2

DRAWING THE LIVING FIGURE, Joseph Sheppard. Innovative approach to artistic anatomy focuses on specifics of surface anatomy, rather than muscles and bones. Over 170 drawings of live models in front, back and side views, and in widely varying poses. Accompanying diagrams. 177 illustrations. Introduction. Index. 144pp. 8³/₈ x11¹/₄. 0-486-26723-7

GOTHIC AND OLD ENGLISH ALPHABETS: 100 Complete Fonts, Dan X. Solo. Add power, elegance to posters, signs, other graphics with 100 stunning copyright- free alphabets: Blackstone, Dolbey, Germania, 97 more—including many lower-case, numerals, punctuation marks. 104pp. 8¹/₈ x 11. 0-486-24695-7

THE BOOK OF WOOD CARVING, Charles Marshall Sayers. Finest book for beginners discusses fundamentals and offers 34 designs. "Absolutely first rate . . . well thought out and well executed."—E. J. Tangerman. 118pp. 7³/₄ x 10⁵/₈. 0-486-23654-4

ILLUSTRATED CATALOG OF CIVIL WAR MILITARY GOODS: Union Army Weapons, Insignia, Uniform Accessories, and Other Equipment, Schuyler, Hartley, and Graham. Rare, profusely illustrated 1846 catalog includes Union Army uniform and dress regulations, arms and ammunition, coats, insignia, flags, swords, rifles, etc. 226 illustrations. 160pp. 9 x 12. 0-486-24939-5

WOMEN'S FASHIONS OF THE EARLY 1900s: An Unabridged Republication of "New York Fashions, 1909," National Cloak & Suit Co. Rare catalog of mail-order fashions documents women's and children's clothing styles shortly after the turn of the century. Captions offer full descriptions, prices. Invaluable resource for fashion, costume historians. Approximately 725 illustrations. 128pp. 8³/₈ x 11¹/₄. 0-486-27276-1

HINTS TO SINGERS, Lillian Nordica. Selecting the right teacher, developing confidence, overcoming stage fright, and many other important skills receive thoughtful discussion in this indispensible guide, written by a world-famous diva of four decades' experience. 96pp. 5³/₈ x 8¹/₂. 0-486-40094-8

THE COMPLETE NONSENSE OF EDWARD LEAR, Edward Lear. All nonsense limericks, zany alphabets, Owl and Pussycat, songs, nonsense botany, etc., illustrated by Lear. Total of 320pp. 5³/₈ x 8¹/₂. (Available in U.S. only.) 0-486-20167-8

VICTORIAN PARLOUR POETRY: An Annotated Anthology, Michael R. Turner. 117 gems by Longfellow, Tennyson, Browning, many lesser-known poets. "The Village Blacksmith," "Curfew Must Not Ring Tonight," "Only a Baby Small," dozens more, often difficult to find elsewhere. Index of poets, titles, first lines. xxiii + 325pp. 5⅜ x 8¼.
0-486-27044-0

DUBLINERS, James Joyce. Fifteen stories offer vivid, tightly focused observations of the lives of Dublin's poorer classes. At least one, "The Dead," is considered a masterpiece. Reprinted complete and unabridged from standard edition. 160pp. 5³/₁₆ x 8¼.
0-486-26870-5

THE LITTLE RED SCHOOLHOUSE, Eric Sloane. Harkening back to a time when the three Rs stood for reading, 'riting, and religion, Sloane's sketchbook explores the history of early American schools. Includes marvelous illustrations of one-room New England schoolhouses, desks, and benches. 48pp. 8¼ x 11. 0-486-45604-8

THE BOOK OF THE SACRED MAGIC OF ABRAMELIN THE MAGE, translated by S. MacGregor Mathers. Medieval manuscript of ceremonial magic. Basic document in Aleister Crowley, Golden Dawn groups. 268pp. 5³/₈ x 8¹/₂. 0-486-23211-5

THE BATTLES THAT CHANGED HISTORY, Fletcher Pratt. Eminent historian profiles 16 crucial conflicts, ancient to modern, that changed the course of civilization. 352pp. 5³/₈ x 8¹/₂. 0-486-41129-X

NEW RUSSIAN-ENGLISH AND ENGLISH-RUSSIAN DICTIONARY, M. A. O'Brien. This is a remarkably handy Russian dictionary, containing a surprising amount of information, including over 70,000 entries. 366pp. 4¹/₂ x 6¹/₈. 0-486-20208-9

NEW YORK IN THE FORTIES, Andreas Feininger. 162 brilliant photographs by the well-known photographer, formerly with *Life* magazine. Commuters, shoppers, Times Square at night, much else from city at its peak. Captions by John von Hartz. 181pp. 9¼ x 10³/₄. 0-486-23585-8

INDIAN SIGN LANGUAGE, William Tomkins. Over 525 signs developed by Sioux and other tribes. Written instructions and diagrams. Also 290 pictographs. 111pp. 6¹/₈ x 9¼.
0-486-22029-X

ANATOMY: A Complete Guide for Artists, Joseph Sheppard. A master of figure drawing shows artists how to render human anatomy convincingly. Over 460 illustrations. 224pp. 8³/₈ x 11¼. 0-486-27279-6

MEDIEVAL CALLIGRAPHY: Its History and Technique, Marc Drogin. Spirited history, comprehensive instruction manual covers 13 styles (ca. 4th century through 15th). Excellent photographs; directions for duplicating medieval techniques with modern tools. 224pp. 8³/₈ x 11¼. 0-486-26142-5

THE MALLEUS MALEFICARUM OF KRAMER AND SPRENGER, translated by Montague Summers. Full text of most important witchhunter's "bible," used by both Catholics and Protestants. 278pp. 6⅝ x 10. 0-486-22802-9

SPANISH STORIES/CUENTOS ESPAÑOLES: A Dual-Language Book, Angel Flores (ed.). Unique format offers 13 great stories in Spanish by Cervantes, Borges, others. Faithful English translations on facing pages. 352pp. 5⅜ x 8½. 0-486-25399-6

GARDEN CITY, LONG ISLAND, IN EARLY PHOTOGRAPHS, 1869–1919, Mildred H. Smith. Handsome treasury of 118 vintage pictures, accompanied by carefully researched captions, document the Garden City Hotel fire (1899), the Vanderbilt Cup Race (1908), the first airmail flight departing from the Nassau Boulevard Aerodrome (1911), and much more. 96pp. 8⅞ x 11¾. 0-486-40669-5

OLD QUEENS, N.Y., IN EARLY PHOTOGRAPHS, Vincent F. Seyfried and William Asadorian. Over 160 rare photographs of Maspeth, Jamaica, Jackson Heights, and other areas. Vintage views of DeWitt Clinton mansion, 1939 World's Fair and more. Captions. 192pp. 8⅞ x 11. 0-486-26358-4

CAPTURED BY THE INDIANS: 15 Firsthand Accounts, 1750-1870, Frederick Drimmer. Astounding true historical accounts of grisly torture, bloody conflicts, relentless pursuits, miraculous escapes and more, by people who lived to tell the tale. 384pp. 5⅜ x 8½. 0-486-24901-8

THE WORLD'S GREAT SPEECHES (Fourth Enlarged Edition), Lewis Copeland, Lawrence W. Lamm, and Stephen J. McKenna. Nearly 300 speeches provide public speakers with a wealth of updated quotes and inspiration—from Pericles' funeral oration and William Jennings Bryan's "Cross of Gold Speech" to Malcolm X's powerful words on the Black Revolution and Earl of Spenser's tribute to his sister, Diana, Princess of Wales. 944pp. 5⅜ x 8⅜. 0-486-40903-1

THE BOOK OF THE SWORD, Sir Richard F. Burton. Great Victorian scholar/adventurer's eloquent, erudite history of the "queen of weapons"—from prehistory to early Roman Empire. Evolution and development of early swords, variations (sabre, broadsword, cutlass, scimitar, etc.), much more. 336pp. 6⅛ x 9¼. 0-486-25434-8

AUTOBIOGRAPHY: The Story of My Experiments with Truth, Mohandas K. Gandhi. Boyhood, legal studies, purification, the growth of the Satyagraha (nonviolent protest) movement. Critical, inspiring work of the man responsible for the freedom of India. 480pp. 5⅜ x 8½. (Available in U.S. only.) 0-486-24593-4

CELTIC MYTHS AND LEGENDS, T. W. Rolleston. Masterful retelling of Irish and Welsh stories and tales. Cuchulain, King Arthur, Deirdre, the Grail, many more. First paperback edition. 58 full-page illustrations. 512pp. 5⅜ x 8½. 0-486-26507-2

THE PRINCIPLES OF PSYCHOLOGY, William James. Famous long course complete, unabridged. Stream of thought, time perception, memory, experimental methods; great work decades ahead of its time. 94 figures. 1,391pp. 5⅜ x 8½. 2-vol. set.
Vol. I: 0-486-20381-6 Vol. II: 0-486-20382-4

THE WORLD AS WILL AND REPRESENTATION, Arthur Schopenhauer. Definitive English translation of Schopenhauer's life work, correcting more than 1,000 errors, omissions in earlier translations. Translated by E. F. J. Payne. Total of 1,269pp. 5⅜ x 8½. 2-vol. set.
Vol. 1: 0-486-21761-2 Vol. 2: 0-486-21762-0

LIGHT AND SHADE: A Classic Approach to Three-Dimensional Drawing, Mrs. Mary P. Merrifield. Handy reference clearly demonstrates principles of light and shade by revealing effects of common daylight, sunshine, and candle or artificial light on geometrical solids. 13 plates. 64pp. 5³/₈ x 8¹/₂. 0-486-44143-1

ASTROLOGY AND ASTRONOMY: A Pictorial Archive of Signs and Symbols, Ernst and Johanna Lehner. Treasure trove of stories, lore, and myth, accompanied by more than 300 rare illustrations of planets, the Milky Way, signs of the zodiac, comets, meteors, and other astronomical phenomena. 192pp. 8³/₈ x 11. 0-486-43981-X

JEWELRY MAKING: Techniques for Metal, Tim McCreight. Easy-to-follow instructions and carefully executed illustrations describe tools and techniques, use of gems and enamels, wire inlay, casting, and other topics. 72 line illustrations and diagrams. 176pp. 8¹/₄ x 10⁷/₈. 0-486-44043-5

MAKING BIRDHOUSES: Easy and Advanced Projects, Gladstone Califf. Easy-to-follow instructions include diagrams for everything from a one-room house for bluebirds to a forty-two-room structure for purple martins. 56 plates; 4 figures. 80pp. 8³/₄ x 6³/₈. 0-486-44183-0

LITTLE BOOK OF LOG CABINS: How to Build and Furnish Them, William S. Wicks. Handy how-to manual, with instructions and illustrations for building cabins in the Adirondack style, fireplaces, stairways, furniture, beamed ceilings, and more. 102 line drawings. 96pp. 8³/₄ x 6³/₈. 0-486-44259-4

THE SEASONS OF AMERICA PAST, Eric Sloane. From "sugaring time" and strawberry picking to Indian summer and fall harvest, a whole year's activities described in charming prose and enhanced with 79 of the author's own illustrations. 160pp. 8¹/₄ x 11. 0-486-44220-9

THE METROPOLIS OF TOMORROW, Hugh Ferriss. Generous, prophetic vision of the metropolis of the future, as perceived in 1929. Powerful illustrations of towering structures, wide avenues, and rooftop parks—all features in many of today's modern cities. 59 illustrations. 144pp. 8¹/₄ x 11. 0-486-43727-2

THE PATH TO ROME, Hilaire Belloc. This 1902 memoir abounds in lively vignettes from a vanished time, recounting a pilgrimage on foot across the Alps and Apennines in order to "see all Europe which the Christian Faith has saved." 77 of the author's original line drawings complement his sparkling prose. 272pp. 5³/₈ x 8¹/₂. 0-486-44001-X

THE HISTORY OF RASSELAS: Prince of Abissinia, Samuel Johnson. Distinguished English writer attacks eighteenth-century optimism and man's unrealistic estimates of what life has to offer. 112pp. 5³/₈ x 8¹/₂. 0-486-44094-X

A VOYAGE TO ARCTURUS, David Lindsay. A brilliant flight of pure fancy, where wild creatures crowd the fantastic landscape and demented torturers dominate victims with their bizarre mental powers. 272pp. 5³/₈ x 8¹/₂. 0-486-44198-9

Paperbound unless otherwise indicated. Available at your book dealer, online at **www.doverpublications.com**, or by writing to Dept. GI, Dover Publications, Inc., 31 East 2nd Street, Mineola, NY 11501. For current price information or for free catalogs (please indicate field of interest), write to Dover Publications or log on to **www.doverpublications.com** and see every Dover book in print. Dover publishes more than 400 books each year on science, elementary and advanced mathematics, biology, music, art, literary history, social sciences, and other areas.